THE ART OF DAVID IRELAND
The Way Things Are

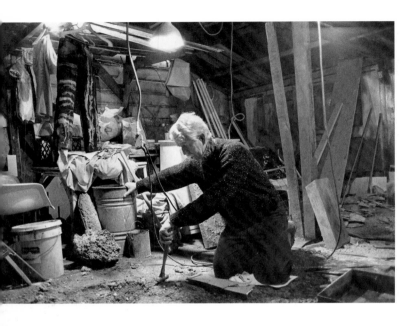

The publisher gratefully acknowledges the generous contribution to this book provided by the Art Endowment Fund of the University of California Press Associates, which is supported by a major gift from the Ahmanson Foundation.

AHMANSON · MURPHY
FINE ARTS IMPRINT

THE AHMANSON FOUNDATION

has endowed this imprint

to honor the memory of

FRANKLIN D. MURPHY

who for half a century

served arts and letters,

beauty and learning, in

equal measure by shaping

with a brilliant devotion

those institutions upon

which they rely.

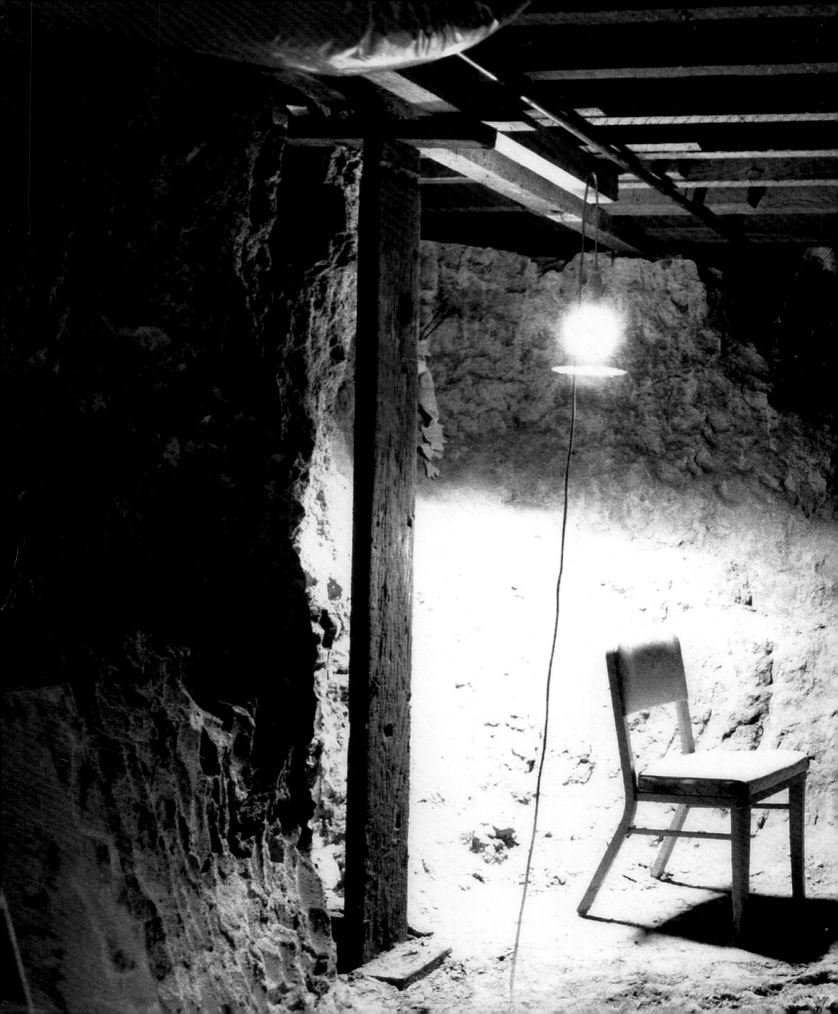

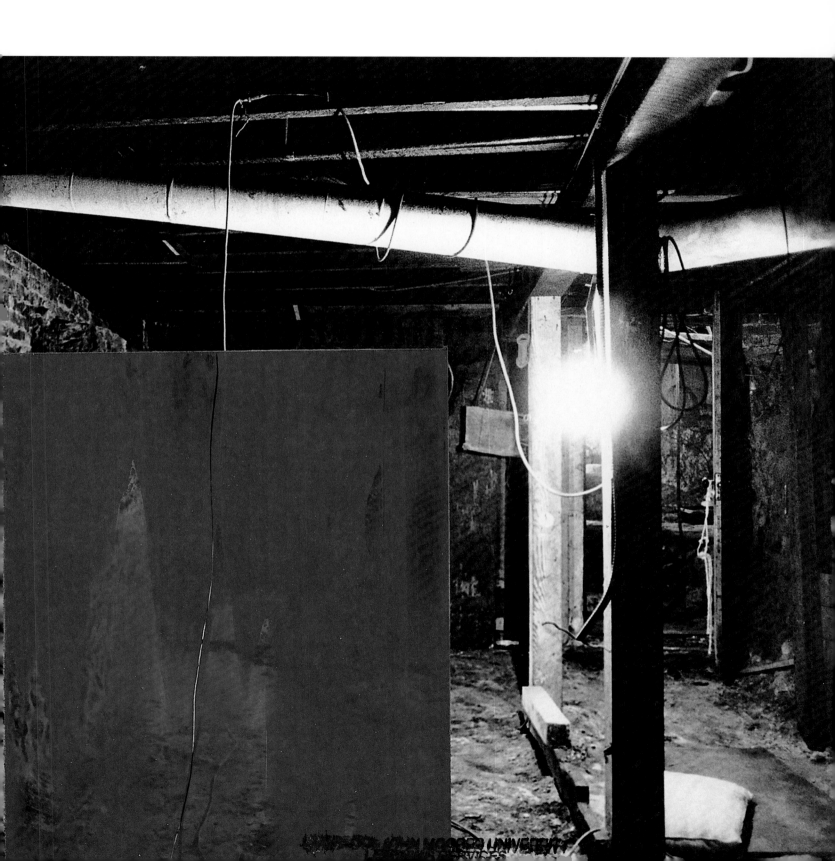

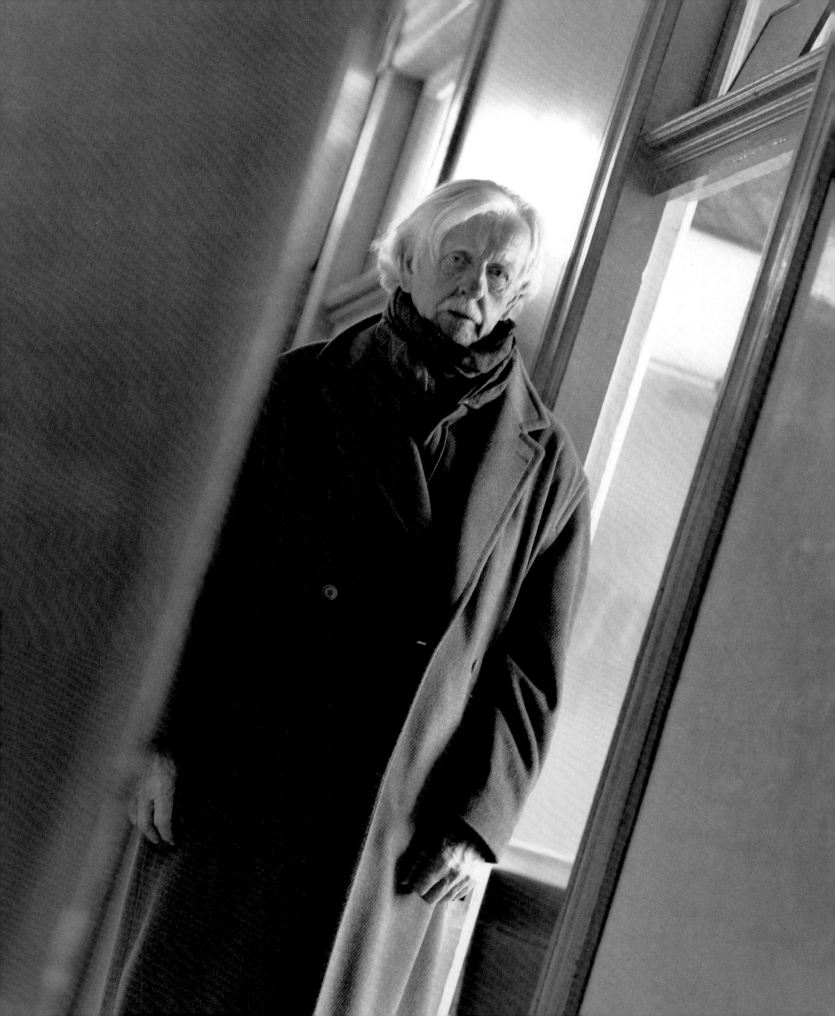

THE ART OF DAVID IRELAND
The Way Things Are

Karen Tsujimoto
and
Jennifer R. Gross

Oakland Museum of California

University of California Press
BERKELEY LOS ANGELES LONDON

This book serves as the catalogue for the exhibition *The Art of David Ireland: The Way Things Are*, organized by the Oakland Museum of California.

EXHIBITION ITINERARY:

Oakland Museum of California
November 22, 2003–March 14, 2004

Addison Gallery of American Art,
Phillips Academy, Andover, Massachusetts
April 17–July 18, 2004

Sheldon Memorial Art Gallery and
Sculpture Garden, University of Nebraska–Lincoln
August 21–November 14, 2004

Santa Barbara Museum of Art
December 11, 2004–March 15, 2005

Oakland Museum of California
Oakland, California

University of California Press
Berkeley and Los Angeles, California

University of California Press, Ltd.
London, England

Images on preceding pages: pp. ii–iii, 500 Capp Street (basement), San Francisco, 1995 (cat. 105); p. iv, David Ireland in his garage, 500 Capp Street, San Francisco, 1988 (cat. 58); pp. iv–v, *Basement Studio with Brown Panel,* 1993 (cat. 90); p. vi, David Ireland, 1999 (frontispiece)

Images on following pages: p. ix, *A Painting on a Wall in a Room Being the Same Material as the Floor* (detail), 1976 (cat. 21); p. x, *Bassinet,* 1988 (cat. 57)

Library of Congress Cataloging-in-Publication Data

Tsujimoto, Karen.
 The art of David Ireland : the way things are / Karen Tsujimoto and Jennifer R. Gross.
 p. cm.— (The Ahmanson-Murphy fine arts imprint)
 Catalog of an exhibition at the Oakland Museum of California, Nov. 22, 2003–Mar. 14, 2004;
 Addison Gallery of American Art, Phillips Acad., Andover, Mass., Apr. 17–July 18, 2004;
 Sheldon Memorial Art Gallery, Univ. of Nebraska–Lincoln, Aug. 21–Nov. 14, 2004;
 Santa Barbara Museum of Art, Dec. 11, 2004–Mar. 15, 2005.
 Includes bibliographical references and index.
 ISBN 0-520-24045-6 (cloth : alk. paper)—ISBN 0-520-24046-4 (pbk. : alk. paper)
 1. Ireland, David, 1930—Exhibitions. 2. Installations (Art)—United States—Exhibitions.
 I. Ireland, David, 1930– . II. Gross, Jennifer R. III. Oakland Museum of California.
 IV. Addison Gallery of American Art. V. Sheldon Memorial Art Gallery. VI. Santa Barbara
 Museum of Art. VII. Title. VIII. Series.
 N6537.I62 A4 2003
 709'.2—dc21 2003011771

Manufactured in Canada
12 11 10 09 08 07 06 05 04 03
10 9 8 7 6 5 4 3 2 1

The paper used in this publication meets the minimum requirements of ANSI/NISO Z39 0.48–1992 (R 1997) (*Permanence of Paper*).

Contents

The Oakland Museum of California gratefully acknowledges the following foundations, agencies, and individuals whose generous support has made the development of this book, and the exhibition it accompanies, possible.

Oakland Museum Women's Board

National Endowment for the Arts

The Andy Warhol Foundation for the Visual Arts

Ann Hatch and Paul Discoe

Paule Anglim

Agnes Bourne and Dr. James Luebbers

Nancy and Steven Oliver

Lenders to the Exhibition

Christopher Grimes Gallery, Santa Monica, California

Fine Arts Museums of San Francisco

Gallery Paule Anglim, San Francisco

Christopher Grimes, Santa Monica, California

Ann Hatch and Paul Discoe, San Francisco

Mr. and Mrs. Barry Hockfield, Penn Valley, Pennsylvania

David Ireland, San Francisco

Iris and B. Gerald Cantor Center for Visual Arts, Stanford University, Stanford, California

Jack Shainman Gallery, New York

Henry and Lisille Matheson, San Francisco

The Museum of Modern Art, New York

Ann and Bob Myers, Orange, California

Nora Eccles Harrison Museum of Art, Utah State University, Logan

Merry Norris, Los Angeles

Eileen and Peter Norton, Santa Monica, California

Oakland Museum of California

Tom Patchett, Santa Monica, California

Private Collections, New York

REFCO Group, Ltd., Chicago

San Francisco Museum of Modern Art

Ellen Ramsey Sanger and John M. Sanger, San Francisco

Jack Shainman, New York

Sheldon Memorial Art Gallery and Sculpture Garden, University of Nebraska–Lincoln

University of California, Berkeley Art Museum

Foreword

California is a fascinating area of focus for our museum. For the last century, the region has been rich ground for artists willing to take risks and explore ideas not yet validated as mainstream. Poised at a juncture where the creative winds blow from east to west and from west to east, our artists have helped nurture a cross-fertilization of ideas that has opened new worlds of aesthetic experience and awareness. Bay Area artist David Ireland fits right in this arena.

For three decades Ireland has immeasurably enriched our artistic landscape, investigating a broad terrain that includes conceptual and installation art, sculpture, and drawing. His respect for history, interest in Eastern and Western ways of perceiving the world, and pure joy in exploring ideas have resulted in work that challenges our routine way of thinking about art and how we value it as part of our everyday life. An often-cited quote of the artist's is revealing: "You can't make art by making art." At its most fundamental level, Ireland's work is about blurring the line between art and life. This he made clear in one of his most celebrated "artworks," his San Francisco home at 500 Capp Street.

Ireland began his artistic activities in the 1970s as an integral member of the San Francisco Bay Area conceptual art community. In the intervening years, his reputation has grown and flourished. His stature is clearly reflected in the respect of his peers, the admiration of younger artists, and the critical attention he has received over the years. It is fitting and with great pleasure that the Oakland Museum of California pays tribute to his achievements through this publication and retrospective exhibition. As an institution committed to recognizing the important contributions California artists have made to our cultural landscape, we have seized upon this opportunity with enthusiasm.

This book and exhibition are the result of another creative person, senior curator of art Karen Tsujimoto. Having previously organized an exhibition of the artist's work in 1988, she has brought to this project enthusiasm and knowledge essential to its realization. To her, and to the inspired teamwork of her art department colleagues, I express my appreciation.

On behalf of the museum, I thank the generous donors, listed elsewhere, who have made this exhibition and book possible. And to David Ireland we express deepest gratitude for a lifetime of creativity. He has given us much to see and even more to think about.

Dennis M. Power
Executive Director
Oakland Museum of California

Acknowledgments

On behalf of the Oakland Museum of California, it has been my pleasure to organize this first retrospective exhibition on the art of David Ireland and to document in this monograph more than thirty years of his accomplishments. During the long and complicated course of planning that was inevitably involved, I have been extremely grateful to have had the full commitment and enthusiasm of my museum colleagues. But the ultimate realization of this undertaking required the goodwill and generosity of many others outside our institutional walls. I would like to take this opportunity to acknowledge with sincere gratitude those individuals who, in sharing my belief in the significance of this project, have helped to bring it to fruition.

First and foremost, I extend my deepest appreciation to David Ireland for his tireless cooperation and graciousness in every regard. Our conversations leading up to this exhibition and publication began more than three years ago. During the period of planning and research that followed, the artist opened his home and studio to me with a gesture of warmth and hospitality that I shall never forget. He patiently answered seemingly endless and detailed questions and generously allowed me access to his personal files and archive, which was invaluable for my research. The numerous conversations we shared over a cup of tea at his home, while we lunched at a neighborhood restaurant, or as we rooted around in his studio looking at work were not only enjoyable and memorable, but also invaluable educational experiences for me. To work with David Ireland so closely has been a tremendous privilege and pleasure.

I also acknowledge the major financial assistance this project has received from the Oakland Museum Women's Board, the National Endowment for the Arts, and The Andy Warhol Foundation for the Visual Arts. The funding provided by these organizations has been crucial to the successful realization of this undertaking, and I am most appreciative.

This project has profited from the generosity of many individuals who share my regard for David Ireland's work. I express my warmest gratitude to Ann Hatch and Paul Discoe who, since our first discussions about this project, have demonstrated their enthusiasm both in word and in deed. They have provided generous financial lead support and helped with our further fund-raising efforts. Paule Anglim, Agnes Bourne and Dr. James Luebbers, and Nancy and Steven Oliver have been equally generous and supportive, and I remain most grateful. As well, I extend my heartfelt thanks to the many other individuals too numerous to list here— friends, artists, colleagues, and admirers of David Ireland's work—who have also made invaluable contributions and joined in our efforts to honor the artist's achievements.

Following its premiere in Oakland, this exhibition will travel to the Addison Gallery of American Art, Phillips Academy, Andover, Massachusetts; Sheldon Memorial Art Gallery and Sculpture Garden, University of Nebraska–Lincoln; and Santa Barbara Museum of Art, thus extending its reach by making the artist's work available to a broader audience. My thanks to Adam D. Weinberg, director, and Susan Faxon, associate director and curator, of the Addison Gallery; Janice Driesbach, director of the Sheldon Memorial Art Gallery; and Diana C. du Pont, curator of modern and contemporary art at the Santa Barbara Museum of Art, for their shared enthusiasm in presenting the exhibition at their institutions.

Certainly this project would not be possible without the generous cooperation of the lenders and owners of the artist's work who have made available important pieces for the exhibition or for reproduction in this publication. I am grateful to the many private collectors, institutions, and galleries listed elsewhere in this catalogue for their expression of cooperation; I hope that the results of this project are just reward for their generosity. In particular, my sincere thanks to Paule Anglim and Ed Gilbert of Gallery Paule Anglim, San Francisco; Christopher Grimes, David Mather, and Calvin Phelps at Christopher Grimes Gallery, Santa Monica, California; and Jack Shainman, Judy Sagal, and Katie Glicksberg of Jack Shainman Gallery, New York,

for their unwavering support in responding to my many questions and needs.

One of the pleasures of working on a project such as this has been the opportunity to connect with a wide community of individuals who, in their friendship and respect for the artist, have freely given of their time and knowledge or shared with me valuable research or photographic material. The goodwill that has been extended to me has been extraordinary. Innumerable individuals have assisted me in this way, but I especially acknowledge Henry Bowles; Damon Brandt; Abe Frajndlich; Richard Greene; Jeff Gunderson, Librarian, San Francisco Art Institute; Laura Hoffman; Betty Klausner; Diana Krevsky; Tony Labat; Susanne Lambert, Nora Eccles Harrison Museum of Art, Utah State University, Logan; Leah Levy; Marie-Louise Lienhard, Helmhaus, Zurich; Tom Marioni; Howard P. and Claudine Nuernberger; Paco Prieto; Jane Levy Reed; Suzanne B. Riess, Regional Oral History Office, The Bancroft Library, University of California, Berkeley; Kathryn Reasoner and Linda Samuels, Headlands Center for the Arts, Sausalito, California; and Anna Sola. I also especially thank Emi Takahara, assistant to David Ireland, who has helped me in countless ways.

With the publication of this book, the first to provide a retrospective view of Ireland's art, it is hoped that a fuller appreciation of the artist's work can be gained. I sincerely thank Jennifer R. Gross, Seymour H. Knox, Jr., Curator of Modern and Contemporary Art at Yale University Art Gallery, for so enthusiastically agreeing to contribute an essay to this publication, which has added a valuable new dimension of analysis to understanding the artist's work. It has also been a privilege to work with the University of California Press, which, from the very beginning, has expressed respect and enthusiasm for Ireland and his art. My appreciation is extended to Deborah Kirshman, fine arts editor; Sue Heinemann, project manager; and Erin Marietta, editorial assistant, whose expertise helped to bring this book to reality. It has also been a pleasure to work with Gordon Chun, designer of this monograph, and his colleagues Suzanne Chun and Judith Dunham, copy editor, whose combined skills have added to the quality of this book.

The extensive research and documentation involved in this publication were accomplished through the diligent and thorough work of three individuals whom I most warmly acknowledge: Kathy Borgogno, art curatorial specialist at the museum, Sharon E. Bliss, and Barbara Eaton. Their unstinting commitment and conscientious efforts have contributed inestimably to this publication. I also sincerely thank M. Lee Fatherree who, with consummate care and attentiveness, completed a major portion of the photographs that enhance the pages of this book.

A project of this scope requires the goodwill and hard work of still many more individuals who must be acknowledged, not the least of whom are my colleagues at the Oakland Museum of California. To all of them I extend my heartfelt gratitude. In both large and small ways they have helped to assure the ultimate success of this undertaking. Philip Linhares, chief curator of art, was an early advocate for this exhibition and was joined by executive director Dennis M. Power and deputy director Mark Medeiros, who have wholeheartedly supported this undertaking throughout. I am also most appreciative of my colleagues in the development department, especially Louise Gregory and Jerry Daviee, whose enthusiasm for this project has helped to guarantee its funding. Likewise, I thank Richard Griffoul, Shirleen Schermerhorn, and Gail Bernstein of the museum's marketing and communications office for their enthusiastic efforts on behalf of the exhibition. For their careful attention to all aspects concerning the artworks, the exhibition, and its national tour, I sincerely thank registrars Arthur Monroe and Joy Tahan. Karen Nelson, art interpretive specialist, has masterfully planned the adjunct educational activities attending the exhibition. Finally, my heartfelt appreciation is extended to David Ruddell, head preparator, who, from the very beginning of this project, has been an invaluable and constant source of support, wisdom, and counsel.

Karen Tsujimoto
Senior Curator of Art
Oakland Museum of California

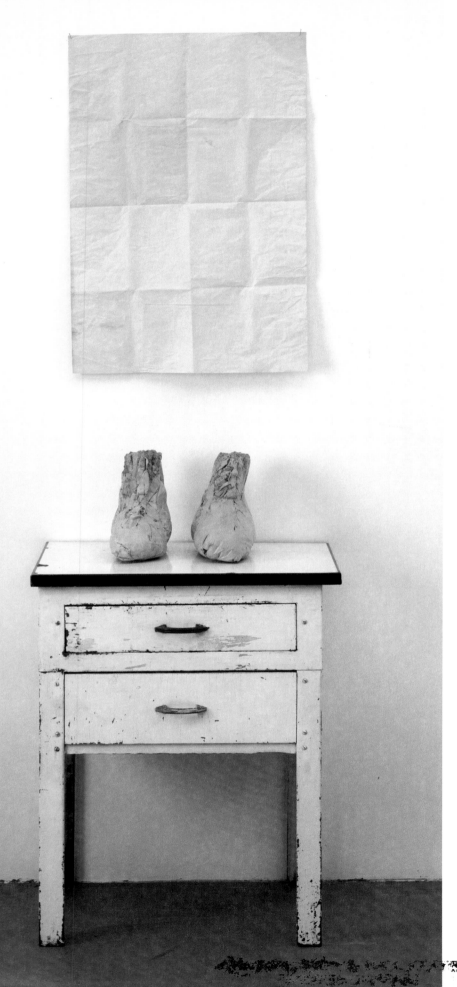

What Is Life

Life is an opportunity	Avail it
Life is a beauty	Admit it
Life is a bliss	Taste it
Life is a challenge	Meet it
Life is a dream	Realize it
Life is a duty	Perform it
Life is a game	Play it
Life is a journey	Complete it
Life is a love	Enjoy it
Life is a mystery	Unfold it
Life is a promise	Fulfill it
Life is a sorrow	Overcome it
Life is a song	Sing it
Life is a struggle	Accept it
Life is a tragedy	Brace it
Life is an adventure	Dare it

—SITA RAM

New Shoes, 1987 (cat. 54)

Karen Tsujimoto

BEING IN THE WORLD

IN A GRAY BOX FILLED with memorabilia from David Ireland's early years can be found a discolored sheet of paper upon which these words were penned by the artist. Amid the other mementos, this thin slip of paper might easily be overlooked. But the text, which Ireland carefully transcribed sometime in the mid-1970s and has saved for all these years, offers an invaluable key to understanding his work. Written when he was in his early forties, after he had made the commitment to turn his full attention to art, the text can be appreciated as a kind of personal mantra, an affirmation of Ireland's new life and the joy he would soon discover through his work.

Once his choice was made, Ireland pursued his art with unwavering conviction. In the more than thirty years since then, he has created a diverse body of work that has gained national and international respect. Yet, as an artist, Ireland is difficult to characterize, for his work takes no predictable form. He moves fluidly from making small drawings on paper to creating sculptures as large as a house, and he freely incorporates into his art anything within his conceptual or physical reach. His art is idiosyncratic, provocative, enigmatic, and often suffused by his great punning wit—leaving many a viewer puzzling about his work. Yet, this is exactly how Ireland wants it to be. Like a Zen koan, a seemingly incoherent riddle posed by Buddhist monks, Ireland's art slyly suggests that it is through befuddlement that understanding and knowledge are ultimately attained.

Without question, Ireland took a circuitous route in arriving at his destination as an artist. As a young man he studied art and design and traveled around the world, satisfying his adventuresome curiosity. He took jobs as an architectural draftsman, an insurance salesman, and a carpenter; married and fathered two beautiful children; and worked as an African safari guide and import businessman—before coming full circle, returning once again to art. This seemingly patternless preamble to his life as an artist implicitly suggests Ireland's fine disregard for convention and hearty sense of adventure and inquisitiveness. This sensibility, indeed this philosophy about life, offers yet another key to understanding Ireland's art and the creative thought process he brings to his work.

Early Years

Ireland's artistic journey began in the Northwest port town of Bellingham, Washington, where he was born in 1930. Situated in the fertile Puget Sound coastline between Seattle and Canada, and serving as an embarkation point for the beautiful San Juan Islands, Bellingham was a town of about thirty-five thousand when Ireland grew up in the rural community supported by agriculture, logging, and fishing. Raised in a comfortable middle-class home with his three sisters, he enjoyed a childhood filled with summer trips to the beach and nearby islands, hikes in the mountains, and skiing in the winter. But as Ireland readily acknowledges, Bellingham was not exactly the place to look at art.

Despite Bellingham's seeming artistic limitations, Ireland's parents ensured that their children were not culturally deprived, although their own interest in the visual arts was limited. His mother, active in the local museum of art and history, was known for her skills as an aspiring actress and maintained a lifelong love of theater that she shared with her family. His father, an insurance businessman, enjoyed music, especially the piano, and surprised his family one summer when he took piano lessons. Their commitment to the cultural enrichment of their children was symbolized by enrolling Ireland and his sisters in an experimental pre-Montessori school that encouraged an appreciation of music and art—looking at paintings by Rembrandt, listening to music by Brahms, dancing to Tchaikovsky's *Swan Lake*. Ireland's childhood enchantment with Rudyard Kipling's poems and novels instilled in him a romantic fascination with travel to exotic places, an allure that would later affect his adult life. In high school he took a few art classes, although a life in the fine arts was far from his mind. Nonetheless, his exposure to art seems to have unconsciously embedded itself in Ireland's youthful mind. As he has observed, "I think sometimes our career sneaks up on us and we don't realize we're getting educated."[1]

Ireland's nascent artistic inclinations were nurtured further by his studies at Bellingham's Western Washington College of Education (now Western Washington University) from 1948 to 1950. Although he focused on required general-education courses, Ireland caught the attention of his art teacher Ruth Kelsey, who saw promise in her young student. An art graduate of the University of California at Berkeley, Kelsey was familiar with schools in Northern California and encouraged Ireland's parents to allow him to apply to the California College of Arts and Crafts (CCAC) in Oakland. Her suggestion could not have been more fortuitous, for Ireland remembers his increasing restlessness as his interest in art, culture, and a world larger than Bellingham came into sharp relief. "I was starved for people to talk to about the things I thought were interesting. That's not to say that the people I knew there weren't bright. It's just that they had a different set of interests. Mine were cultural, and where that's the case, you have to go to the city, where cultural communication is taking place—you can't live in the woods."[2]

In 1950 Ireland moved to Oakland and enrolled at CCAC. For the next three years he rented various small apartments near the school, as his modest budget allowed, and began immersing himself in his studies. Since its founding in 1907, CCAC had an established reputation for training artists in the practical disciplines of industrial and applied arts and crafts and art education, based on the turn-of-the-century arts and crafts concepts of British craftsman William Morris. As Ireland recalls, the school later became known as a kind of West Coast Bauhaus, with one of its main goals to ensure that graduating students would be able to earn a living through their art. This philosophy was especially evident during World War II, when several European émigré artists joined the CCAC faculty, including book designer Wolfgang Lederer, stage designer Eric Stearne, and fabric artist Trude Guermonprez, who had assisted Anni Albers at Black Mountain College.

The school was a magnet attracting aspiring artists and craftspeople from throughout the western United States. Enrolled at CCAC at the same time as Ireland

were several students who also later went on to artistic acclaim. Among them were Peter Voulkos, who was then working on his master's degree in functional ceramics; Robert Arneson, who was studying commercial art and art education; Nathan Oliveira, who was completing his bachelor's and then master's degree in painting and printmaking; and Manuel Neri and Robert Bechtle, who were studying ceramics and painting, respectively. Although Ireland was not part of these artists' social circle, he enjoyed the school's intimate campus life. He found that general formalities were kept to a minimum and the instructors did their best to bring themselves to the same level as their students.[3]

When he entered CCAC, Ireland had romantic notions of being a stage designer. He was enamored of the idea of creating elaborate ballet and theater sets and traveling around the world in the company of cultured people—even though, save for his mother's love of theater, he had experienced little personal involvement with stage productions. Despite his youthful aspirations, Ireland recalls this period as being one of a continual search for a place where he fit into this new creative environment.[4] The classes he took were basic and broad ranging, including life drawing, painting, lettering, package and interior design, and architectural rendering, the latter of which served Ireland well as it provided him a way to earn a living after graduating from college.

The art world of the early 1950s was experiencing a period of radical change, with the abstract expressionists then at the height of their fame and notoriety. The reverberations of this new style of painting were especially felt across the bay in San Francisco at the California School of Fine Arts (now San Francisco Art Institute), where Clyfford Still had taught from 1946 to 1950, and painters such as Richard Diebenkorn, Frank Lobdell, and Hassel Smith were working in a gritty, abstract style. At CCAC, however, the impact of abstract expressionism was negligible. Ireland took painting classes, but he recalls responding disparagingly to the work of artists such as Jackson Pollock and Willem de Kooning. As he explains, he just was not ready for that kind of art.

Although it would be many years before Ireland found his true niche, the time at CCAC helped foster within him new ways of thinking about and looking at the world, and realizing what was important to him as a visual artist.

Of the teachers that Ireland studied with, he especially recalls theater and industrial arts designer Eric Stearne, painter and printmaker Nathan Oliveira, and metal and jewelry craftsman Bob Winston. Winston, a sculptor and one of the finest jewelry artists working in the Bay Area at the time, was known for having revived the lost-wax method in jewelry design. He was also in charge of the school's experimental workshop where students learned to work with a wide range of materials. Ireland remembers being impressed by Winston's inventive manipulation of materials and savored the time investigating what could be produced from the classroom equipment, much of which Winston had personally lent to the school. Although Ireland never pursued jewelry design, he gained an appreciation for different materials and a love of working with his hands.

Ireland also discovered printmaking through his studies with Nathan Oliveira. It was at CCAC that Oliveira himself became deeply involved with the discipline, particularly lithography, which was then somewhat neglected in art schools. After receiving his master's degree from CCAC in 1952, Oliveira joined the faculty as an instructor in printmaking for a semester, with Ireland working as his assistant. Writing to his parents, Ireland described how much he enjoyed printmaking and the freedom he discovered in handling the medium.[5] Many years later, when Ireland began making prints again after a hiatus of almost two decades, he expanded on his fascination with the processes and materials of printmaking, citing his attraction to the seductive quality of printer's ink, the mystery of discovering what would finally appear on paper, and the pure physical work of pulling a print. "Printers like process. . . . There's something about machinery and the physicality of printmaking that is unlike other things. There's this thing about wheels

David Ireland
Logical Form Study, 1950–53 (fig. 1)

and machines and odors that go into printmaking. . . . So I responded to that."[6]

Equally influential was Eric Stearne, who taught in the design department. A wartime émigré whose professional background was in experimental theater, Stearne had worked with the renowned German stage director Max Reinhardt. Unable to obtain theater work in the United States, he redirected his attention to teaching industrial and interior design courses at CCAC, as well as a stage design class in which Ireland was initially the first and only student. Given the fledgling nature of the course, no actual theater sets were designed; instead, the curriculum focused on two-dimensional renderings (left), model building, and reminiscences that Stearne avidly shared with his young charge. But Stearne was also adamant about imparting the harsh realities of the theater profession. He often pointed out, with a justified sense of irony, that it was much easier to earn a living in industrial than stage design. Taking this advice to heart, Ireland gradually shifted his attention to the industrial and architectural design courses that Stearne also taught. In retrospect, Ireland's early class projects, such as working on a "home show" and designing lamps (p. 191), seem to foreshadow some of the interests that distinguish much of his later art. So promising was Ireland's work that Stearne at one point encouraged a business partnership between them, although nothing came of the discussion. Even in his off hours from class assignments, Ireland sought opportunities to expand his experience: he solicited jobs to custom-design and build cabinets for local furniture shops, and he once painted his apartment kitchen a combination of rust, dark mustard, and blue, as though it were a three-dimensional painting.[7]

Ireland also recalls the influence of Laszlo Moholy-Nagy's book *Vision in Motion* during this period. This now-classic industrial design textbook introduced Ireland to the important Bauhaus premise of the interrelatedness of art and life and the belief that all arts are equal, whether painting, photography, music, poetry, sculpture, architecture, or industrial design. As one

chapter subheading clearly states: "Designing is Not a Profession but an Attitude." Moholy-Nagy saw the role of the contemporary designer as that of an "integrator," a synthesizer of ideas in art, technology, and social thought through ongoing "laboratory experimentation." Without experimentation, he believed, there can be no new discoveries, and without discoveries, no regeneration. Moholy-Nagy also advocated the importance of intuition, recognizing that the intuitive process "has a speed and certainty which the conscious cannot match. . . . The intuitive is the fluid world of all the senses whose movements throw up ever new forms and meaning."[8]

In the years since his first exposure to Moholy-Nagy's ideas, Ireland has similarly described how for him the art-making process is like a laboratory experience. But unlike a traditional scientist whose research is a means to an end, Ireland engages in artistic research that is, more often than not, an end in itself. As he has explained, "I think art making is a matter of finding things out and not considering practical issues, but thinking about things that are internal and of an investigatory nature for ourselves."[9] Intuition has similarly played an important role in Ireland's work. "Things that you intuit somehow defy logical description," he has stated. "You can maybe defend these things afterward, but at the moment of intuition, that's exactly what you do."[10]

Although little discussed in most writing about his work, Ireland's years spent at CCAC can be seen as crucial in helping to define, however sketchily, a philosophical stance that finds expression in his mature work. The wide array of classes he took, the different tools and materials he worked with, and the varying points of view to which he was exposed prompted Ireland to see art making in a broad and pluralistic way. Encouraged to experiment, he learned not to be afraid to try or consider anything. Ironically, Ireland never took a formal course in sculpture while at CCAC; his experience in working three-dimensionally was almost exclusively through the study of industrial and architectural design. As he recalls,

he became interested in "sculpture of another sort."[11]

Surprisingly, when Ireland speaks about his early years in lectures and interviews, he rarely cites specific artists or artworks that made a decisive impression on him. Rather, he refers to intangible experiences and memories. Of his youthful dream of being a stage designer, Ireland explains that it was the *idea* of being a set designer that was so important for him, that he was intellectually and romantically aroused by such a possibility.[12] Another experience he recalls is when he went home for Christmas vacation after his second year at CCAC and presented his parents with a hanging mobile made of red and green ornaments (p. 160). The symbolic gift of what he had accomplished in art school created quite a stir among the neighbors and friends who came to see this radical artwork. But what remains most memorable for Ireland is that he was able to bore a hole in the living room ceiling to hang the mobile. Whenever he returned home after that, he could rub his fingers over the small patched hole, remembering where his artwork had once hung.

Ireland's recounting of this experience is a kind of parable that hints at the work to come. Beneath his simple Christmas story is a progression of ideas that weaves together his often seemingly disparate oeuvre. It involves sculpture, architecture and modifications of it, memory, real life, history, how people perceive and value art, and the opportunity to allow something different to happen.

In 1953 Ireland graduated from CCAC with a bachelor's degree in industrial design and a minor in printmaking. Stearne had encouraged him to continue with graduate studies, even suggesting a school in London, but Ireland's fate was decided when he was drafted into the United States Army within a few months of graduating. Stationed in Fort Leonard Wood, about a hundred miles outside of St. Louis, Ireland never saw active duty, and he found the experience to be an intellectual and emotional wasteland. But all that would soon change when he began an almost twenty-year odyssey of worldwide travel and exploration.

Following his discharge from the army in 1955, Ireland returned to Bellingham. He worked for a year as an illustrator and color coordinator for local architect Galen Bentley, saving his earnings for his first trip abroad. Anxious to have adventures and explore the world, Ireland set off for Europe in 1956, visiting, among other places, England, Scotland, and France, with his childhood friend Jack Rykken. He enjoyed his travels tremendously but, because he was not yet fully focused on art, little of what he saw in museums and elsewhere touched or inspired him. With the onset of the cold European winter, Ireland decided to visit a friend and former CCAC classmate, Michael Lacey, who was then living in the warmer environs of South Africa. This serendipitous decision proved fateful for Ireland. Smitten immediately by the flora and fauna and the adventure of living in such an exotic place, Ireland stayed for almost a year and a half, working as a draftsman for a Johannesburg architectural firm, living on a farm, and traveling throughout southern and eastern Africa.

In late 1958, with his wanderlust temporarily satisfied, Ireland returned to Bellingham to join his father's insurance firm. Grateful for what his parents had provided him, he felt the need to show his appreciation by this gesture, and for the next several years he worked as an insurance broker. Settling into a more traditional life, Ireland married Joanne Westford, a Bellingham native, in 1961, and a few years later he was the father of two children. Despite his focus on family, business, and civic activities, Ireland maintained his African contacts and eventually established Hunter Africa, a gallery and import business for African artifacts and big-game skins, at the time the only one of its kind on the West Coast.

Not surprisingly, Ireland's interest in insurance began to wane, and when his father retired, Ireland left the family business as well, shifting his full attention to Hunter Africa. With a growing clientele based in the San Francisco Bay Area, Ireland made the critical decision to move his family and business to San Francisco in 1965. With his wife as an active partner, Ireland opened a storefront in North Beach that catered to interior designers and offered an armchair safari experience by selling such merchandise as animal skins and fur-covered chairs and pillows. Shortly thereafter they also began a safari business. For the next seven years Ireland lived the exotic and adventuresome life that he had dreamed about as a child reading Kipling. He led photography and hunting safaris throughout eastern Africa, climbed Mount Kilimanjaro, and traveled throughout Asia as well.

Although Ireland was not involved in art during these years, he was "responding to what was there," observing all that surrounded him.[13] Ernest Hemingway described this as the way a writer "trains" for his profession. "If a writer stops observing he is finished," the author once told an interviewer. "But he does not have to observe consciously nor think how it will be useful. Perhaps that would be true at the beginning. But later everything he sees goes into the great reserve of things he knows or has seen."[14]

The Journey Back to Art

Ireland's African years were priceless, but by the early 1970s, his life began to change dramatically. In 1970 Ireland's marriage ended in divorce, and two years later he closed his African import and safari businesses. These shifts were further magnified, but positively so, when, in 1972 at the age of forty-two, he decided to enroll in graduate school at the San Francisco Art Institute (SFAI) on the GI Bill.[15] What appears as a radical turn in Ireland's life journey is tempered by his admission that he had, all along, been keeping an eye on the art world. "I started to see things and became attracted to mostly the expressionist people, even though what was popular in that time was the emergence of people like John Cage and the Fluxus artists," he recalls. "Andy Warhol was a big name, not to be treated lightly."[16] Intrigued by what was going on in the art world and emboldened by a sense of artistic hubris, Ireland easily made the decision to refocus his attention on art. "I just felt that it was what I should be doing."[17]

Ireland's return to art was exhilarating. Although he took a variety of courses at SFAI, he immediately reconnected with printmaking, especially lithography, and rediscovered the multisensory experience of being in a studio again. So intense was his enthusiasm that, simultaneous with his graduate studies at SFAI, Ireland enrolled in additional classes at Laney College in Oakland, where he studied with Gerald Gooch, who was especially encouraging. At the time Laney College had a wider range of printmaking equipment than SFAI, which allowed Ireland to experiment with working on a larger scale and with different techniques and materials. "I had this appetite for making art and I just made art day and night," he remembers. "Just drawing, making marks, doing paint things, doing not paint things. I was starting to think about process and materials, things that led eventually into the kind of work that interests me now."[18]

As reflected in several of his prints and works on paper from this period, Ireland was initially influenced by the ragged expressionist work of Frank Lobdell and,

especially, Nathan Oliveira. But whereas Oliveira's figurative imagery has always explored the human condition through the artist's communicative gesture and the ethos of abstract expressionism (p. 9, bottom), Ireland's work, though then sometimes vaguely figurative (p. 12), was essentially more abstract, as seen in an untitled print from 1972 (p. 9, top). Indeed, shortly thereafter, Ireland intensified his focus on formal abstractions that indicate his growing awareness of process art and minimalism with its reductive aesthetics.

In numerous works on paper Ireland experimented with how different tools and materials behave. Using a wide range of media and techniques—graphite, tempera, gouache, crayon, charcoal, and monotype—he tested varying ways to make a mark, define an area, create a texture, and suggest translucency, fluidity, or opacity (pp. 15, 16, 20). While these pieces are clearly student experiments, their variety reinforces Ireland's preoccupation with process and materials, and several works foreshadow concerns that later resurface. One is Ireland's general preference for working with a limited range of hues, including black, gray, brown, and white, or what he refers to as "non-colors." Several early works also introduce a shape that continues to reappear in two- and three-dimensional form. It is an elongated, oval-like shape that, though clearly articulated, is difficult to identify and name. It appears in Ireland's prints and drawings from graduate school (pp. 9, 14) and later manifests itself in objects made of concrete, paper, and even dirt (pp. 8, 31). Ireland describes these shapes as intentionally having "little design intelligence" and has variously referred to them as "potato-turd-like objects" and "untitled identified objects."[19] Unpretentious, even slightly dumb, they introduce concepts critical to understanding Ireland's mature sensibility—that art can be enigmatic, difficult to define, and unartful in the classic sense of the word.

Since these early pieces, Ireland has continued to pursue his love of drawing. Attracted to the hands-on intimacy of working with various materials and reveling in the different surfaces and textures they can produce, he has created hundreds of drawings over the years,

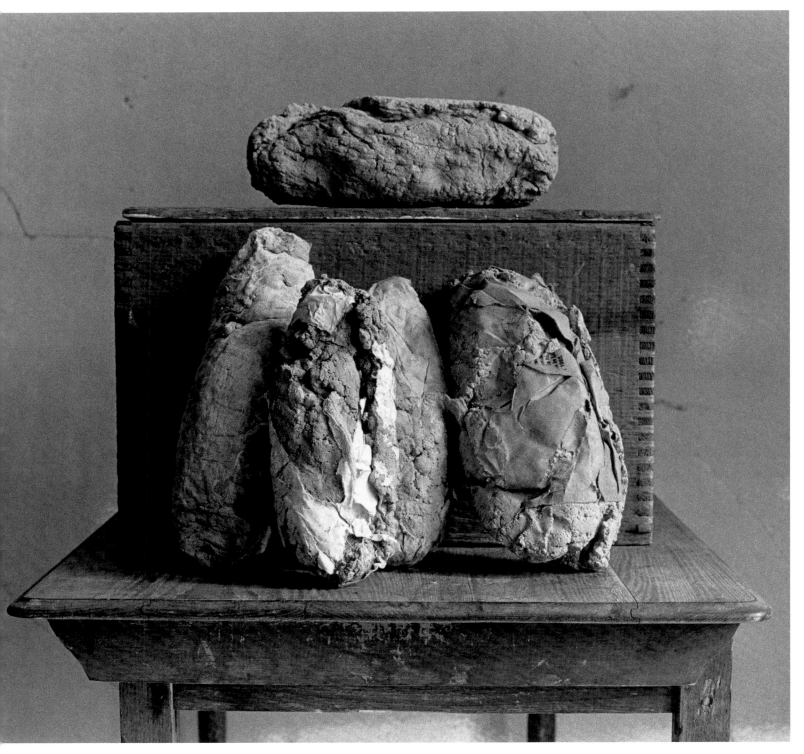

Untitled Identified Objects, 1988 (cat. 63)

ranging from scraggly and bony ones to others that reveal the luminescence of pure color (pp. 142, 144–49). Rarely are these drawings meant to be studies for larger pieces; rather, they are valued works unto themselves. Like small devotionals, they help guide Ireland along his artistic journey, clarifying the parallels between creativity and contemplative practice and meditative and aesthetic awareness. "Drawing of a certain kind, or drawing of a certain intent, is very important, and not to be discarded necessarily," Ireland observes. "Drawing is in a way the kind of backbone of art making."[20]

By the time Ireland prepared for his master's thesis in 1974, his work had changed dramatically, taking on a minimal and process-oriented look. Under the guidance of Kathan Brown, his graduate advisor in printmaking and whom Ireland credits as an important inspiration in his early years, he became aware of minimal artists such as Sol LeWitt, Robert Mangold, Brice Marden, and Robert Ryman, whose sparely articulated work was then gaining national prominence. Not only was Brown teaching at SFAI, but she was also running Crown Point Press, in Oakland, a highly regarded printmaking studio where many of these and other major East and West Coast artists came to work, and she often invited them to speak to her students. Ireland's exposure to these individuals and their aesthetics, which similarly empha-sized process and the pure physicality of a work, helped expand his way of seeing and thinking about his art. His *Quarter Circle Drawing*, 1972–73 (p. 13), for exam-ple, composed of dirt and ink on paper that was then coated with wax, was made by the repetitive process of pressing one side of the inked paper against the other to build up the rich rusty color that distinguishes the draw-ing. As Ryman has explained about his own reductive art, "There is never a question of *what* to paint, but only how to paint. The *how* of painting has always been the image."[21] Ryman's influence is also clearly evident in Ireland's *Peeled Drawing*, 1974 (p. 18), and *Zigzag*, 1975–76 (p. 33), which assert, in Ryman-like fashion, that the image is first and finally about the medium itself as it sits on its material support.

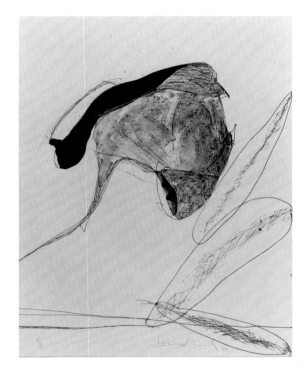

David Ireland
Untitled, 1972 (fig. 2)

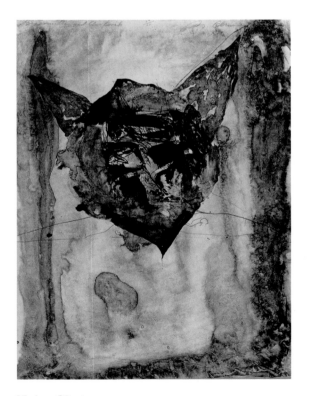

Nathan Oliveira
Graconeille and the Devil, from *Oliveira—Twelve Intimate Fantasies*, 1964 (fig. 3)

Ireland's response to the work of Brice Marden is reflected in several of the monotypes that formed his master's thesis. Like Marden's diptych and triptych paintings and prints of the time, some of Ireland's images appear as almost impenetrable wall-like physical presences, as in *Untitled Landscape,* 1974 (p. 16). By the same token, such works also foreshadow the richly textured and luminous wall surfaces that later distinguish many of Ireland's architectural and large-scale projects (pp. 42–43, 72). Several works from this period are also characterized by an emphatic horizontal division of the image and, like Marden's work, refer to the experience of landscape, what Ireland describes as the visual clash between earth and sky (p. 20). But whereas Marden gave his paintings and prints pristinely flat and monochromatic surfaces, Ireland often crumpled or folded the paper of his monotypes numerous times. Extremely concerned with process, he sometimes put his works through the press fifty times or more, layering the ink surfaces to achieve particularly rich visual effects.

Ireland's assimilation of minimal art helped him realize the infinite creative possibilities that exist even in reductive art such as Sol LeWitt's, whose conceptual underpinnings Ireland greatly respects. Yet several of Ireland's early works also suggest that his African experiences were lurking in his unconscious and percolated through to his art. Although he marginalizes this notion, it is tempting to see his pieces made of dirt (p. 21) as recalling the red South African earth that he once farmed. The wrinkled skinlike texture of *Landscape,* 1974 (p. 20), also suggests the hide of an elephant or hippopotamus, animals that Ireland knew well in the wild.

Even more crucial to Ireland's development at this time was his growing awareness of and interest in conceptual art, especially as it was being practiced in the Bay Area. Encouraged by Kathan Brown, Ireland met artist Tom Marioni, a key figure in the Bay Area conceptual art movement who would become a close friend, influence, and inspiration. Marioni was the founder and director of the Museum of Conceptual Art (MOCA), in San Francisco, which, after opening in 1970, became the key locus for the area's first generation of conceptual artists. As impresario for MOCA, Marioni defined the conceptual art that he exhibited as "idea-oriented situations not directed at the production of static objects."[22] He focused on performance art, actions, and temporary installations, although he later revised his stance to include sculptural objects.

Indicative of Marioni's interests was one of the first group exhibitions he organized in 1970, *Sound Sculpture As,* which addressed the phenomenon of sound. For the exhibition, San Francisco artist Paul Kos created *Sound of Ice Melting,* which consisted of several microphones clustered around two large blocks of ice to record their melting. Marioni's contribution, under the pseudonym of Allan Fish, was to climb a ladder and urinate into a bucket below, the modulated sound of the filling bucket contrasting with the audible response of the audience. That same year Marioni also conceived, under his pseudonym, an exhibition presented at the Oakland Museum (now Oakland Museum of California) that demonstrated his interest in Joseph Beuys's notion of art as "social sculpture." Titled *The Act of Drinking Beer with Friends Is the Highest Form of Art,* the exhibition consisted of an evening set aside for friends to join Marioni at the museum to drink beer and socialize, with the resulting debris left on view for several days as a record of the event. This and other works by Marioni and artists involved with MOCA helped establish San Francisco as an important activity center for conceptual art, then flourishing throughout the United States and globally.

A complex field with multiple practices within it, conceptual art ranged from such early projects as Terry Atkinson and Michael Baldwin's invisible *Air-Conditioning Show* to Hans Haacke's kinetic sculpture of grass growing on a plexiglass cube to Lawrence Weiner's pieces that existed only as ideas in a notebook. In 1967 Sol LeWitt, an early and important spokesman for conceptual art, wrote one of its first manifestos, clearly stating that the concept is the most important aspect of an artwork. "Conceptual art is made to engage

the mind of the viewer rather than his eye or emotions."[23] He went on to propose that, among other things, the skill of the artist is not important, nor is the appearance of the artwork. Instead, conceptual art "is intuitive, involved with all types of mental processes, and it is purposeless."[24]

Joseph Kosuth, another early spokesman for conceptual art, helped define this art form as a rejection of the traditional categories of painting and sculpture and proposed that aesthetics (or decoration as he saw it) has nothing to do with art. Importantly, he advocated that art's "art condition" is a conceptual state, and that an idea or concept itself can be considered the art.[25] In developing his point of view, Kosuth acknowledged the debt to Marcel Duchamp, whom he credits as giving art its own identity. For Kosuth and many like-minded conceptual artists—including Ireland—Duchamp is a key figure who helped restore intellectual rigor to the artist's practice and the freedom to think and act without regard for any authority or principle. As Duchamp once declared, art must have something to do with the gray matter of our understanding.

Ireland admits that he was initially slow to respond to these seemingly radical ideas. But as he was increasingly exposed to them through his contact with Marioni and MOCA, he eventually became a member of the Bay Area conceptual art community, which included not only Marioni and Kos, but also Terry Fox, Howard Fried, and Tony Labat, among others.

During this period, Ireland produced a number of two-dimensional works made from a wide assortment of materials, including not only dirt and talcum, but cement as well. He even made a work from an unfolded paper bag (p. 19). He especially favored working with these ordinary materials because they were inexpensive and universal and most important, because their character was homely and artless. Ireland presented a material simply and directly, with as little intrusion of himself as possible, allowing it to be exactly what it wanted to be, as in the case of simply unfolding a blue paper bag and accepting all the creases and cracks as they naturally

appeared. As he explained in a 1976 interview, his concern was to express "that the mere presence of the material *is* . . . it is as it is and whatever I do to it destroys this idea because those are all arbitrary selections."[26] Increasingly, Ireland wanted to strip away the aesthetic pretensions and, to his mind, arbitrary decision-making process of making art. "I was trying to . . . give credence, give place to all things, give place to the uneducated image, give place to the earth, give place to everything; which is why the cement is, again, important because it's gray, it's no color. . . . And it's for that same reason that I avoid putting an image down, I can't put a stroke on because that's my point of view. . . . I want to be with it as it is, I cannot improve on it, I cannot improve on myself."[27]

The Zen inferences in Ireland's comments are not accidental, for this Eastern way of perceiving the world is a crucial part of his creative philosophy and was evident in many of his early works. Although Ireland consciously avoids formally associating himself with Zen Buddhism, and speaks little of it, he has long been aware of its teachings and has embraced many of its thoughts and practices in his life and art. The title *Folded Paper Landscape,* which he gave to his paper bag piece, for example, is initially puzzling. But when understood in the context of Eastern thought, its significance becomes clear. In the art of Zen, the landscape serves first and foremost as a setting for enlightenment: the viewer is lost in contemplation of the scene and attains spontaneous illumination. Ordinary and simple-minded as the paper bag piece may appear, it is an important signifier of Ireland's personal quest for enlightenment.

Since the late 1950s and the emergence of the Beat generation, San Francisco has been a major center for the study of Zen Buddhism, with important figures such as Shunryu Suzuki and Alan Watts introducing Americans to the seemingly eccentric and paradoxical world of Zen practice. After Ireland moved to the Bay Area in the mid-1960s, he began to absorb himself in the subject.[28] He frequently listened to Watts's weekly radio talks about Zen Buddhism and read extensively on Eastern philosophy. Several of his friends, including

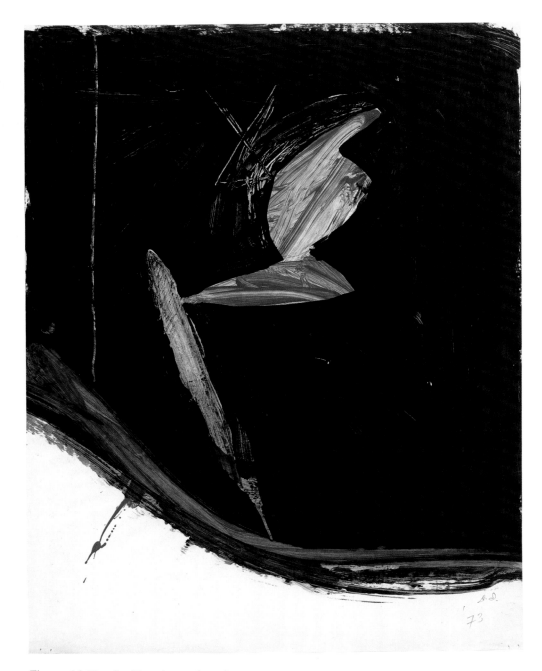

Figure with Harmless Torpedo, 1973 (cat. 2)

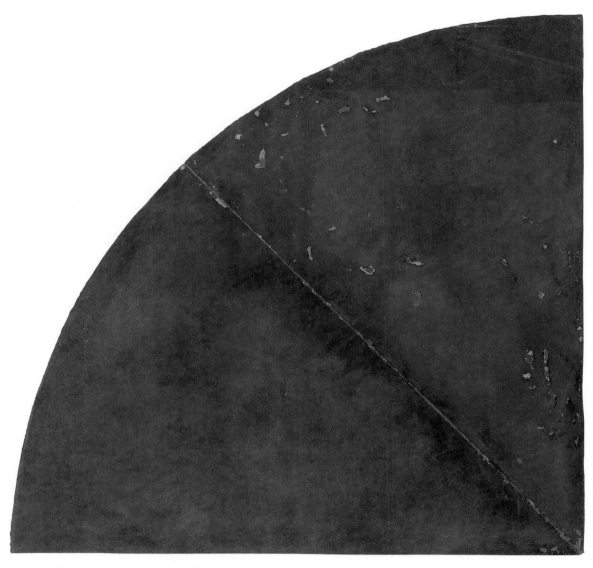

Quarter Circle Drawing, 1972-73 (cat. 1)

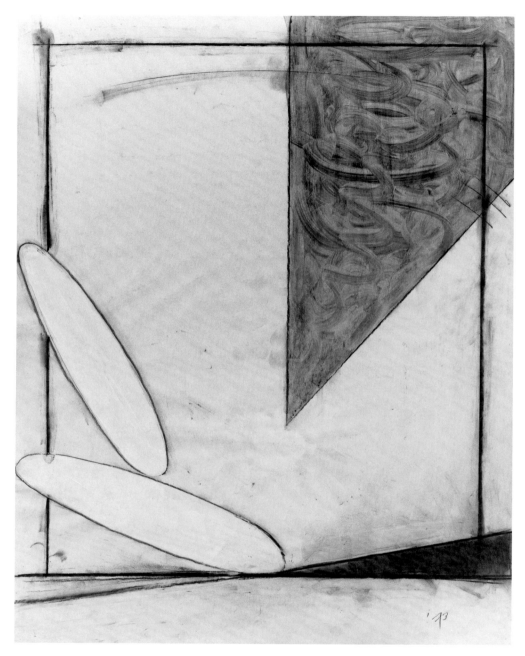

Proscenium, 1973 (cat. 5)

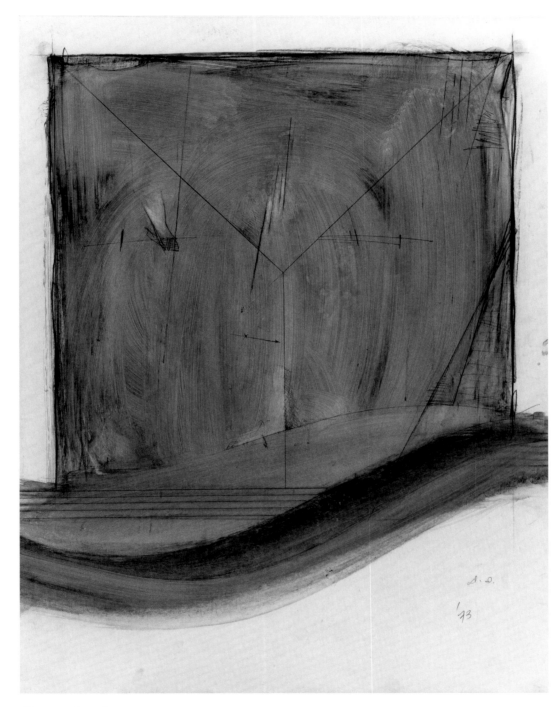

Wave, 1973 (cat. 6)

Untitled Landscape, 1974 (cat. 11)

Architecture, 1974 (cat. 7)

Peeled Drawing, 1974 (cat. 10)

Folded Paper Landscape, 1973 (cat. 3)

Landscape, 1974 (cat. 9)

Dirt Work with Flakes, 1974 (cat. 8)

Gene and Sarah Estribou, with whom he had traveled in Africa during his safari years, were also deeply involved in the practice of Zen. Ireland's trip with the Estribous to Asia in 1975, not long after finishing graduate school, was an especially transformative experience. Writing from India to another friend, Frances Hill, also a devout Zen practitioner, Ireland exclaimed: "I feel that I am in paradise and the love of people radiates through my body. I am always happy and not thinking about anything but that. There is some magic here and can only be explained by some history of Devotion."[29] Still in Ireland's library is a well-worn copy of Watts's 1957 book *The Way of Zen,* a classic text introducing Zen Buddhism to Westerners, and many of the quotes that the artist prizes, and has sometimes printed on exhibition posters and announcements, are from Zen teachings and texts.

As Watts has written, Zen Buddhism is not a religion or philosophy per se. Rather, it is a "way of liberation" that frees the individual from arbitrary rules and self-imposed absolutes followed out of a sense of social, psychological, or spiritual security. Living Zen, he explained, is above all a process of unlearning and of abandoning ideology, which ultimately leaves the mind like an open window. As Shunryu Suzuki advised Zen students, the most important thing is to keep an empty and ready mind. "If your mind is empty, it is always ready for anything; it is open to everything. In the beginner's mind there are many possibilities; in the expert's mind there are few."[30] Ireland's positive response to the liberating thoughts of Zen is not surprising. Like the open-ended nature of conceptual art, Zen offered a way for Ireland to untether himself completely. "If you meditate on the idea of all things being, the universe blows wide open and you find this incredible place out there where you literally are without ceiling, without ground underneath."[31]

Among the many lessons Ireland has absorbed from Zen teaching is the folly of valuing one thing over another—all things are equal and perfect as they are. He speaks of this as stripping away the ranking system. "These scraps of dirt that I've put up on the wall are my avenue toward meditation. If I can accept this dirt as art, this piece of cement on paper, why can't I let the universe also be my art? That's the focus of my meditation —saying I can accept this piece of dirt, I accept the universe and all within it."[32] Dust is also Buddha, as an old saying goes. Ireland thus offers drawings made simply of talcum and sculptures that look like potatoes or excrement. Cement is as acceptable as the finely ground pigment used in traditional painting, and brooms are as valid as any other sculptural medium. As the opening lines of the oldest Zen poem read:

> The perfect Way (Tao) is without difficulty,
> Save that it avoids picking and choosing.
> Only when you stop liking and disliking
> Will all be clearly understood.[33]

Ireland also embraces a Zen sense of humor, recognizing that an appreciation of art, as well as life, cannot be based on intellect or logic alone. The Zen manner of posing a nonsensical question (koan) such as "Why is a mouse when it spins?" is a way to baffle the mind and ultimately turn it inside out. In a similar vein, Ireland seeks to undermine logic in his art by titling a paper bag *Folded Paper Landscape,* or a sculpture made of copper, a broom, and concrete sitting on a stool *Good Hope* (p. 108). These works and their titles may provoke and even irritate many a viewer, just as a Zen koan might, but that is precisely the point. As Watts has written, "The aim of Zen is to focus the attention on reality itself, instead of on our intellectual and emotional reactions to reality—reality being that ever-changing, ever-growing, indefinable something known as 'life,' which will never stop for a moment for us to fit it satisfactorily into any rigid system of pigeon-holes and ideas."[34]

THROUGHOUT HIS GRADUATE school period, Ireland exhibited in various local and national print competitions, gradually building his experience as a professional artist. Especially auspicious was a San Francisco show at the John Bolles Gallery soon after he received his master's degree in the spring of 1974. Several of his recent monotypes were given favorable review from *San Francisco Chronicle* art critic Thomas Albright, who wrote of the works' rigorous austerity and richness of texture.[35] Ready to expand his artistic reach and build on his modest accomplishments, Ireland decided to move to New York later that year.

Ireland lived and worked in New York for approximately a year, from late 1974 to 1975, interrupting his stay with a trip around the world, visiting among other places Thailand, Burma, Singapore, India, Afghanistan, Australia, and England.[36] He established a studio on East Fifty-ninth Street and also had access to printmaking facilities at Hunter College, where he continued to produce monotypes. But he soon began to sense what he termed the "tyranny" of the techniques, medium, and imagery with which he was working. In his own words, Ireland started to drift even more into the realm of ideas. Despite its brevity, this time in Manhattan was crucial to his developing philosophy about making art, which became more conceptual in nature. Although Ireland went to museums and visited galleries to show his portfolio, the times most important to his growth were the solitary hours he spent in his studio.

During this period Ireland completed several monochromatic wax crayon drawings that appear as purely minimal artworks (pp. 26, 27). But at the same time they were also attempts to give visual expression to certain Zen ideas about nonduality and the oneness of all things. Ireland made the drawings by scribbling all over a piece of paper with a wax crayon until the scribbles eventually consumed one another and the entire surface was completely covered with crayon. The medium and image were ultimately indistinguishable from one another. He deliberately avoided imposing aesthetic or intellectual choices about design or composition and accepted the color of the crayons just as they were manufactured. As Ireland explained, "I let the color crayon as color crayon be my art."[37] The carefully cut out, negative square or rectangular shapes that appear in the center of some of the drawings were intended to direct attention away from the edges of the artwork, which define its "thingness," and prompt the viewer to grasp its opposite— emptiness. As Ireland explains, "If you put a mark on a piece of paper, or a hole in the piece of paper, it has to have, in some cases, equal merit and equal significance."[38] These pieces were Ireland's attempt to visualize the Eastern idea that form is emptiness and emptiness is form. "The idea that nothing was something was in my thought."[39]

It was while in New York that Ireland had a revelation about his art. Visiting the city's myriad galleries and museums, seeing other artists' work, and gauging where he and his evolving art fit in, it became apparent that any attempt to create a new composition or image that would make a meaningful contribution to the already long and picture-filled history of art was futile, if not folly. As he later recalled, "That realization was a wonderful thing because it freed me of the burden of looking for *the* image. All I had to do was accept some other things in place of [that] pursuit. That was when I started the *94-Pound Series*."[40]

Ireland's *94-Pound Series* laid the conceptual grounding for much of his subsequent art. To make this piece, the artist first spread a carpet of dry cement from a ninety-four-pound sack of the material throughout his studio. From this environment, Ireland repeatedly made similar all-over drawings each day until the cement was depleted. After that he started the *94-Pound Discard*, which entailed discarding the works every day until they were almost gone. Ireland's intent in these repetitious pieces, at the time referred to as *Repeating the Same Work Each Day*, was to work in a meditative state of aesthetic detachment, to remove the traces of personal control and self-expression that had informed his previous work.[41] In effect the work was an ongoing visual mantra that recalls Alan Watts's comments on Zen

meditation: "Simply watch everything going on without attempting to change it in any way, without judging it, without calling it good or bad. Just watch it. That is the essential process of meditation."[42]

Ultimately the piece was a turning point in Ireland's art. Through it he realized that the repeated, mindless image has equal value to any new or unique work that an artist might create. His subsequent decision to methodically discard the drawings reaffirmed the lesson that the repeated gesture is as valid as the novel action. The *94-Pound Series* also underscored that, for Ireland, the conceptual framework and the process of creation are more important than the materialized object. As he has explained, the resulting artwork is "like a prayer or . . . a religious object that in itself doesn't contain your salvation or your enlightenment; it only reminds you of your obligation to the philosophy. So the work, then, as object, isn't as significant as that I make a piece . . . that reminds me of [my] responsibility—the responsibility of trying to see what is . . . as a Zen master would have it."[43]

Not all of the works from the *94-Pound Series* were actually discarded. Ireland saved a few, which he describes, not as drawings, but as "relics" of an activity (p. 25). Superficially, these cement relics appear related to his earlier dirt pieces, and some, such as *A Portion of: From the Year of Doing the Same Work Each Day/ Elephant's Castle* (pp. 28–29), incorporate the voids that were so conceptually important to Ireland at the time. But as the artist has explained, his mindset was crucially different in the *94-Pound Series:* "The intention was . . . to take some information or some craft that I developed . . . and just use it with ease, with detachment, for making these mantras . . . each day; making a drawing that was similar to the one the day before, but getting all the same enthusiasm as though I were discovering a new one each day or making a new image."[44]

A Portion of: From the Year of Doing the Same Work Each Day, 1975 (cat. 14)

Black Crayon with Rectangular Hole, 1975 (cat. 12)

Crayon with Rectangular Hole, 1975 (cat. 13)

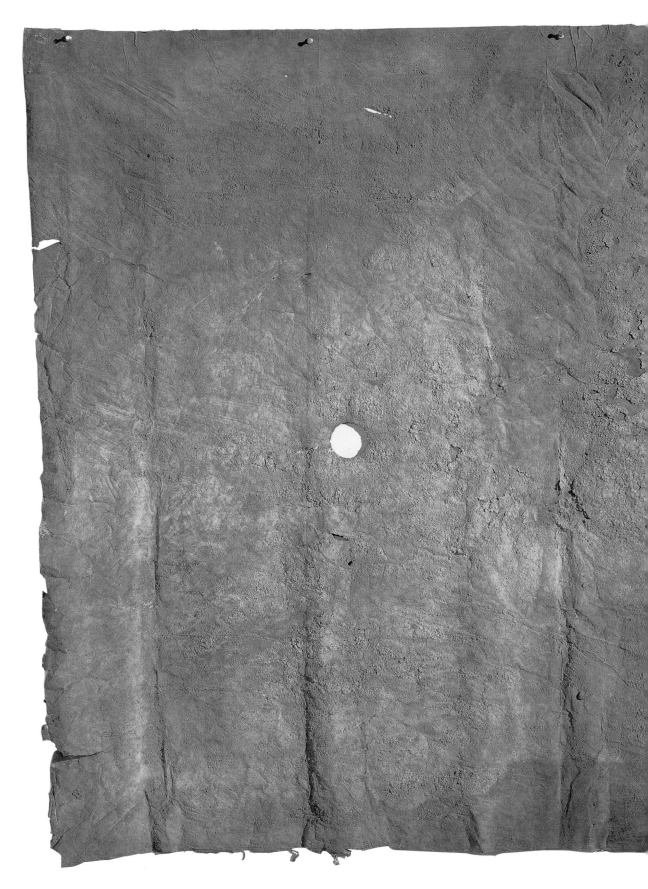

A Portion of: From the Year of Doing the Same Work Each Day/Elephant's Castle, 1975 (cat. 15)

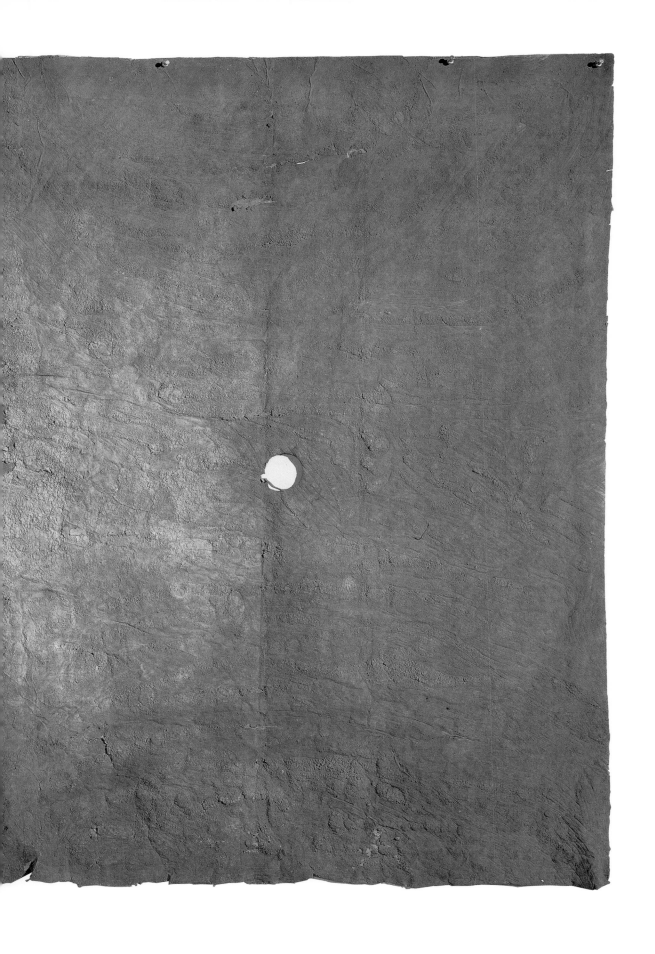

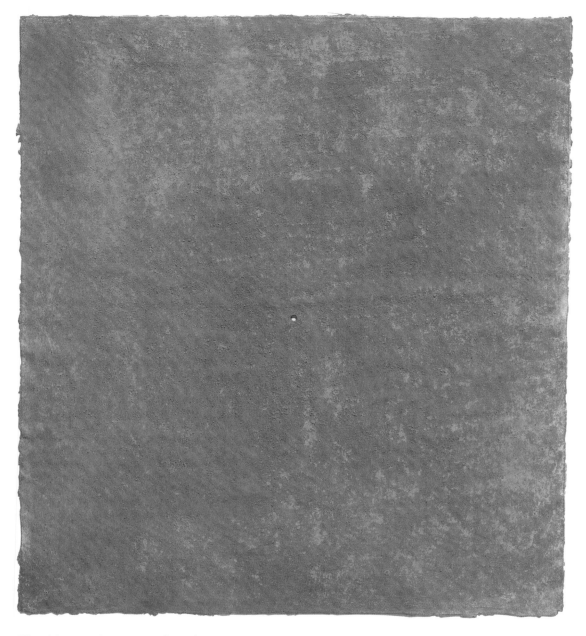

Waxed Cement with Hole, 1975 (cat. 16)

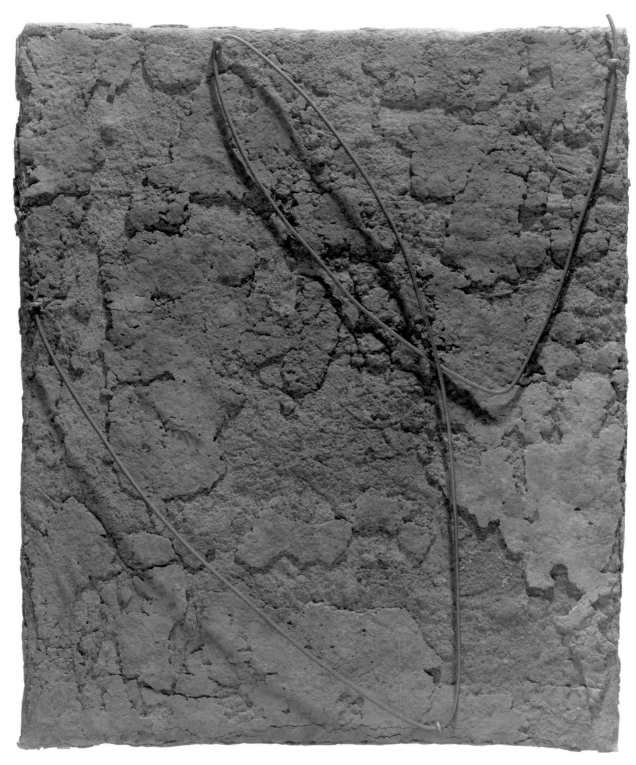

Wire and Concrete, 1975 (cat. 18)

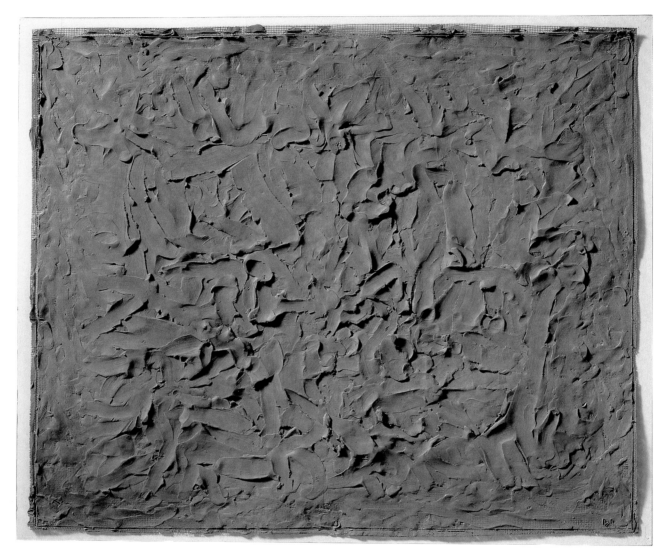

Finger Prints, 1975–76 (cat. 19)

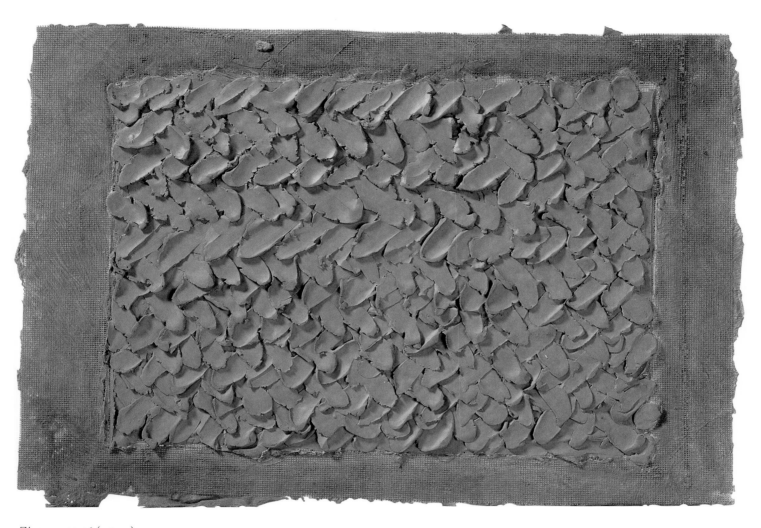

Zigzag, 1975–76 (cat. 20)

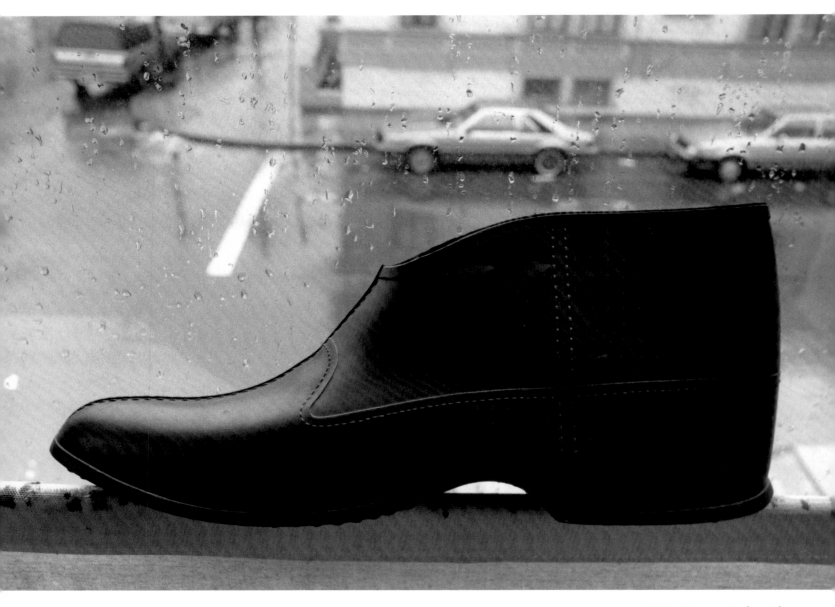

Rubber Shoe, ca. 1989 (cat. 68)

"You can't make art by making art"

Toward the end of 1975 Ireland moved permanently back to San Francisco. His return marked a period of further clarification about his art-making philosophy, which increasingly became a meditation on the nonduality of art and life.[45] Key to the consolidation of Ireland's thoughts were several pieces he completed shortly after his return. The first, done with Tom Marioni, was a month-long project at MOCA, in early 1976, titled *The Restoration of a Portion of the Back Wall, Ceiling, and Floor of the Main Gallery of the Museum of Conceptual Art* (pp. 160–61).

Over the years MOCA had gone through considerable physical changes, and Marioni wanted to return it to its original state, to retain the integrity of its earlier history as a printing company, as well as to preserve the subtle residue of activities of different artists who had worked there. Referring to photographs, Ireland restored the textures, colors, and shapes of the original wall: where the silhouette remained after a clock had been removed from a dusty corner or where an artist had painted around pieces of machinery backed up against the wall. Ireland even went so far as to return printer's ink to the floor and used the smoke from a hibachi to restore grime on the wall. The final result of Ireland's efforts was essentially an invisible work, so well integrated was it into a context of real time and space. Marioni, though clearly the mastermind behind the idea, had provided Ireland the opportunity to express his own work at the same time. "Here was a chance . . . to communicate an idea without a lot of stuff in between," Ireland explained. "All I had to do was follow the photograph . . . the shapes weren't even mine. No, I didn't put any of my influence on the shapes. . . . That was what was so beautiful about it."[46]

The MOCA renovation was a signal work for Ireland. Although Ireland has never abandoned object making, this piece reinforced several concepts critical to his sense of the creative process—that the art experience can exist outside the making of specific objects, that the imposition of the artist's creative will can be negligible, and that the boundary between art and life can be extremely porous and flexible. Ireland came to see his role as an artist as not, necessarily, to be original, but to retrieve or uncover existing information, thereby revealing its potential as art. The nature of Ireland's seemingly "mindless" involvement with the MOCA renovation reflects the "Six Precepts" of Tilopa, which the artist has long embraced:

> No thought, no reflection, no analysis,
> No cultivation, no intention;
> Let it settle itself.[47]

In the same year Ireland created another personally significant piece, conceptually related to his earlier crayon drawings. *A Painting on a Wall in a Room Being the Same Material as the Floor* was a site-specific work for a 1976 group exhibition at the Los Angeles Institute of Contemporary Art (p. 54). For the piece, Ireland started by painting a roughly circular image on a wall with diluted cement that matched the color of the floor. As with his crayon drawings, the image gradually became consumed by Ireland's process of painting so that, in the end, the image disappeared and became part of the wall. Ireland refers to this phenomenon in his art as entropy, an artistic adaptation of the scientific term denoting the systemic breakdown and dissolution of matter and energy. But his use of the term also suggests the Zen view that distinctions are not made between one thing and another. As Alan Watts once proposed about this blurring of life experiences, "The paintings are vanishing into the walls; but they will be marvelous walls. In turn, the walls will vanish into the landscape; but the view will be ecstatic. And after that the viewer will vanish into the view."[48]

From this point forward, Ireland shifted his attention to an art about, in, and of life itself. So interwoven are the two that at times one is hard-pressed to distinguish the art from the nonart in his life. More to the point, such distinctions are irrelevant to the artist. Believing that art is found in the work-a-day world

LIVERPOOL JOHN MOORES UNIVERSITY
LEARNING SERVICES

as much as in a gallery or museum, Ireland literally discovered art in the streets when, in 1976, he repaired the sidewalk in front of his house and had Marioni videotape the event (p. 154). If asked to distinguish why this repair work is art when compared with that of a cement mason, Ireland responds that it is because he brings to his actions an artist's point of view. "I don't pretend to be original by doing the sidewalk," he explains. "I'm only uncovering it, revealing it as a place for people to find their art if they choose to. When you strip away the ranking system, strip away what qualifies and what does not qualify as art, then you can get rid of all that garbage and you find that there is lots of art out there. Everything, if you choose to deal with it, is art."[49] What Ireland emphatically suggests is that any situation, any object, can be art, *if so experienced.* What you call yourself, how you think of yourself, and how you view the world are the critical issues. According to Ireland, "There's an art for every person. It's not an elitist thing. Everybody, if they choose, can be an artist. It means if they respond, they're creative."[50]

In assuming this stance, Ireland has followed closely in the footsteps of the German artist Joseph Beuys, who, several years earlier, expanded the definition of art by advocating the belief that "everyone is an artist" if so experienced. As an anthropological concept, the term *art* refers not only to the creation of aesthetic objects, but also to universal creative faculties, whether the art of medicine or the art of making friends. Extrapolating from this, Beuys believed that the concept of art could be applied to all human endeavors; indeed, the whole process of living could be seen as a creative act, or what Beuys defined as "social sculpture."

The Bay Area conceptual art community, of which Ireland was now an involved member, actively propounded Beuys's ideas. Indeed, Marioni has explained that MOCA was founded on Beuys's premise of art as social sculpture,[51] and many of the works produced in the Bay Area during these years reflected this philosophy. In 1974, for example, Bonnie Sherk created *The Farm,* a life-scale environmental "social art work" in which the artist transformed property near a major San Francisco freeway interchange into a farmyard and gardens, along with planning various programs for the local residents. Sherk's work was based on her belief that using "art"— the human creative process—to connect people to their environment influenced the quality of their life and, in turn, the survival of the human species.

Ireland has similarly embraced this expanded concept of art. "I have this notion," he states, "that art occurs in the process of life itself, and you don't have to go outside of the context of your own life. It's all there, and you just tap into it. You open up to it. You have to make yourself available to possibilities."[52]

This philosophy is thrown into sharp relief in one of Ireland's best-known works: his personal residence at 500 Capp Street in San Francisco. In late 1975 the artist purchased an 1886 Victorian in the working-class Mission District, which was intended to serve as both his home and his studio (p. 39). Originally built by a ship captain, the building had survived the 1906 earthquake, been used as a boardinghouse, and later was purchased by a Swiss accordion maker who maintained his business on the lower level. When Ireland moved in, an accumulation of almost ninety years of history confronted him— layers of wallpaper and paint, old carpeting, grime and stains, abandoned furniture, kitchenware, and other personal artifacts left by the previous owner. In the ensuing months, the process of cleaning the house and getting to know it became subsumed into Ireland's art.

Ireland did not initially intend to create an artwork of 500 Capp Street but, inspired by his revelatory experience at MOCA, soon came to perceive his work on the house as an artistic undertaking. He equated his moves with those of any painter or sculptor: re-forming materials, making choices, intuiting the next step to take. He approached his everyday tasks of stripping wallpaper, sanding floors, and varnishing walls with the deliberate respect and finesse that for him firmly fixed his actions in the realm of art. "Slowly I progressed as an artist, and I reached a philosophical point where I realized that the lively presence I was looking for in my paintings was

here on the walls, as I stripped away and cleaned off the surfaces," Ireland explained. "The integrity I was looking for in my art was there on the walls and floors. . . . I realized I was getting more and more satisfaction from the look and feel of real walls, real windows, real architecture."[53]

Ireland's goal, however, was not to improve or remodel 500 Capp Street but, rather, to uncover its history as an artifact molded by human use and the passage of time. In the process he also offered evidence of his own imprint. His decision, for example, to remove the baseboards and trim from several of the windows and doorways was carefully considered as a way to violate the architectural order of the house (pp. 42–43). When a window was broken, Ireland opted to replace the glass with a shiny copper etching plate accompanied by a tape recorder that, when played, describes the view seen from the blocked window (p. 46). Through these actions Ireland intentionally wanted to "aggravate" the environment, to challenge the home as a traditional symbol of comfort and security, to suggest that a house might be considered something beyond how it is traditionally defined. Through aggravation, the artist believes, one can expand visual space and visual ideas.

Ireland's work on the house can also be appreciated as a kind of modern archaeological exploration. The artist acknowledges as much himself, once describing 500 Capp Street as though it were an archaeological dig. "I felt like an anthropologist as I discovered where doorways had been covered with wallpaper, or a stairway by a wall. The architecture, the social signs were very exciting to me."[54] Confronting the years of amassed human history, Ireland sought to uncover the original structure of the house, the withered skin and bones as it were, saving much of what he unearthed along the way as evidence of his exploration. As the numerous layers of wallpaper were stripped to reveal the original plaster walls, for example, Ireland intentionally preserved the stress cracks, water stains, and other signs of aging. Glass canning and mayonnaise jars, left abandoned in the house, were filled with sweepings from the porch,

grime from the window casings, and sawdust from sanding the floor (p. 49). Dank, wet shreds of stripped wallpaper were wadded into balls and carefully stacked on a stool (p. 47). A television set, its protective outer casing removed, offers an image that appears upside down (p. 48). A metaphor for the house, it lays bare its bones and sinew and literally turns one's viewpoint upside down.[55]

Electing to keep certain items left behind in the house, Ireland re-presented them as archaeological evidence of a modern-day social system. Just as an anthropologist gathers pottery shards to piece together both an artifact and a culture, Ireland similarly kept such "relics" as a stash of old dried pears and pieces of string, which he perceived as evidence of the previous owner's day-to-day existence. *Broom Collection with Boom,* 1978/88 (p. 51), for example, is made from old brooms found scattered throughout the house. Ireland initially wired them together into a freestanding sculpture that forms a near-circular pattern, and then later added a boom to stabilize the piece. Arranged from the least to the most worn broom, and then back again, the work is symbolic of a social tool used for cleanliness. More important for the artist, it is a visual metaphor for the passage of time: a broom is purchased, used until it is worn down, and then a new broom is purchased, and the cycle continues.

Ireland's collection of newspaper rubber bands, discovered in the house and saved in a glass canning jar, is accompanied by a tape recording he made of the sound of a rubber band being removed from a newspaper (p. 50). Like the *Broom Collection with Boom,* the work is an observation on time and a ritualized social system: the newspaper delivered regularly, its binding methodically removed, the crackle of the paper and snap of the rubber band a mantralike reminder of our daily existence. Inelegantly displayed on a dull gray wooden stand, the piece is a Zen marker of "straightforwardness," of moving right along with life, simply acknowledging its flow without trying to arrest or interrupt it.

Since identifying these early artifacts, Ireland has

accumulated his own markers of time. One is a collection of worn shoes he has saved over the years and stores in a cabinet in his study. Another is *A Decade Document, Withcomet, Andcomet, Andstool,* 1980–90 (p. 175)—empty toilet paper rolls from a ten-year period reconfigured into a sculpture referencing Ireland's bathroom at 500 Capp Street. The piece, as its title implies, is a record of the passage of time as expressed through the most private of domestic routines.

In Ireland's mind, the work on 500 Capp Street was decidedly not a renovation or remodel. Rather, he refers to his activities as a "stabilization" and "maintenance action" in which the house is retained as a "social relic." The final protective coating of polyurethane that he applied on the floors, walls, and ceilings was a symbolic culmination of his efforts to retain the structure as a historical artifact. Ireland saw this last step as akin to a painter's finishing application of varnish on a canvas or a scientist's preservation of a specimen under glass. "I decided that by acknowledging the perfection here, the perfection of human beings, then I could recognize the limitless nature of art. Everything can be art. We must not discount the possibility that just because we have not designated something as art, it is not art."[56]

With the declaration of his home at 500 Capp Street as a work of art, Ireland became part of a specialized community of historical and contemporary artists whose work has been concerned with readjusting the value system of art as it is conventionally known. This community that Ireland readily acknowledges ranges from the Fluxus and arte povera artists to John Cage, Marcel Broodthaers, Joseph Beuys, Yves Klein, and Bay Area colleagues Tom Marioni, Paul Kos, and Howard Fried, among others. But as is so often the case, one must return to Marcel Duchamp, whom Ireland recognizes as the patriarch who "set us free."[57] His acknowledgment of this important mentor is made clear in sculptures such as *Initial Machine,* 1992, and *Duchamp's Tree,* 1996 (pp. 167, 170, 171), which paraphrase the French artist's work. Concerning the overlap of art and life, Duchamp often articulated his preference for the art

of living to the making of art. As he once stated: "My art would be that of living: each second, each breath is a work which is inscribed nowhere, which is neither visual nor cerebral. It's a sort of constant euphoria."[58] Of his interest in making art out of the ordinary or common, whether verbal or physical, he declared that common situations gave him "an infinite field of joy—and it's always right at hand."[59] Duchamp was also preoccupied with ideas as opposed to simply producing objects; if he didn't have new ideas, he stopped making things. Finally, there is his clear disinterest in hierarchy and dogmatism as reflected in his belief that, as far as art is concerned, "there is no solution because there is no problem."[60] Like Duchamp and subsequent like-minded artists who have teased out new ways of perceiving, defining, and making art, Ireland has approached the creative act with a similar sense of openness, inquisitiveness, and joy. "Art lets us make observations of things that were always there," Ireland once wrote. "And if the things are not there then it really doesn't matter for it is just a little soon, and still it doesn't matter."[61]

OPPOSITE: 500 Capp Street, San Francisco, 1983 (cat. 40)

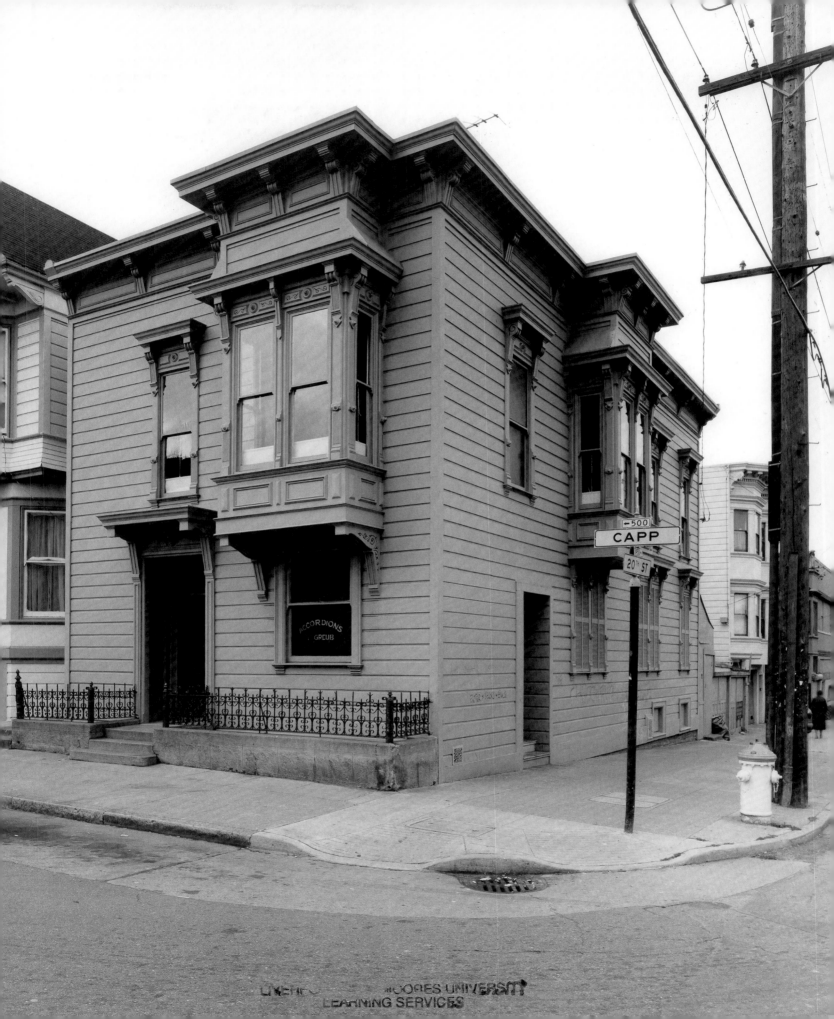

ACCORDIONS
GREUB

500
CAPP
20TH ST

Ground Floor Plan of 500 Capp Street, 1976–77 (cat. 24)

Footprint of 500 Capp Street, 1976–77 (cat. 23)

500 Capp Street, San Francisco, 1980 (cat. 33)

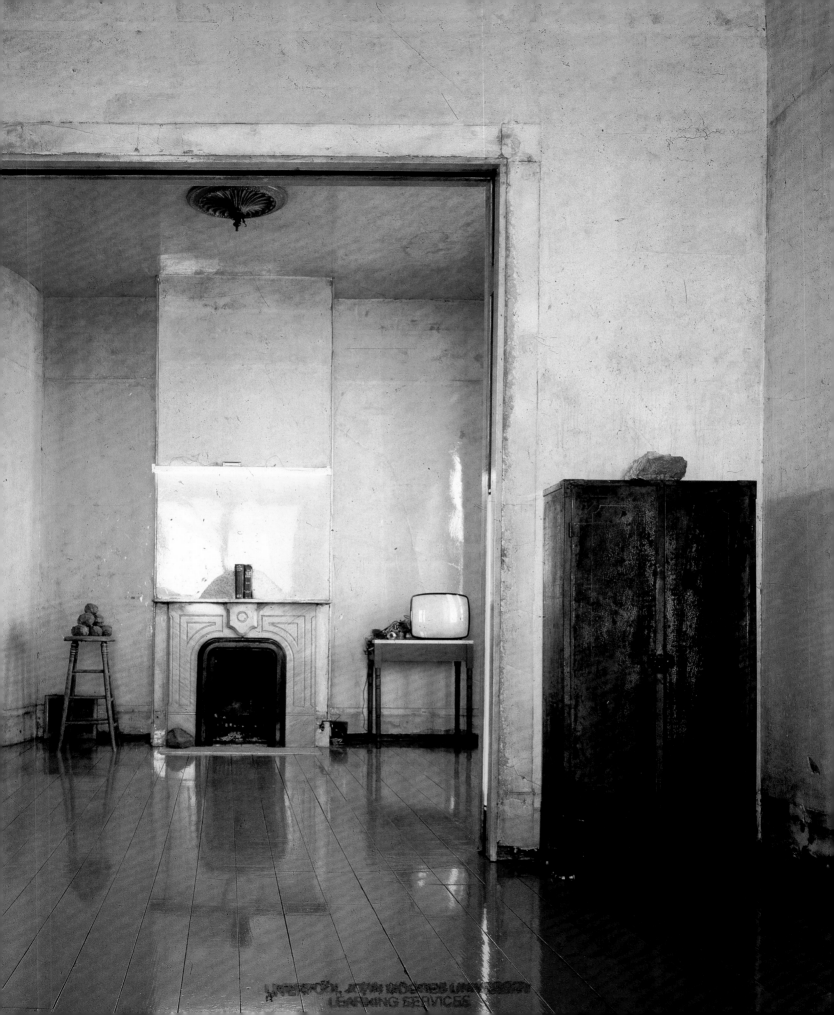

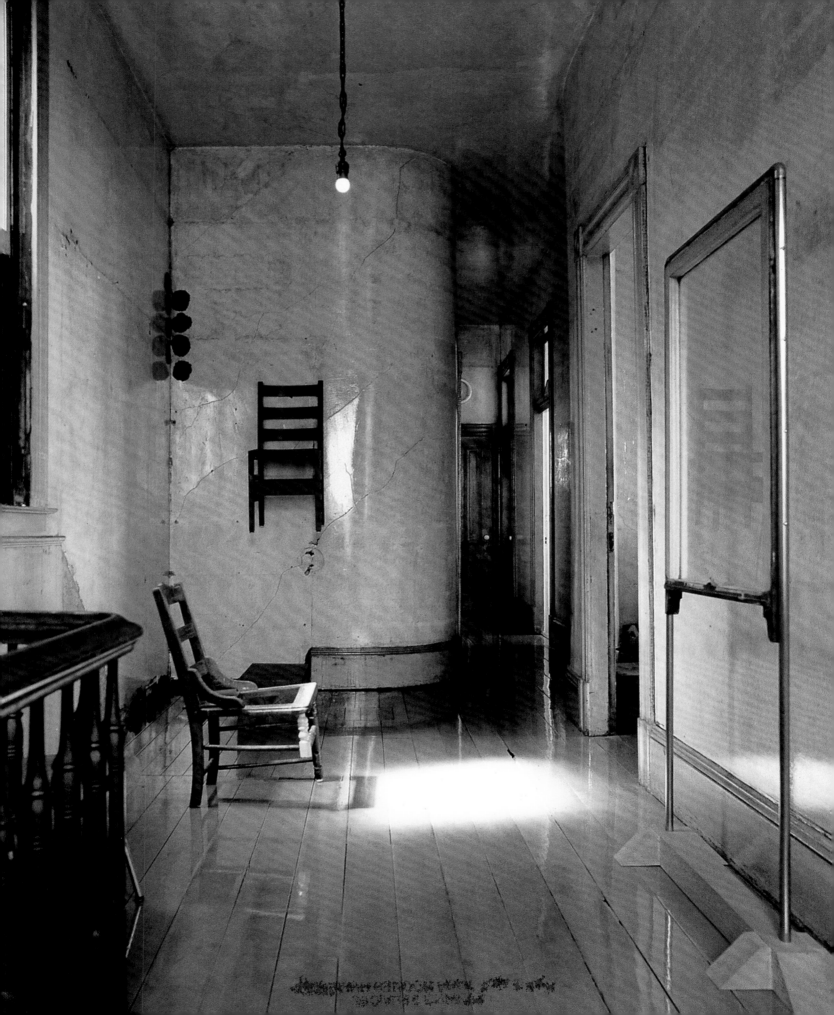

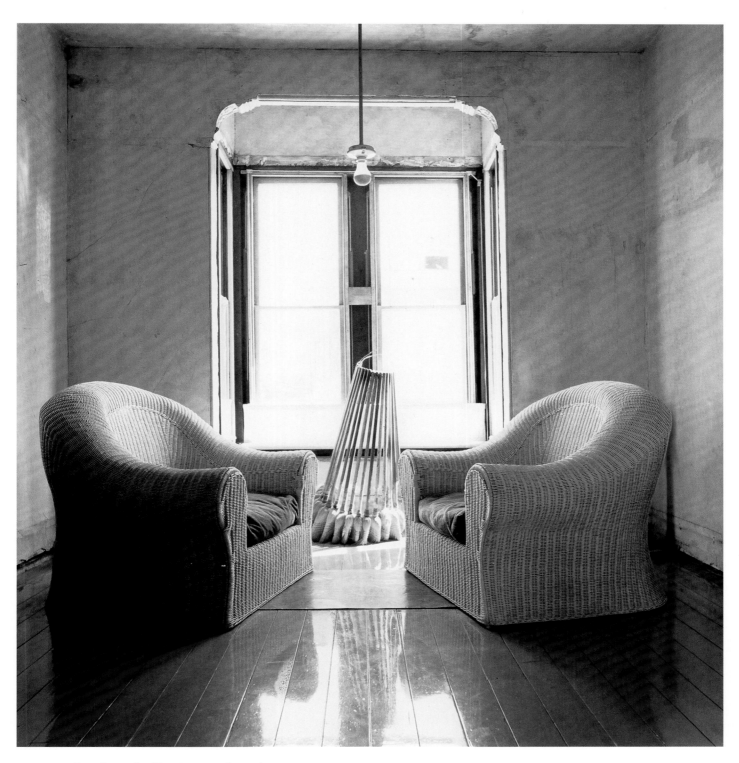

ABOVE: 500 Capp Street, San Francisco, 1985 (cat. 46)

OPPOSITE: 500 Capp Street, San Francisco, 1986 (cat. 48)

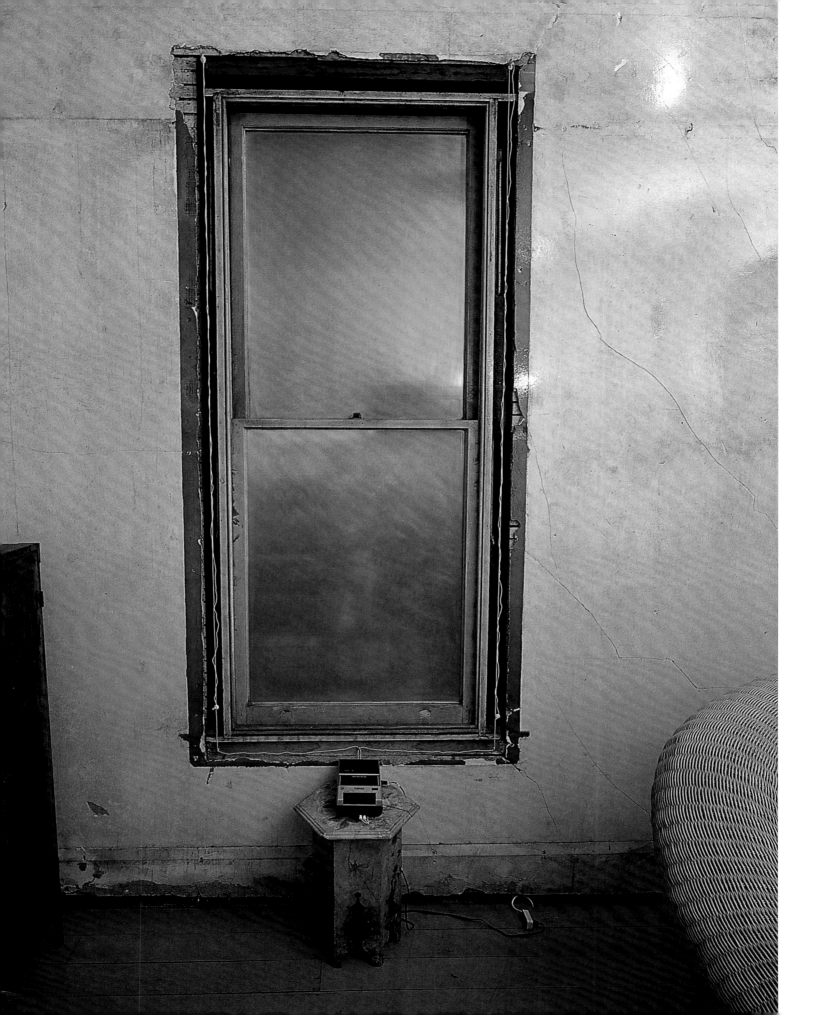

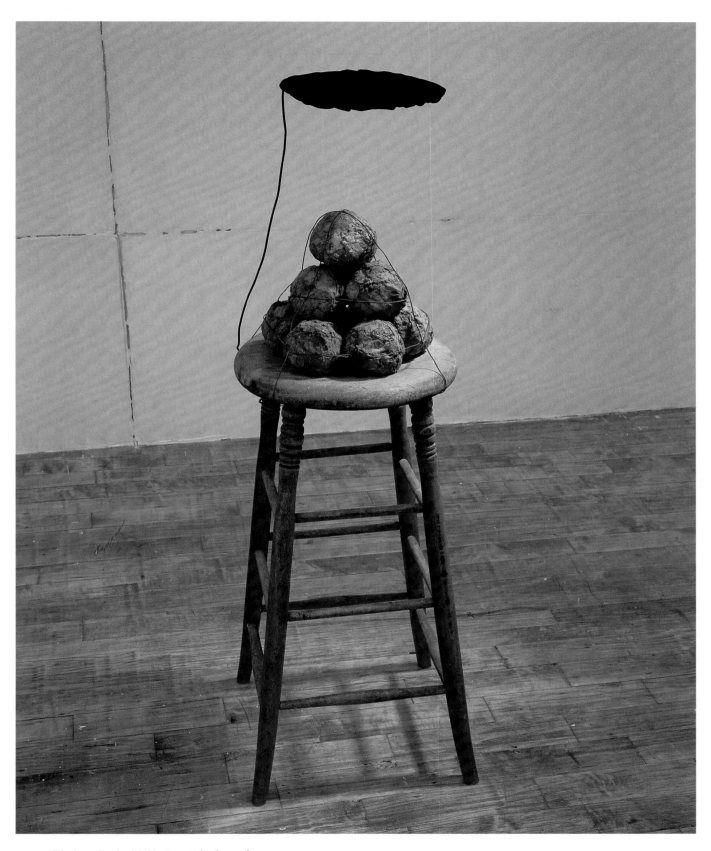

ABOVE: *Elephant Stool with Shade*, 1978/91 (cat. 32)

OPPOSITE: 500 Capp Street, San Francisco, 1981 (cat. 35)

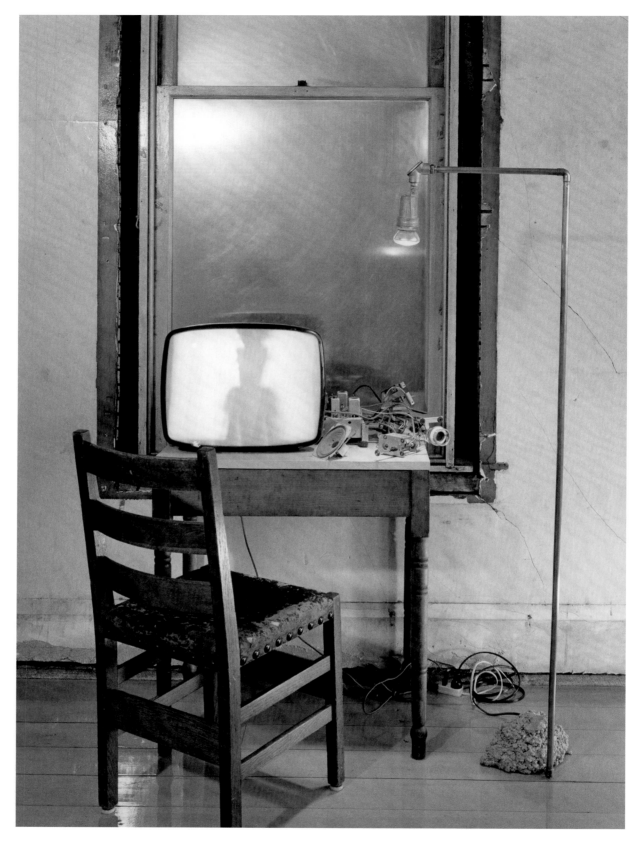

TV with Viewing Chair, 1978 (cat. 30)

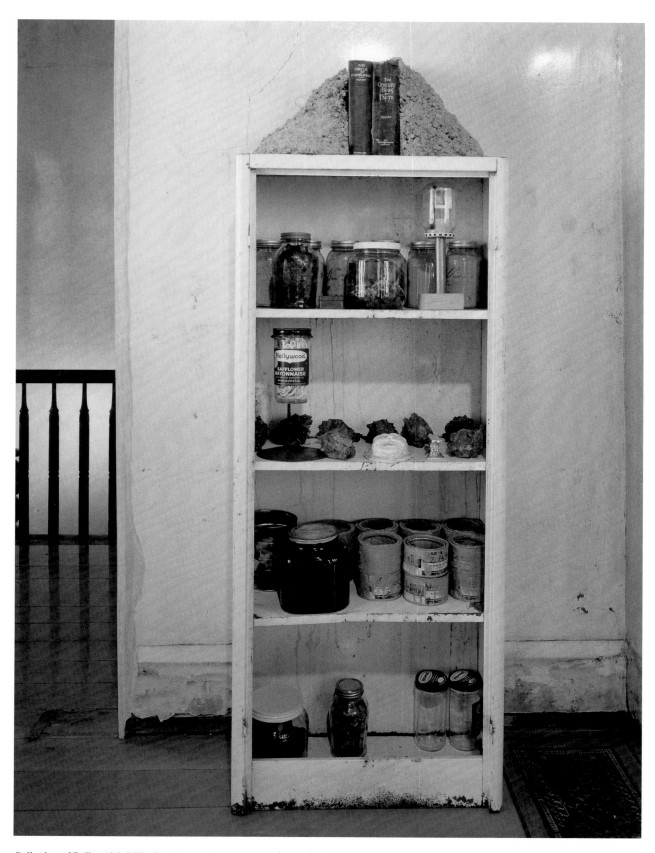

Collection of Relics with Mike Roddy's Ink Cans, 1976–78 (cat. 25)

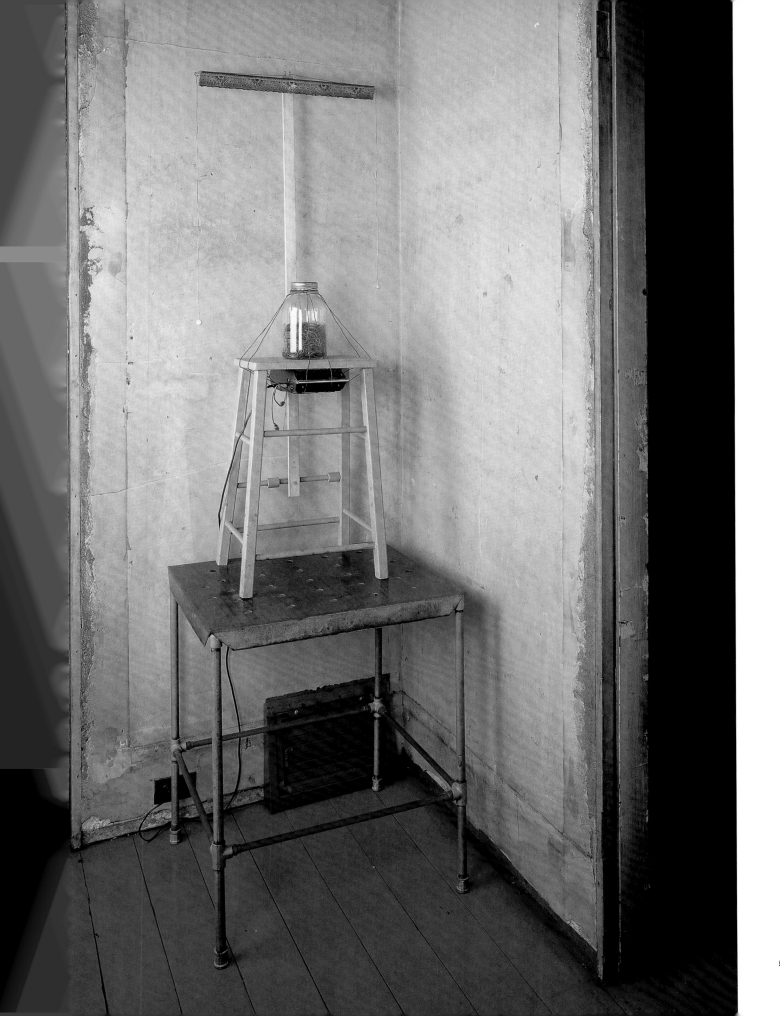

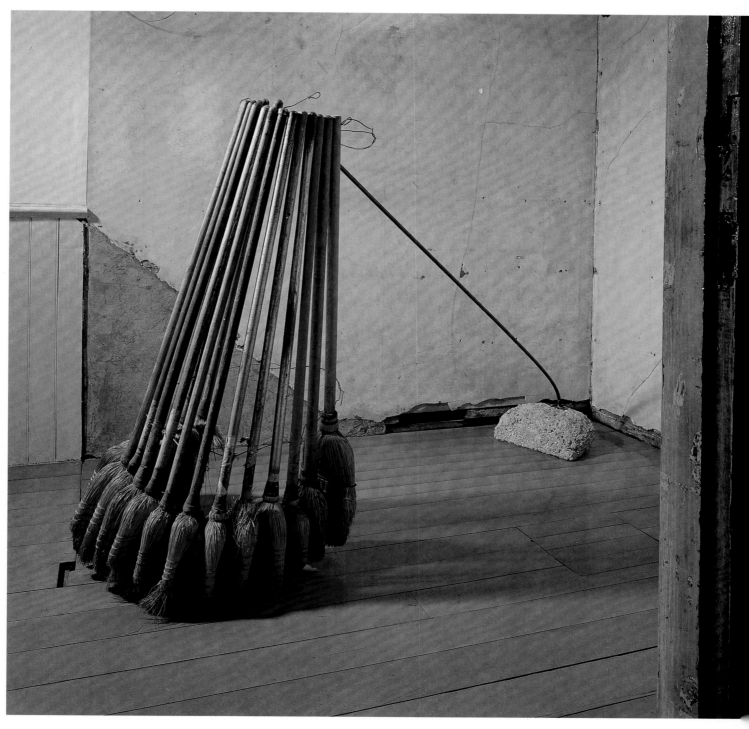

ABOVE: *Broom Collection with Boom,* 1978/88 (cat. 31)

OPPOSITE: *Rubber Band Collection with Sound Accompaniment,* 1977 (cat. 27)

500 Capp Street, San Francisco, 1987 (cat. 53)

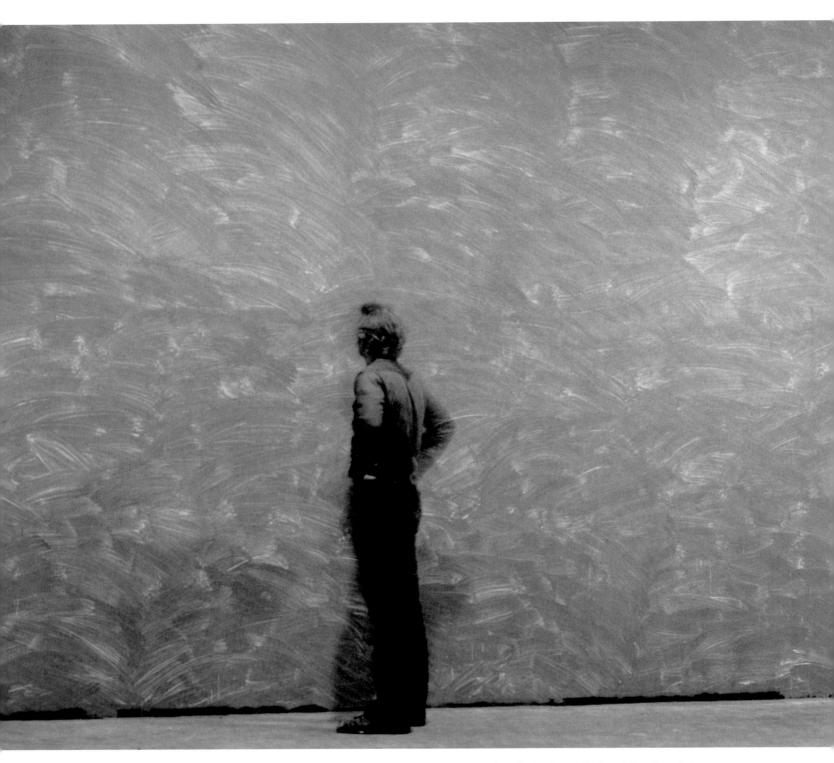

A Painting on a Wall in a Room Being the Same Material as the Floor, 1976, installation for exhibition *18 Bay Area Artists*, Los Angeles Institute of Contemporary Art (cat. 21)

A Sense of Place

The public opening of 500 Capp Street in 1978 marked the beginning of the mature phase of Ireland's work. In the years since, he has created provocatively diverse works—from other life-scaled environmental installations to handheld objects—that seemingly bear little or no resemblance to each other. Attempting a linear chronology of Ireland's stylistic development is challenging at best, for he simply does not work or think in this fashion. His approach to art views the world as a phenomenon waiting to be explored without the constraints imposed by established systems of interpretation and evaluation. Context is also crucial to Ireland, with much of his work, especially the large-scale installations, a singular response to a given situation. Yet, surveying the landscape of Ireland's artistic journey reveals that he has followed a path, circuitous though it may seem, where many of his ideas and the resulting art arc in wide sweeps and then back again, each new undertaking tracing a somewhat familiar track. Certain preoccupations tend to repeat themselves in various iterations and guises. One of these is Ireland's interest in evoking a sense of presence and place.

When Ireland speaks of a sense of place, he is not simply referring to the physical attributes or quantifiable dimensions of a place. Rather, he is interested in the notion of psychological space. "My goal as a sculptor is to affect the space so that someone can come into it and respond to the manipulation in one way or another," he explains. "The response has to do with what is or was there and what is there now. The issues then become one of psychology in a particular context. Things like this are happening all the time, but as an artist I start to have some control over the situation."[62]

In the course of his investigations, Ireland has often turned to light as his silent partner. It is, he claims, "the thing that makes things happen," psychologically activating a space in both dramatic and subtle ways. Ireland became aware of the inconspicuous power of light while working on his wall painting for the 1976 group exhibition at the Los Angeles Institute of Contemporary Art (p. 54). As he gradually painted the entire wall with liquid cement, he noticed how the wall affected adjacent spaces as well as the artwork exhibited nearby. "It had something to do with the light level in the gallery and a certain somberness, a certain presence to the whole space was altered by this work. . . . That was very curious and interesting to me."[63] In much of his subsequent work Ireland has continued to explore this phenomenon of light, its visual and mind-altering effects, and how it can define a sense of place. These investigations have ranged from other large wall installations in museums and galleries (pp. 72, 73) to a major sculptural project a short distance from his 500 Capp Street home.

In 1979 Ireland purchased a derelict old frame house at 65 Capp Street that he fully planned to renovate and sell as an investment opportunity (p. 60, bottom).[64] Completed in 1982, it was eventually purchased by art patron Ann Hatch, who established the Capp Street Project, an artist-in-residence and exhibition space that opened the following year.[65] Ireland began his work by literally demolishing the building and creating in its place a stunning two-story house cum sculpture in which light itself is the subject and content of the work (pp. 60, top; 61). Every aspect of the new building, from its exterior and the size and placement of windows to the location of walls and definition of spatial volumes, was considered for its evocation of light.

From the moment one sets eyes on the house, it is clear how different it is from its sister structure up the street. The industrial look of the corrugated metal exterior and the cool geometry of the interior spaces are a marked contrast to the cracked and stained environment of 500 Capp Street. Yet the two houses have elements in common. Their austere exteriors give little hint of the extraordinary visual experience that awaits visitors once they cross the entry threshold. The sinuous aerial bridge that snakes its way across the second level of 65 Capp Street echoes the curved hallway at 500 Capp Street (pp. 52–53) and was a way for Ireland to emphasize the sculptural qualities of his new work. More important

is how the artist used light to define the essence of each house. Experiencing the amber-hued radiance of 500 Capp Street is like becoming one with a well-rubbed and glowing piece of ivory; experiencing the interior of 65 Capp Street is like entering a receptacle of pure light.

Working on the remodel of 65 Capp Street over a two-year period, Ireland was able to study the passage of the sun through the different seasons, and he essentially allowed its movement to dictate his plans both inside and out. The resulting sculptural environment reveals the transitory but expressive range of light, where even the slightest change or movement animates the entire structure. The corrugated sheet-metal exterior, for example, was chosen for its capacity to be modeled by light at different times of the day. Like a painting in process, the exterior has a hazy and cool metallic sheen in the morning but, by dusk, warms to the apricot-colored glow of sunset. By selectively locating the windows and dormers, Ireland was also able to control the influx of light to the inside, directing it so that it illuminates and defines the interior spaces in often dramatic and spectacularly theatrical ways. Over the course of a typical day, the light streaming in from the windows changes so radically that two adjacent walls appear nearly black and white.

Both inside and out, 65 Capp Street appears astringently spare, yet at the same time offers a serene shelter from the outside world. With its fortresslike exterior sealing off the din of life around it, the interior evokes the simplicity of a Zen sanctuary, where the space itself—an abode of vacancy—has an economy of spirit intended to distill one's focus and attention. To experience it is to encounter the fullness of seemingly empty space and grasp the essence of intangible light. As Lao Tzu, the founder of Taoism claimed, it is only in emptiness that the truly essential can be discovered. The reality of a room, for instance, is to be found in the vacant space enclosed by the roof and walls, not in the roof and walls themselves. Writing of his experience in visiting 65 Capp Street and Ireland's home, art critic Thomas Albright was one of the few early observers to

note how the two environments cast a peculiar contemplative feeling on the visitor. It is as though, he wrote, Ireland's works were a form of quiet, persistent, self-effacing ritual and meditation.[66]

Ireland is not the first to explore the phenomenon and perception of light in such large-scale environments. Other artists, among them Robert Irwin, Dan Flavin, and James Turrell, have similarly focused on light as an integral part of the aesthetic moment, emphasizing an experiential rather than intellectual encounter. As Turrell has written, what is most important is "to create an experience of wordless thought."[67] Earlier, in the 1960s in New York, Flavin shared his observations that "art was shedding its vaunted mystery" and "pressing downward to no art . . . a neutral pleasure of seeing known to everyone."[68] Simultaneously, in California, Irwin had begun questioning conventional attitudes about art and the hierarchy of what and how visual information is presented. Why, for example, he wondered, does one focus on objects rather than the light that reveals them? In exploring these issues, Irwin soon began creating room-size installations that were nearly empty but in which he subtly manipulated the quality of light in order to enhance the viewer's consciousness of the existing space. Through his minimal maneuverings, one might discover, quite unexpectedly, a crack in a floor or post in a room that had always been there. The few elements he sometimes incorporated in his spare installations, such as a length of string stretched from one wall to another, conspired to skew normal perceptions so that one became aware of the physical environment as it might not be experienced otherwise.

Ireland shares with these artists a desire to prompt a sense of experiential discovery, to encourage an awareness of presence and place, and to reveal those extraordinary experiences that are on the frontier of everyone's common sense and simple perception but are often ignored or canceled out. John Cage's observation that music is all around us and that it is only the listening that stops offers an important analogy that resonates with Ireland's own observation: "Art is all around us, it's only seeing that stops."[69]

With the growing attention Ireland began to receive from 500 and 65 Capp Street, important commissions gradually came his way. Among them was a 1984–85 collaboration with Los Angeles artist Robert Wilhite to design an artist's apartment for the Washington Project for the Arts (WPA), an alternative art and dance studio space in Washington, D.C. Shortly thereafter, in 1986, he was selected to be the lead artist-in-residence at the Headlands Art Center (now Headlands Center for the Arts), in Sausalito, California, to work at Fort Barry, an abandoned 1907 army base. Simultaneously, Ireland was also one of several artists chosen to create work for San Francisco's Candlestick Point State Recreation Area, an urban revitalization project with the California State Department of Parks. His work was also gaining broader national attention, as signified by a 1984 solo exhibition at the New Museum of Contemporary Art in New York (pp. 62–63).

Ireland's collaboration with Robert Wilhite on *Jade Garden* for the WPA (pp. 64, 65) is a stunning variation on the theme of light. Invited by then director Jock Reynolds, the two artists were given the charge of transforming a derelict 450-square-foot washroom in a former five-and-dime store (p. 64, top) into a "functional sculpture" that would serve as an apartment for visiting artists. While Wilhite was largely responsible for designing the furnishings and lighting elements, Ireland focused on the physical space itself, creating a surprisingly labyrinthian floor plan for such a small environment. Ever the explorer, Ireland explained that he wanted to lead people through a miniature adventure as they encountered the space.

When Ireland works on such projects, an understanding of context and an appreciation of history are important. But at the beginning of his work on *Jade Garden*, he found little to distinguish the run-down space save for one plastic-covered window that illuminated the room in a diffused pillow of light. "We sat around on upside-down five-gallon pails and stared at it," Ireland recalls. To recapture that quality of light became "a question of integrity."[70] In conceiving the final plans for the space, Ireland liberally quoted from his previous projects. To intensify the presence of light, he repeated a favorite technique of painting the walls with a high-gloss polyurethane, and the corrugated metal used on the exterior of 65 Capp Street reappears as an interior wall surface that further exaggerates the movement of light as it bounces from one surface to another. The practical regard Ireland brought to the materials can also be traced to the earlier time when he worked simply and directly with dirt and cement. As he did back then, the artist accepted the construction materials used in *Jade Garden* for what they were, reveling in the ordinariness of their existence. Thus the flat-head nails, Phillips screws, and metal corner beading were left fully exposed and undisguised. Galvanized steel sheets were installed like wallpaper in the small kitchen, and the drywall was neither taped nor mudded but left as it was. The evocative pale green of the walls is simply the natural color of the standard-issue water-resistant drywall that Ireland installed and then coated with a polyurethane varnish. Ordinary in its construction, *Jade Garden* is nonetheless extraordinary in its presence, suggesting, as its name implies, a refuge of polished celadon.[71]

Ironically, despite Ireland's seemingly strong ties to architecture and the laudatory attention he has received from this professional field over the years, he feels little connection to the discipline. "It's strange," he once observed, "because I'm probably more removed from architecture than any other art discipline."[72] Although he studied architectural rendering in college and worked in the field in his early years, the vision that Ireland brings to his large-scale "functional sculptures" is that of an artist who savors the hands-on process of working with different materials to build different things, no matter the scale or size. "I am a builder and I deal with surfaces," Ireland has stated about his work. "Process and material go hand in hand with one another, sometimes light being the ingredient, or else some more dense materials."[73] Avoiding the "masterminding" that he associates with traditional architecture, Ireland prefers to disorder things a bit, to create visual collisions that

surprise viewers and throw them off-kilter, prompting them to ask, "What's going on here?" when encountering one of his spaces for the first time. "Architects are problem solvers," Ireland has observed. "I prefer to explore without any purpose or end in sight."[74]

Despite his nontraditional approach, Ireland has a profound regard for history, particularly appreciating it as a way to define a sense of presence and place in his work. This respect for history is another thread that ties together many of his site-specific projects. Over the years, starting with his work on 500 Capp Street, Ireland has established a reputation as an artist working with distressed historical places. It was this reputation that led to his project for the Headlands Center for the Arts, located in former army barracks not far from the Pacific Ocean (p. 66). In 1986 Ireland was selected as the center's first artist-in-residence, whose defined project was to develop and implement the first phase of plans for the derelict facilities. His work focused on the rehabilitation of three main areas in Building 944, where the offices and main public spaces are located: the entryway (p. 67) and two multipurpose meeting rooms known as the East Wing and Rodeo Room (pp. 68–69), the latter a name Ireland chose as a nod to a cattle-branding operation that once stood on the property.

As he had done at 500 Capp Street, Ireland, along with project manager Mark Thompson and a team of twenty-four artist interns, revealed the spaces as remarkable archaeological remains that had survived the ravages of time. When Ireland began the project, the barracks were painted monochrome beige and were in bad repair. It was not a friendly place, as the artist recalls, having been neglected for almost a decade. During his residency Ireland gradually broke through the dreary institutional look of the building to reveal the character of the rooms that passing time had helped to define. In the span of a year's work done mostly by hand, eight layers of paint were stripped from the pressed-tin ceilings, plaster walls, oak stairways, and redwood wainscoting. Dingy linoleum was removed to reveal the underlying maple floors, and the boarded-up windows were unmasked, allowing light

to finger its way into the long-neglected rooms. Layer by layer, Ireland carefully disclosed the pockmarks and scratches, the mottled and cracked textures chronicling the imprint of human use, and then paid tribute to this history by preserving it with a transparent glaze of polyurethane or hand-applied wax.

Ireland's respect for refined craftsmanship is ever apparent in his treatment of the details and surfaces of rooms. Working with his hands comes naturally to the artist, and this technical mastery is part of his process. While he may sometimes preconceive what he might do in a given space, it is the "thinking with one's fingertips" that yields the greatest satisfaction. A close look at one of the walls of the Rodeo Room, for example, reveals a delicate layering of mottled sage and dusty ochre— remnants of the layers of paint that were applied over the years. Light also plays a crucial role in revealing the spirit of the place. The process of recovering the character of the environment as Ireland saw it went hand in hand with the quality of light that infused it. "If you have a regard for light—its gentleness and the subtleness and intensities on different days—you can only treat what the light illuminates with the same kind of regard."[75] Guiding Ireland's work throughout was his intuition. Thriving on surprise and serendipity, he uncovered the rooms without a set plan; instead, each new discovery led to a decision that in turn led to the next discovery. "That's part of the art process, that you sometimes operate quicker than you can intellectually work out. You can't wait until you can explain it, or you couldn't do anything."[76]

Ireland's excavation of history took a literal turn in *Newgate*, 1986–87, when he unearthed several tons of concrete debris from an old San Francisco landfill to create this site-specific work (pp. 74, 75). The piece was one of several public artworks planned for the proposed, but never completed, Candlestick Point State Recreation Area, near what was then the city's ballpark on the San Francisco Bay. Much of the property began as landfill created during World War II, was later used as a dumping ground for demolished buildings, and eventually also

became an automobile graveyard. When Ireland began his work, the area was an inhospitable scar of land filled with waste and weeds. Responding to the bleak disorder of the environment, Ireland conceived of his piece as a contemporary archaeological ruin—a massive burial site of urban rubble and decay.

Long fascinated with the tunnels and labyrinths of temples and tombs that he has explored during his worldwide travels, Ireland looked for inspiration to the ancient past and to the prehistoric tradition of relating sculpture to architecture. Rising from the desolate chaos that surrounds it, *Newgate* possesses a primeval grandeur that recalls its Irish forebear, the passage tomb of Newgrange, dating from around 3200 B.C., which Ireland once visited. A Stone Age burial ground made from more than four thousand tons of rock, Newgrange is distinguished by a massive stone cairn at its entrance and a sixty-two-foot-long passageway leading to a cross-shaped inner chamber illuminated once a year, on the winter solstice, by the sun. Ireland's plan for *Newgate* echoes physically and psychologically its ancient namesake. He identified the passageway's entrance with a ragged concrete cairn and then reconfigured the massive slabs of concrete debris into two huge walls that gradually converge into a narrow passageway leading to a view of the bay.

Ireland's installation *Pittcairn*, 1988, is similarly an investigation into urban archaeology (pp. 76, 77). This large site-specific work was one of several commissioned by Pittsburgh's Three Rivers Arts Festival and the Carnegie Museum of Art, a celebration of public art at the city's historic Point State Park. Located on acreage where the Allegheny, Monongahela, and Ohio Rivers converge, the park also commemorates the site where once stood the historic 1759 Fort Pitt, Pittsburgh's namesake and an important embarkation point for early American settlers exploring lands to the west. As Ireland's hybrid title suggests—*Pitt* referring to the city's historical fort, and *cairn,* to a pile of stones used as a landmark—*Pittcairn* is about history and marking a sense of place.

After investigating Pittsburgh's chronology of growth, from an eighteenth-century river fortification to a thriving mining and steel center, Ireland discovered, during his wanderings through the city, large concrete blocks made from local mill slag used to separate industrial bulk materials. Selecting around fifty of these heavy blocks, Ireland worked with crane operators to create three Stonehenge-like portals that referenced the meeting of the three rivers, and then had the remaining blocks randomly scattered about the area. In the artist's mind he was returning the material to its fundamental chaotic state in an area that was once the city's original riverfront, thereby reclaiming the historical significance of the site of Pittsburgh's original stone foundations and riprap. That visitors were unaware that the scattered blocks upon which they clambered were an artwork did not displease the artist. To the contrary, Ireland was delighted that his sculpture was almost invisible. Here was the most desirable situation of all—where art and life were essentially indistinguishable. "Ideally my work has a visual presence that makes it seem like part of a usual, everyday situation," Ireland has elaborated. "I like the feeling that nothing's been designed, that you can't tell where the art stops and starts."[77]

Ireland clearly shows a respect for the passage of time and human history in much of his art. But his work is not just about history per se; rather, he also attempts to expose the transitory nature of identity and how content and meaning can be radically altered based on perception. This theme consistently resurfaces in Ireland's work, as can be seen in an exhibition he had at the Helmhaus, Zurich, in 1991. As is often his working methodology, Ireland began conceptualizing the exhibition by first exploring the city's neighborhoods and buildings as though he were on a reconnaissance mission, but one whose end result was unclear and undefined in his own mind. Only after a chance encounter with a basement filled with dismembered concrete casts and plaster models used for the making of Zurich's historical public artworks—busts of dignitaries and generals on horses—did Ireland begin to envision the direction his

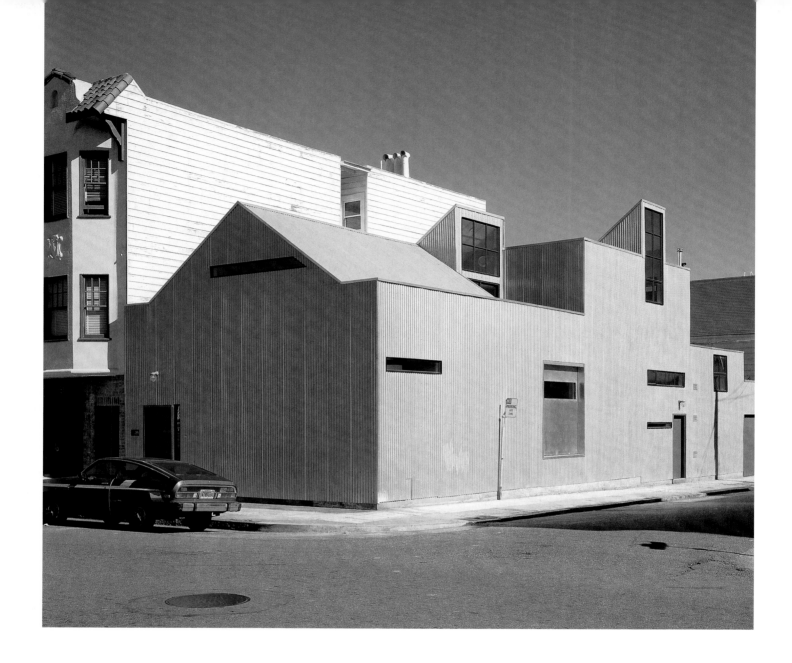

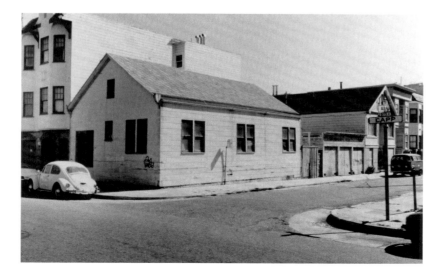

ABOVE: 65 Capp Street, San Francisco, 1982 (cat. 37)

LEFT: Original structure at 65 Capp Street, San Francisco, 1978 (fig. 4)

OPPOSITE: 65 Capp Street, San Francisco, 1981 (cat. 36)

Installation view of exhibition *Currents: David Ireland*, New Museum of Contemporary Art, New York, 1984 (cat. 42)

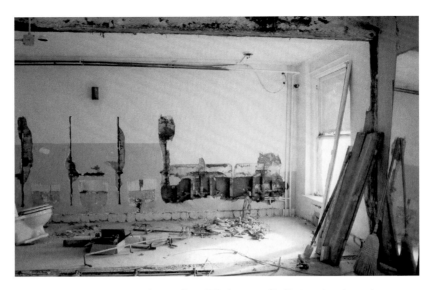

ABOVE: Washington Project for the Arts, Washington, D.C., interior view prior to renovation by David Ireland and Robert Wilhite, 1984 (fig. 5)

BELOW: *Jade Garden*, 1984–85, Washington Project for the Arts, Washington, D.C., a collaboration with Robert Wilhite (cat. 44)

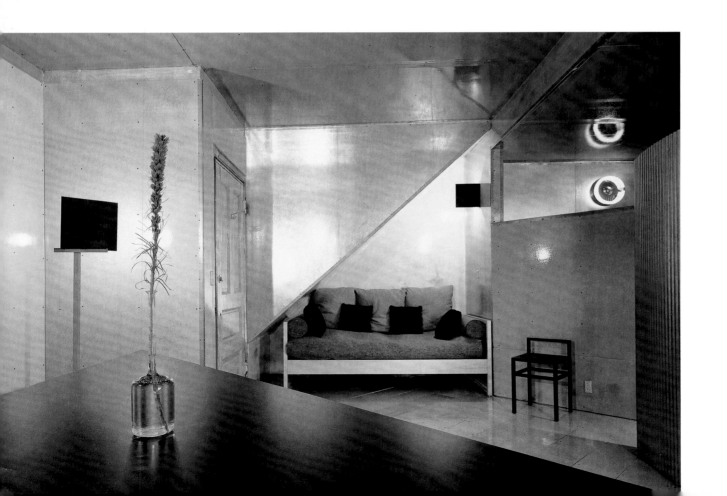

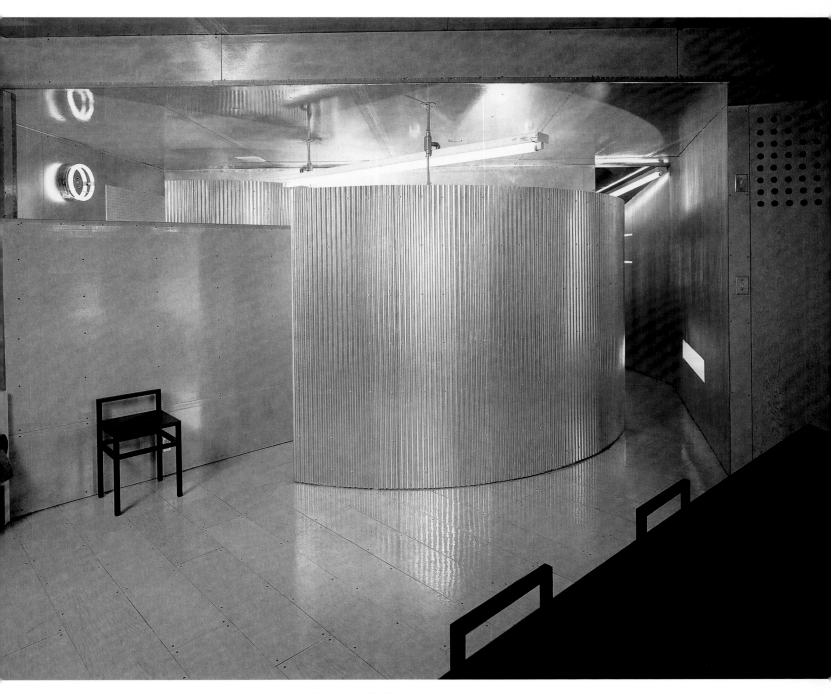

Jade Garden, 1984–85, Washington Project for the Arts, Washington, D.C.,
a collaboration with Robert Wilhite (cat. 43)

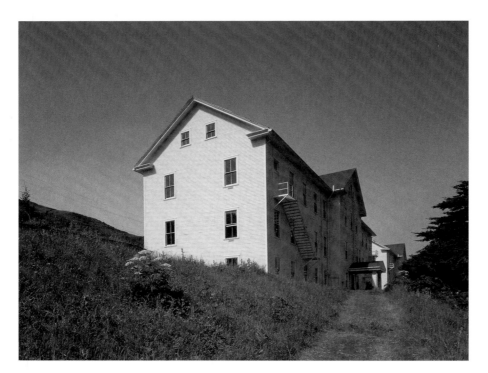

Building 944, Headlands Center for the Arts, Sausalito, California, 1987–88 (fig. 6)

Headlands Center for the Arts, Building 944 entryway, Sausalito, California, 1986–87 (cat. 49)

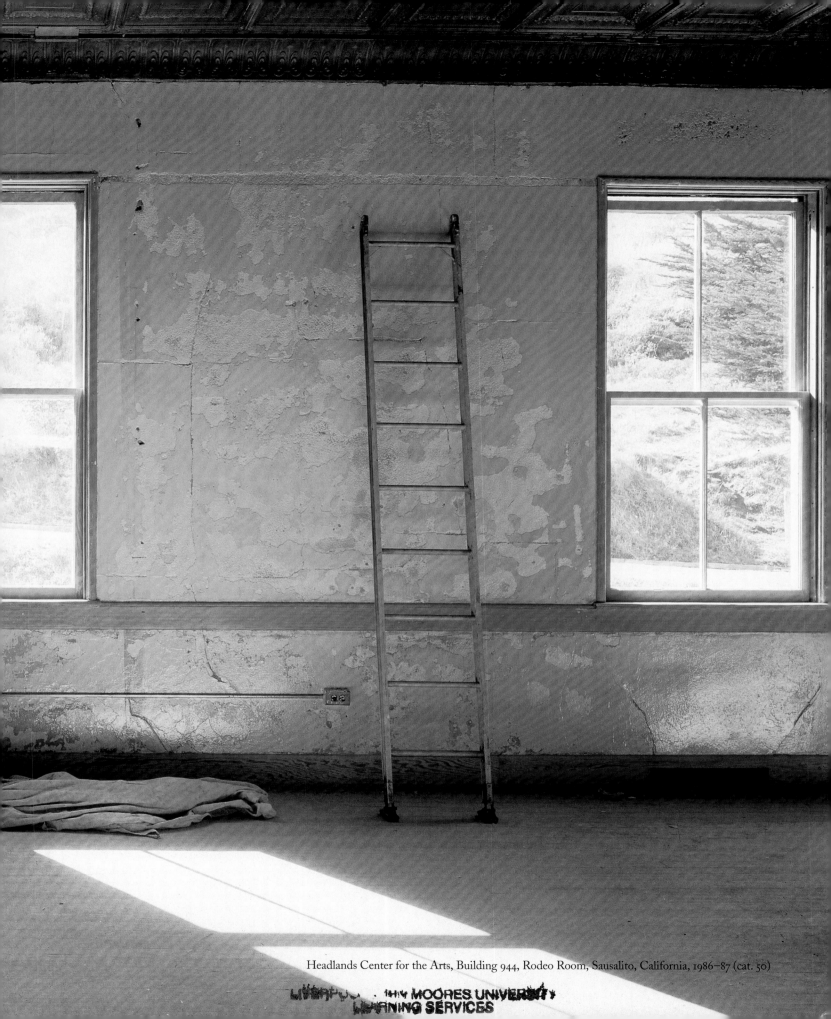

Headlands Center for the Arts, Building 944, Rodeo Room, Sausalito, California, 1986–87 (cat. 50)

exhibition would take (pp. 80–81). The discovery of this forgotten cache was a gold mine for the artist. The material was at once historically venerable and specific to Zurich, but anonymous as well. No longer clearly definable, the broken, dusty, and abandoned relics occupied a space somewhere between raw material and art. In Ireland's final installation, he gathered artifacts from various storage areas and then laid them out on the gallery floor so that the sprawling, jutting forms appeared almost like a ragged outcropping of rock (p. 82). Or he installed them to spill from a window ledge like flowing gray sludge (p. 83).

Writing about the Helmhaus installation, curator Marie-Louise Lienhard noted the freedom with which Ireland approached the found material. For unlike the citizens of Zurich, Ireland was not burdened with the civic and historical symbolism associated with these public commemorations. Rather, as Lienhard indicated, Ireland perceived his discovery as pure raw material, like "moraines, deposited on the edges of the art-glacier; left behind, abandoned, and brought back up to the surface. Brought back to full respect, but inevitably and necessarily as something other than that which they once were. Ireland challenges the observer to see the pieces with an open mind, not what they were, not in regards to what he knows about them, but as something that he has never before seen; as something to which he can summon no visual reference. In this way, the 'raw material' can be experienced anew."[78]

As with many artists who create site-specific installations, Ireland's Helmhaus installation and works such as *Newgate* and *Pittcairn* are evidence of his interest in context and reclamation. In this regard, Robert Smithson is an artist with whom instructive parallels can be drawn. Smithson's interest in materials such as sod, sulfur, asphalt, and even garbage is reiterated in Ireland's nonhierarchical choices to work with dirt, wet wallpaper, and concrete debris. Smithson once remarked about using such nontraditional materials, "In the technological mind rust evokes a fear of disuse, inactivity, entropy, and ruin. Why steel is valued over rust is a technological

value, not an artistic one."[79] Ireland also shares with Smithson a fascination with barren, entropic sites. Smithson's decision to create work from an exhausted sand quarry or a dying lake, as he did with *Spiral Jetty*, 1970, is echoed in Ireland's attraction to similarly haggard and desolate places, whether an unsightly landfill or even the gloomy environs of his own cavelike basement and garage, which serve as a resource and alternative studio for his work (pp. ii–v). As Smithson claimed, the "strata of Earth is a jumbled museum."[80]

Ireland's affinity for such entropic places was revealed in his earlier years as he traveled around the world, scaling the harsh heights of Mount Kilimanjaro, roaming the desolate cliffs of Afghanistan, and exploring the sterile reaches of the Irish Aran Islands. Recalling a trip he took to Scotland in the 1950s, the artist observed, "There is something so incredible . . . in terms of the almost entropic nature of the land and sky. There is so much energy almost consumed in this rugged terrain and in this rugged sky that there is hardly room for anything else in a psychological way . . . it is dominating and it is an incredible feast."[81]

Entropy is a word key to both artists' sensibility. Smithson saw all around him evidence of entropy, the material world's natural tendency toward collapse as witnessed in the fragmentation of rock quarries, avalanches, and mud slides, and the decomposition of dead bodies of water. His fascination with devolving nature formed the essential basis of his art. As he wrote about his work on *Spiral Jetty:* "To organize this mess of corrosion into patterns, grids, and subdivisions is an esthetic process that has scarcely been touched."[82] Ireland has approached his own work with this shared consciousness. He has looked at deteriorated and time-worn sites not for the negative aspects of their disuse and neglect but for the possibility of reclaiming them and giving them new life.

In Ireland's *Smithsonian Falls, Descending a Staircase for P.K.,* 1987 (p. 78), created around the same time as *Newgate* and *Pittcairn,* he clearly references Smithson's interest in entropy and his "flow" and "pour"

pieces of mud and asphalt, while also giving a nod to Duchamp's icon of modernist contrariness, *Nude Descending a Staircase.* For this piece, conceived for a 1987 solo exhibition at the San Francisco Art Institute, Ireland poured concrete down the main concrete stairway of the gallery, allowing it to generally follow its own course and then dry. He later broke up the concrete and scattered the pieces on the stairway so that visitors could step around them and reach the upper gallery without using the aluminum ladder he provided as an alternative to the stairs. Despite its seemingly casual and unplanned appearance, the work offers a double-sided experience of the materiality of concrete—the hardened lavalike form of the gray substance providing a contrast to the more intellectualized and controlled structure of the stairs made of the same material. The piece also reflects, in microcosm, issues that are central to Ireland's conceptual sense of sculpture and help link seemingly unrelated works such as *Newgate* and 500 Capp Street. *Smithsonian Falls,* like other life-scaled pieces by Ireland, recognizes sculpture as place, makes explicit the process of creation, and asserts that sculpture is an experience of both temporal and spatial dimensions. Time, as well as motion through space, becomes essential to experiencing the work.

In 1993 Ireland embarked on yet another project that elaborated on his fascination with gritty, inhospitable environments as a resource for his art. In a collaboration with independent curator Jane Levy Reed, the two journeyed together to Skellig Michael, a craggy uninhabited island off the southwest coast of Ireland, to collect experiences, impressions, and images that formed the basis of Ireland's 1994 exhibition and catalogue, *Skellig,* organized by Reed for the Ansel Adams Center for Photography in San Francisco. A *sceilig,* from which Skellig Michael derives its name, means "splinter of stone," the translation of which aptly characterizes this forlorn and jagged peak of rock rising from the sea (p. 86, top). Despite its harsh and bitter character, Skellig Michael was home to a small settlement of ascetic monks between the sixth and eighth centuries who, in their desire to escape worldly temptation and

become closer to God, crossed perilous waters to establish one of the earliest known hermitages. What remain of their reclusive spiritual life are ruins of a medieval monastery, a graveyard, and beehive huts, crumbling corbel stone walls, and more than two thousand handformed stairs that traverse the jagged heights of the island (p. 86, bottom). It was the island's bleak geography that so intrigued Ireland and which provides a foil to his own often stark and coarse art. It was on Skellig Michael that Ireland met his own sensibility as he established a psychological kinship with the hermetic monks who had roamed the island's stony heights. "The creative process," as Ireland observes, "is much like a religious commitment that functions without explanation."[83]

The process of journey and arrival, so important to Ireland's sensibility of artistic exploration, is a theme that reappears in the *Skellig* project. It took form in an 8mm black-and-white film loop that repetitively showed the island in the distance as it is approached by boat; significantly, a landing is never made. The projector from which the film was shown was geared to move back and forth on a track, causing the image to pitch and sway like a boat on rough waters. The recurring image and syncopated rhythms of the projector were, as Ireland conceived the piece, like a monk's daily prayer or mantra. In the grainy, continuously repeating long shot, Ireland presented the island as a vague and unreachable goal, a metaphor for the hermit's own spiritual journey and, perhaps, that of the artist's as well.

The installation (p. 92), austere like the island itself, included sculptures in various media scattered throughout the exhibition space—a triangular cabinet from which a pile of potatoes cascaded, a crude lump of concrete impaled by an ax and hammer (p. 87), skinny metal light stands with bulbous shiny hoods that both illuminated the gallery and functioned as sculptural elements in themselves. Many of the exhibited works had nothing to do with Skellig Michael in the literal sense but shared its sense of bleakness and severity. The seemingly random placement of the sculptures, like the errant natural forces that helped to form Skellig Michael, was Ireland's way of

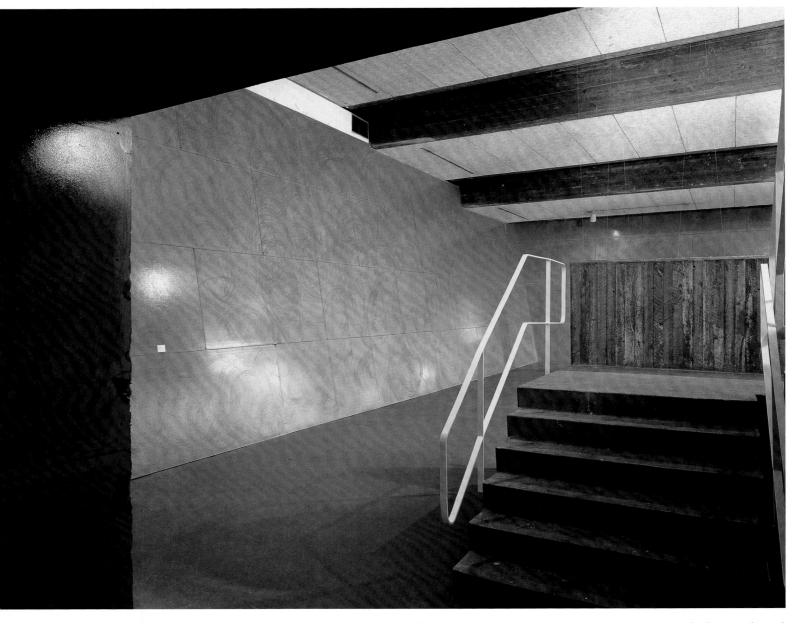

Contadina, 1985, installation for exhibition *Inspired by Leonardo*, San Francisco Art Institute (cat. 45)

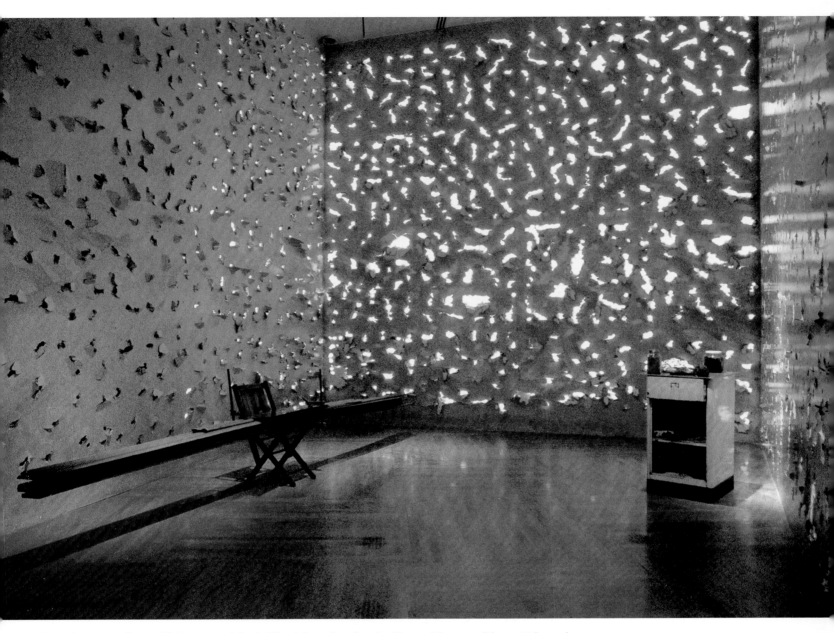

Installation view from exhibition *Awards in the Visual Arts 7*, Los Angeles County Museum of Art, 1988 (cat. 59)

ABOVE: *Newgate,* 1986–87, installation at Candlestick Point State Recreation Area,
San Francisco (cat. 52)

OPPOSITE: *Newgate,* 1986–87 (cat. 51)

ABOVE: *Pittcairn,* 1988, installation for *Sculpture at the Point,* Three Rivers Arts Festival, an activity of the Carnegie Museum of Art, Pittsburgh (cat. 61)

OPPOSITE: *Pittcairn,* 1988 (cat. 60)

breaking down the distinction between the exhibition space and the artwork, defining sculpture not only as three-dimensional form but as a psychological experience as well.

Notable was the inclusion of photographic images. While Ireland has taken photographs for years, they have largely been for documenting artwork or personal events. It was during his *Skellig* project that he began his first formal ventures into photography as a valid expression within his artistic oeuvre. Some of the resulting works, such as *Rolling Skellig,* 1993–94 (p. 93), were directly related to his Irish journey; others were based on Ireland's own crude and forlorn Skellig-like sculptures (pp. 88, 89). Many of the photographs were willfully altered, with the artist painting over the images with red and green pigment, which respectively signifies the blood of Christ and the country of Ireland. "Aggravating" the photographic images, just as he aggravated the spaces at 500 Capp Street, is, as Ireland explains, a way of encouraging viewers to respond to and contribute their experience to the work, to tap into the mystery of perception and meaning.

The Skellig and Helmhaus projects, though visually very different, appear to have planted ideas in Ireland's mind that took further root and came to fruition in works such as *Angel-Go-Round* and *Box of Angels,* both from 1996 (pp. 95–97). On the one hand, the Skellig trip brought a different kind of clarity to Ireland's concept of art making as he connected the lives of Irish monks with his own life in the studio. While the artist has always quietly maintained a grasp of Zen spirit that has significantly influenced his work, the Skellig trip seems to have resulted in a different form of ascension to consciousness. Whether seen through the eyes of a Zen or Christian monk, or the eyes of the artist himself, the quest for clarity is a journey to deepen and enhance one's communion with the universe. As Ireland observes: "Artists, like priests, do not question their calling. I didn't

OPPOSITE: *Smithsonian Falls, Descending a Staircase for P.K.,* 1987, installation for exhibition *David Ireland: Gallery as Place,* San Francisco Art Institute (cat. 55)

choose 'artist' from a checklist of career possibilities. It's just what I am and what I have to do."[84] The Helmhaus exhibition, in turn, reconfirmed the importance of honoring history and recognizing the interconnectedness of all things: that a drawing made of cement, the repair of a sidewalk, or a concrete mold for an eighteenth-century statue are all related. "If we believe, which we must, that matter cannot be created or destroyed, then all of the material is here, it's already arrived. There's not a carload of it waiting. It's all here. And we should see the capacity to think in the same way."[85]

Ireland thus expanded his vocabulary to allow a somewhat more traditional Western iconography to appear in his work, as seen in *Angel-Go-Round* and *Box of Angels.* Unlike much of his bleak and astringent art, these pieces have a decidedly quasi-narrative and humanistic quality, largely due to Ireland's use of symbolic figurative imagery. For *Box of Angels,* Ireland crammed a mass of reproduction statuary into a turn-of-the-century museum vitrine.[86] His choice of working with angels and classical reproductions was, as he explains, yet another call on history that was personal, artistic, and religious.[87] On the one hand, Ireland refers to his youthful recollections of seeing stuffed animals carefully staged in glass cases, a fascinating, if not bizarre, experience for a child, where the corporeal form is so vivid but the spirit is completely dead. By the same token, he acknowledges the tremendous psychological and emotional influence that icons have in people's lives. He explores this in *Box of Angels* at the same time that he slyly comments on the mass production of culture and religion. Traditionally seen as mediators between heaven and earth, Ireland's angels are intended to represent thoughts of divine spirituality as their beseeching eyes look skyward and their arms reach for the heavens. But their jumbled and chaotic state also suggests things in total disarray. The symbolism of the vitrine as a protector for that which is precious and valued by society is equally important to the artist. With his encased piece, Ireland makes clear the importance of caring for one's art, history, and religion, no matter their pathetic state.

Ireland is one of many artists whose work has commented on art history. Several of the arte povera artists, with whom Ireland is often compared, incorporated elements of classical sculpture in their work—for example, Jannis Kounellis once described his work as "the iconography of iconoclasm."[88] A similar sensibility informs Ireland's *Angel-Go-Round*. In this piece a gray fiberglass angel, suspended from a motor in the ceiling, "flies" over a mass of concrete garden statuary that includes nymphs, maidens bearing vessels, and replicas of Persephone and Michelangelo's *David*. Seen across the expanse of a gallery, with the whirring sound of the motor as the angel mutely and endlessly circles above the mound, the work is both astonishing and mesmerizing.

In reviewing Ireland's 1996 installation of *Angel-Go-Round* at the Yerba Buena Center for the Arts in San Francisco, art critic Kenneth Baker wrote of the multiple ways the piece might be interpreted. "Is Ireland mocking renascent religiousness here? Is his angel trying to summon the pagan gods or doing surveillance to make sure they are as dead as they look? Or is this an allegory of art making in which Ireland sets up his own muse and spins it like a prayer wheel over artistically lifeless forms? The piece might be about belief as a kind of hypnosis or about nothing more than the bankruptcy of representational tradition in sculpture."[89] In his review Baker offers several intriguing interpretations. Yet one he overlooks concerns the more humanistic issues of spirituality and mortality—of the angel shepherding and protecting her flock as she continuously hovers above it. Indeed, when Ireland was once asked in an interview about his thoughts on mortality, he acknowledged: "It's out there and you know it's out there. You feel the angel feathers flapping once in a while."[90] But as Baker concludes in his review, and as Ireland would agree, the meaning of the piece ultimately depends on what the viewer brings to it. As with all of Ireland's work, what is most important is the encounter—the experience of the experience. It is through this that one creates meaning and comes to understand the world and the self.

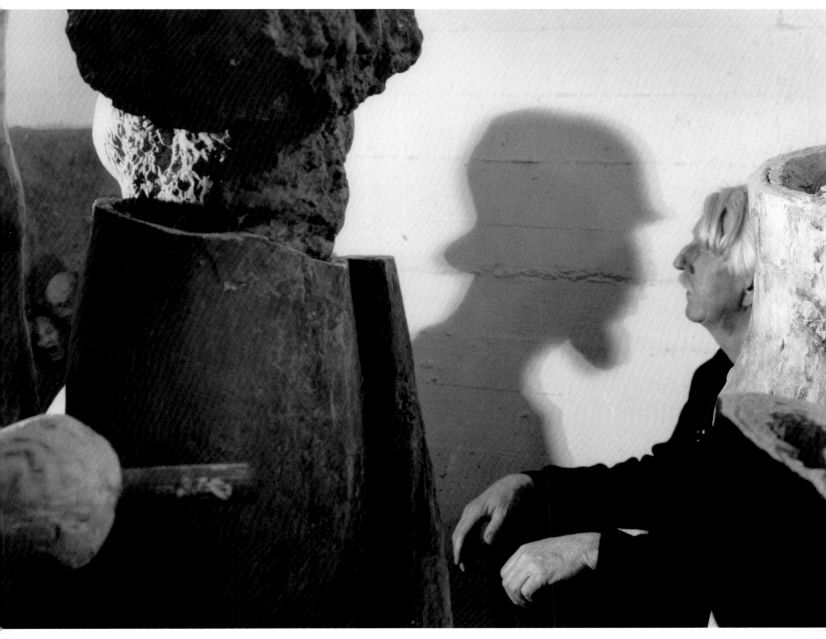

David Ireland working on exhibition *David Ireland in Switzerland: You Can't Make Art by Making Art*, Helmhaus, Zurich, 1991 (cat. 73)

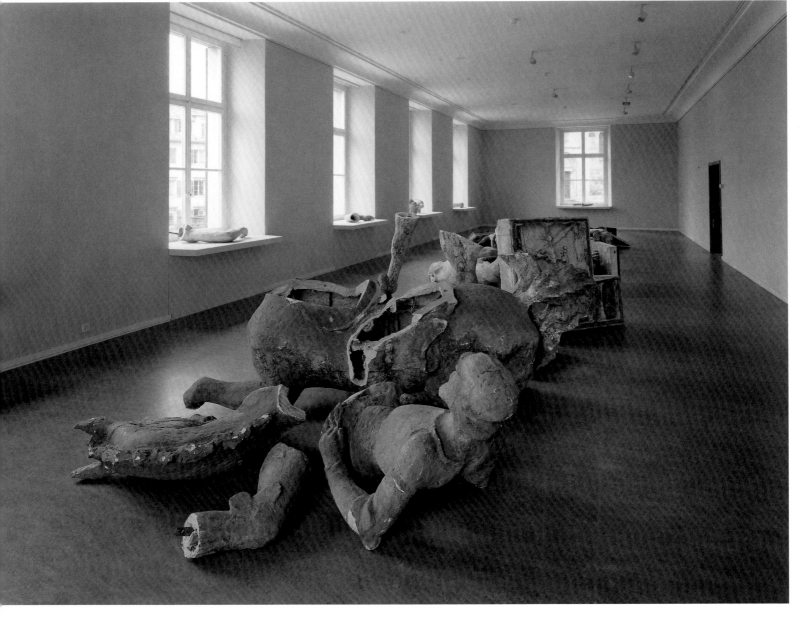

ABOVE: Installation view from exhibition *David Ireland in Switzerland: You Can't Make Art by Making Art*, Helmhaus, Zurich, 1991 (cat. 76)

OPPOSITE: Installation view from exhibition *David Ireland in Switzerland: You Can't Make Art by Making Art*, 1991 (cat. 77)

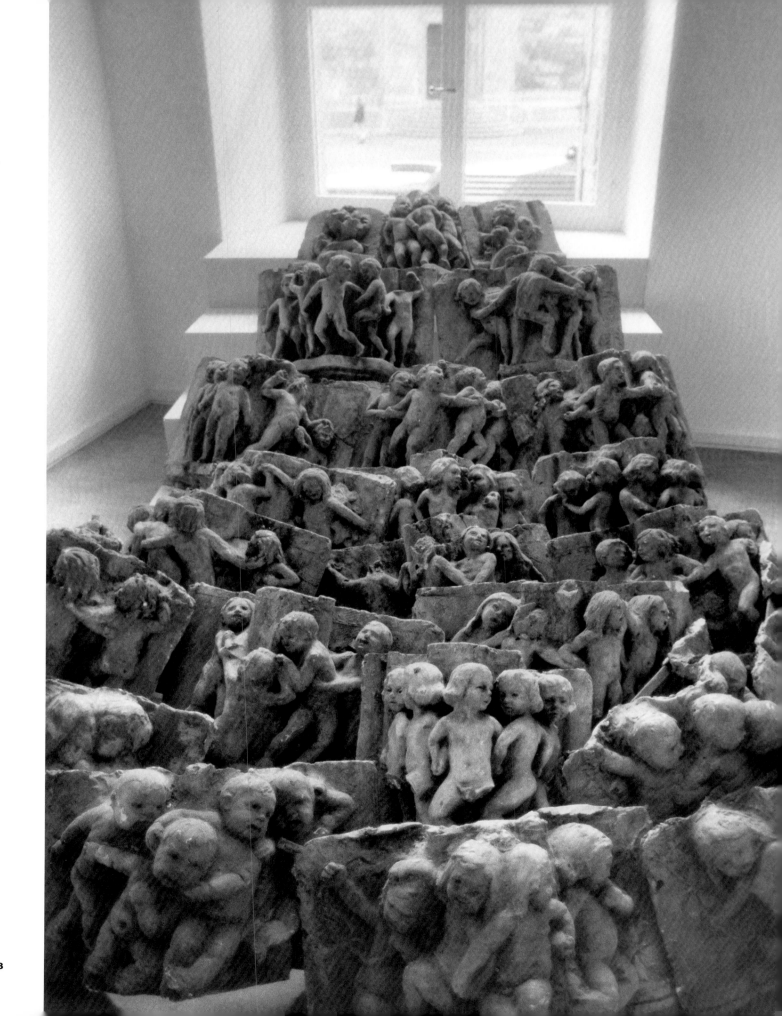

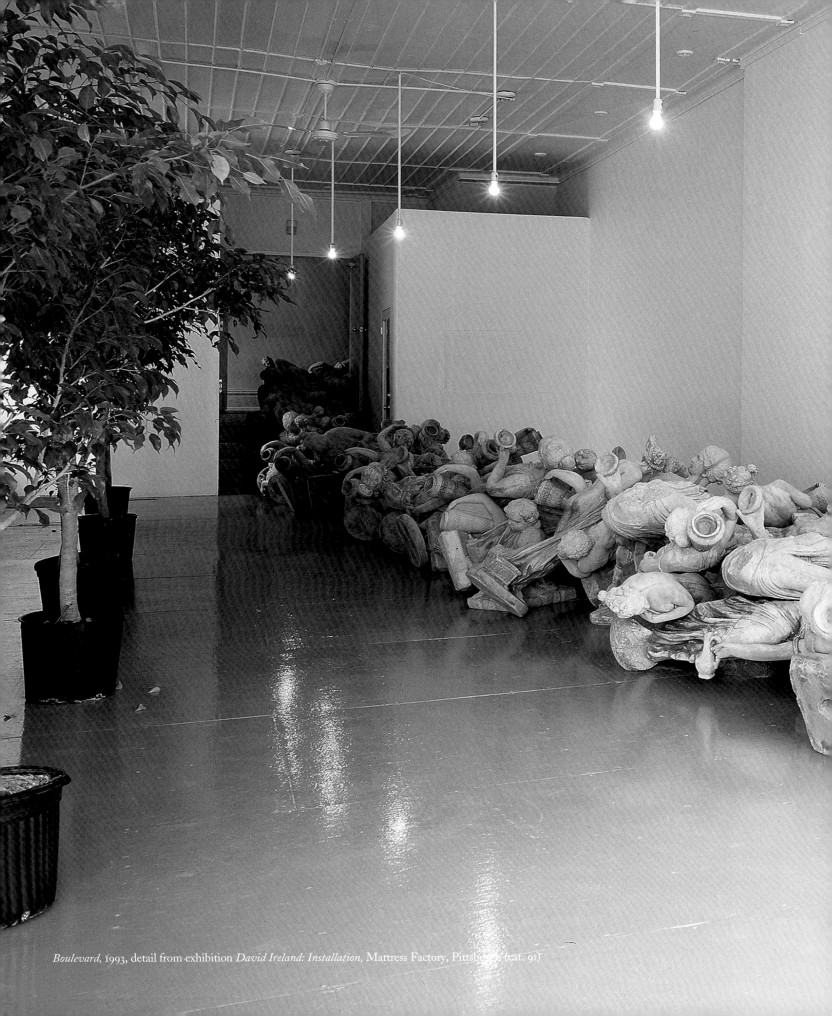

Boulevard, 1993, detail from exhibition *David Ireland: Installation*, Mattress Factory, Pittsburgh (cat. 91)

Skellig Michael, Ireland, 1993 (fig. 7)

Skellig Michael, Ireland, 1993 (fig. 8)

Spout o' Tools, ca. 1988–89 (cat. 64)

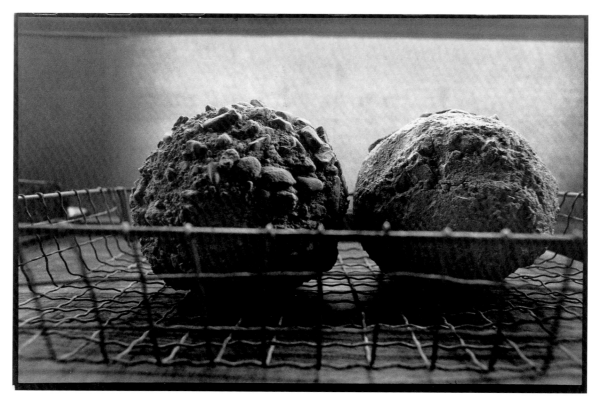

Concrete Acorns in Wire Basket, 1993 (cat. 93)

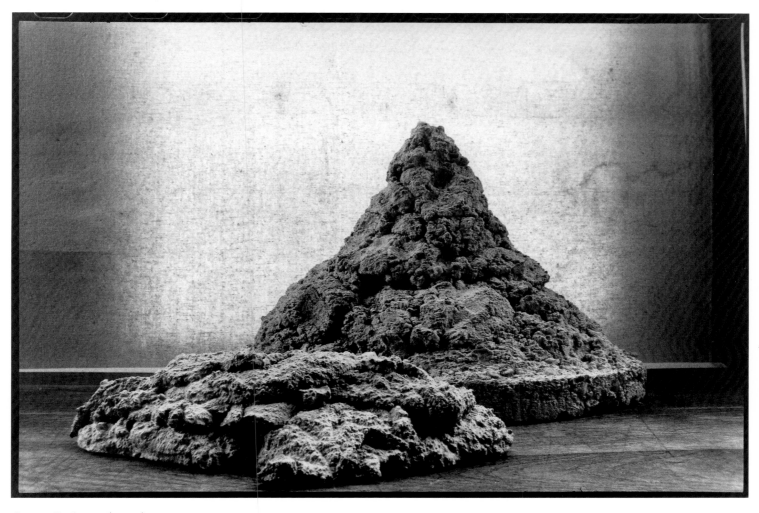

Concrete Study, 1993 (cat. 94)

After Skellig, Green, 1993 (cat. 88)

After Skellig, Red, 1993 (cat. 89)

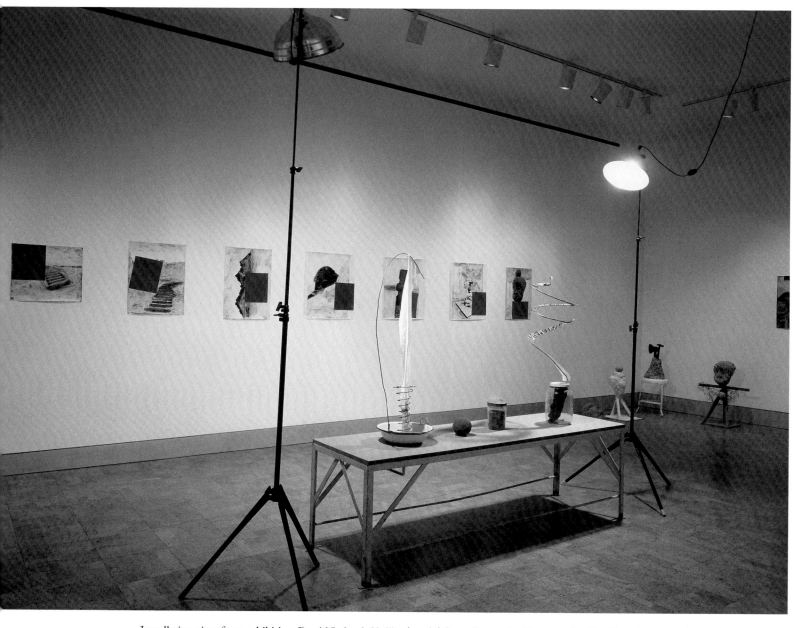

Installation view from exhibition *David Ireland: Skellig,* Ansel Adams Center for Photography, San Francisco, 1994 (cat. 101)

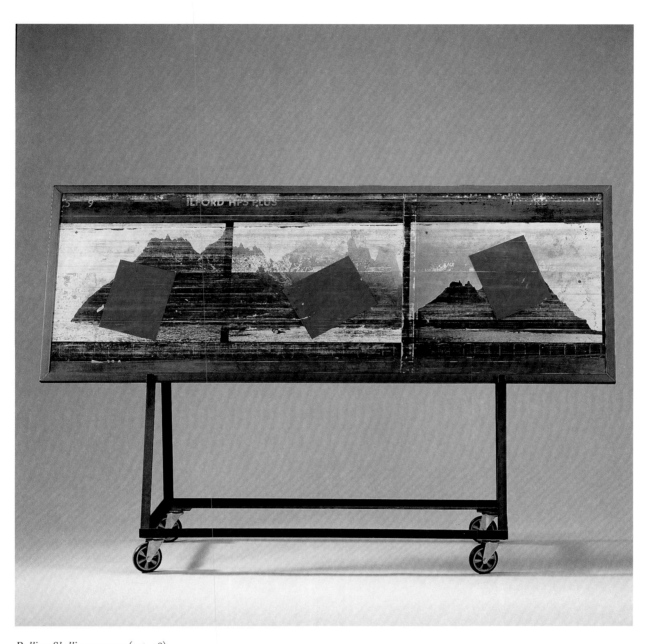

Rolling Skellig, 1993–94 (cat. 98)

Installation view from exhibition *David Ireland and Gallery Paule Anglim Contemplate the de Young Museum,*
Gallery Paule Anglim, San Francisco, 2001 (cat. 129)

Box of Angels, 1996 (cat. 108)

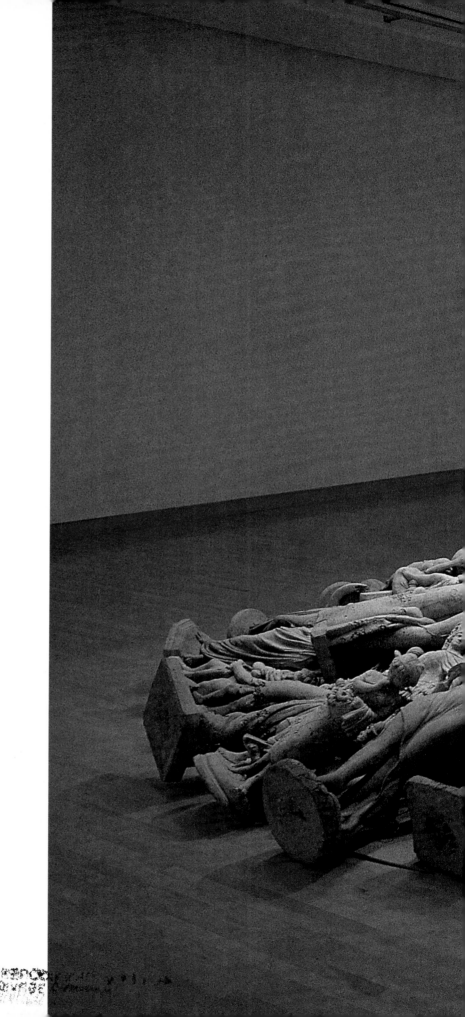

Angel-Go-Round, 1996, installation view from
exhibition *Affinities and Collections,* California
Center for the Arts, Escondido, 1998 (cat. 107)

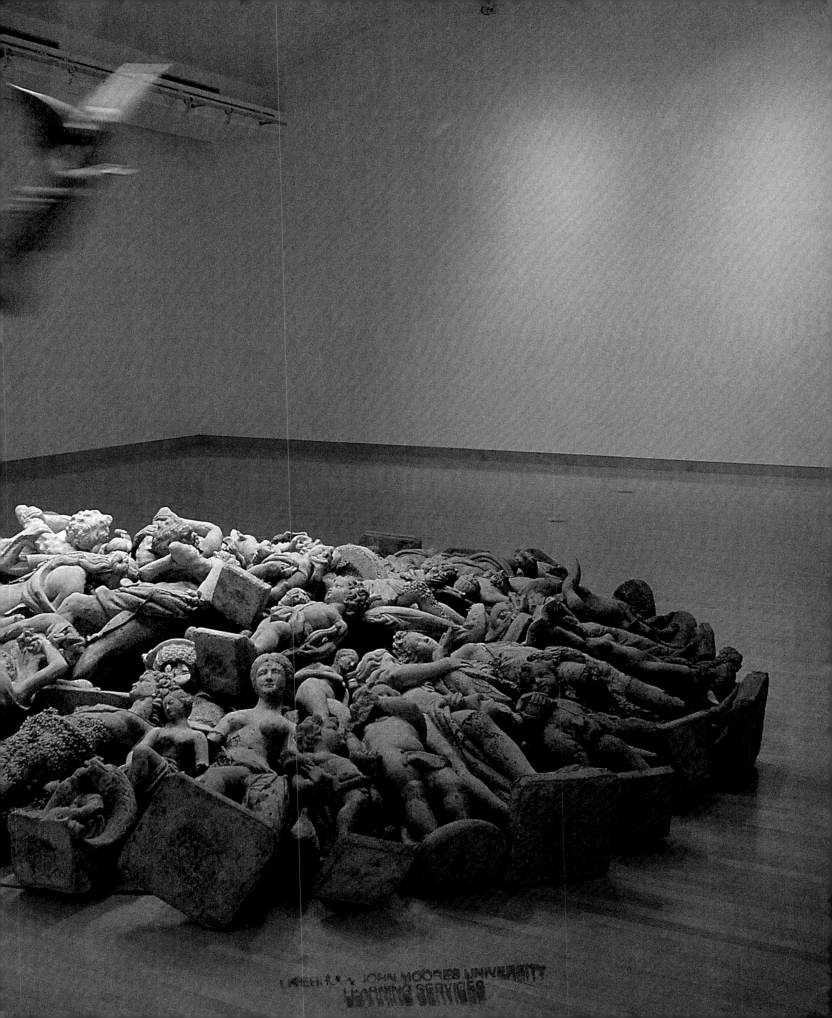

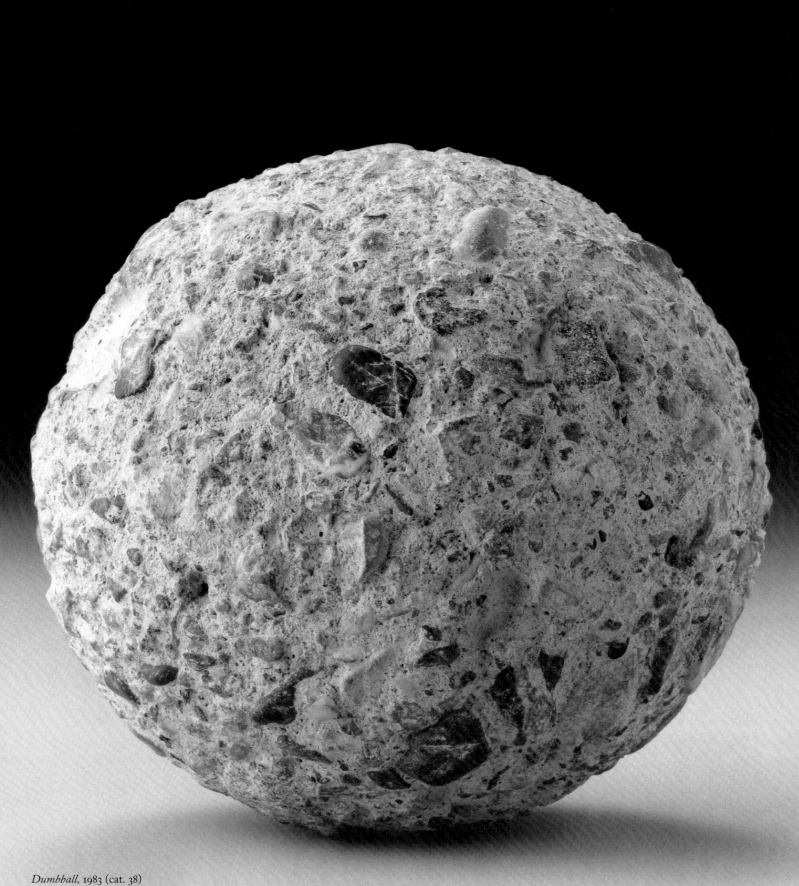

Dumbball, 1983 (cat. 38)

Sculpture in Multiple Dimensions

Ireland came of age as an artist during a period in the 1970s and 1980s that saw the flourishing of a wide range of artistic expressions that crossed national and international borders. Ranging from minimalism to arte povera, from conceptual to environmental art, these expanded possibilities suited Ireland's temperament and helped validate his broad-ranging artistic investigations. In Ireland's mind, art can be made from anything and in any way. It can be poured, painted, handcrafted, industrially produced, spoken, written, performed, or videotaped. It can, as well, be made from materials of the earth, found objects, commercial artifacts, and even immaterial elements such as liquid, air, or sound. A work may last for a passing moment or exist in time immemorial. Fully acknowledging the multiple points of view that inform his art, Ireland once described himself as a post-discipline artist. His intentional lack of a programmatic theoretical basis for his art has allowed him to respond freely and with ease to a wide variety of artistic expressions.

Of the many forms Ireland's artwork has taken over the years, the simplest in appearance, yet the most revealing of his thought process, are his *Dumbballs,* hand-sized spheres of concrete that he started making around 1983 (p. 98).[91] The name for these unassuming gray balls refers to the lack of intelligence needed to make them. The knowledge or skill of an artist is not required; all that is needed is time, fifteen hours or so, to toss a lump of wet concrete back and forth between one's hands until it sets and dries into a natural rounded form.

Despite its elementary appearance, the *Dumbball* reflects several issues central to Ireland's philosophy about making art. First, the *Dumbball* is so named because it addresses Ireland's interest in deintellectualizing the art object, in stripping away the ego and intelligence normally associated with a work of art. A child can make one as well as a genius; no aesthetic judgments need be imposed. The *Dumbballs* are also an example of Ireland's interest in process, of his ongoing focus on the phenom-

enon of *making* itself. Tossing a lump of wet concrete back and forth until it cures is a way of both marking time and perceiving time as the form literally grows out of the process (p. 102). This awareness of the physical and mental process experienced by the body and mind during the act of making, and the simultaneous transformation of material, has always been central to Ireland's consciousness, whether he is sanding a floor or varnishing a wall. But with the *Dumbball,* this consciousness reaches a point of unmatched clarity, for the repetitive motion required to make a *Dumbball* is like repeating a mantra or trying to paint a perfect circle, a calligraphic exercise often performed in Zen practice. Through the concentrated attention required to render a circle or, in Ireland's case, to make a round concrete ball, the perfection of the world is grasped. Indeed, Ireland has often referred to the *Dumbballs* as his own private universe, small perfect planets he can hold in his hands. But like the practice of Zen, or anything else for that matter, making a *Dumbball* requires one to pay attention. As Ireland points out, the perfection of the sphere is determined by dedication to the process: if one cuts short the process, the ball will be misshapen or simply fall apart.

Like the cement drawings that preceded them, the *Dumbballs* signify a consciousness free of artistic ego and intelligence, and as such they are very important to the artist. To symbolize this, Ireland created the special *Dumbball Box,* 1983 (p. 104), to display the concrete balls with the same care and attention that might be given to religious or historical relics. "I wanted to honor them and make them respectable, not a throw-away idea or a gag or a joke," Ireland has explained. "I wanted [them] to be seen as a significant and important process work."[92]

Since their appearance in the early 1980s, the *Dumbballs* have continued to resurface in Ireland's work. For example, they were incorporated into two sculptures honoring John Cage, an artist whom Ireland greatly respects and feels a kinship with. A disciple of Zen master D. T. Suzuki, Cage made it his lifelong project to dislodge cultural authoritarianism and introduce in its place the pleasures of everyday life undistorted

by domineering ego. His perspective on life, a merging of Eastern philosophy with Western phenomenology, helped assert the idea that art, and the means for its creation, lies all around us. His legendary 1952 composition, *4'33"*, for example, consisted of a performer silently sitting at a piano for four minutes and thirty-three seconds. The only "music" heard was the ambient sound produced by the audience-filled environment—coughing, paper rustling, whispering—demonstrating Cage's revolutionary axiom to let sounds be themselves. Using the *I Ching* (*Book of Changes*), Cage also introduced chance procedures into his art as a way to escape the trap of egocentrism normally associated with artistic creation.

In two works from 1992 and 1993 incorporating the *Dumbball*, Ireland acknowledges Cage's influence. His *79 Dumbballs with Carriers, Dedicated to the Memory of John Cage,* 1992 (pp. 106–7), as implied in the title, is a portable work that pays homage to the artist's seventy-nine years of life. It is also a mutable piece. There are no strict instructions that define it beyond the idea of having the viewer randomly roll the balls across a floor and listen to the "music" they make. The *Dumbballs* and their carriers can be scattered or variously stacked depending on the circumstances and desires of the individual interacting with the work. Just as Cage did, Ireland recognizes the phenomenon of indeterminancy, opting for variability and flexibility over an expression of artistic genius and encouraging the notion that art should be a participatory experience.

Ireland's *A Variation on 79, Side to Side Passes of a Dumbball, Dedicated to the Memory of John Cage (1912–1992),* 1993 (p. 133), comprised of two music stands and five etched scores, similarly pays respect to Cage's musical ideas and his use of chance operations. To "compose" two of the scores, Ireland took a *Dumbball* and rocked it side to side over an etching plate and then had the incidental markings printed on paper etched to look like blank sheets of music. The seventy-nine random passes of the ball over the copper plate were metaphorical "lifelines" representing each year of Cage's life. For the other scores, Ireland threw pieces of cut string and

rubber bands onto etching plates and then had their random arrangement printed as a musical composition. Through his actions, Ireland acknowledged Cage's ritual of throwing the *I Ching* coins to determine his decisions. His use of rubber bands and strings additionally established symbolic links to Cage's often witty thought process. Rubber bands, when stretched to various lengths, can be used to make sound, and the choice of string is a pun on string instruments. The inclusion of two music stands and several sheets of music from which to choose reinforces the notion of unguided possibility that is central to the piece. There is no beginning or end to the compositions and no specific sequence to them. It is up to the viewer to choose the order of the scores and thereby determine the nature of the musical performance. In the nonsensical sensibility of the work, Ireland follows in Cage's footsteps, confronting a number of sacred assumptions about creativity, professional skill, individuality, and the presumed value of order and intellectual determination.

The first public exhibition of the *Dumbballs,* in 1983 at the Leah Levy Gallery in San Francisco, marked a shift of Ireland's focus to making discrete sculptural objects. Until that time, Ireland had directed most of his attention to his two Capp Street projects. Although he did make sculptures, such as his *Broom Collection* and *Rubber Band Collection with Sound Accompaniment,* the works were generally created from material discovered at his 500 Capp Street home, and as such were considered archaeological relics specific to that location. Starting in the early 1980s, however, Ireland began to produce a wider range of sculptural objects, many of which referred to his time in Africa.

In 1983, the same year he exhibited his *Dumbballs,* Ireland wrote a brief memoir of his first journey to Africa in 1957, sharing publicly for the first time recollections of his life in the Transvaal some twenty-six years earlier.[93] In it Ireland describes the farmhouse where he lived at Driefontein, which was made of stone and mud, with corrugated iron for the roof. From its porch, he savored the view of a plot of rich red earth that was his

small patch to farm. He wrote of winter evenings spent sitting by the fire with Freya Weber, owner of the farm, listening to her colorful stories of diamond strikes and living in the bushveld for some sixty years. He recalled how he searched for diamonds in the Kalahari Desert, cursed the heavens when a rainstorm destroyed his small crop of mealies and potatoes, and worked alongside John, the farmhand, who stole the farm's tractor and later stabbed a man with a screwdriver.

In and of itself, the memoir is an evocative piece of writing that suggests how Ireland's impressions and experiences in Africa, in all their beauty and daily drama, have remained vivid in his memory. Importantly, the memoir also hints at how these experiences have informed Ireland's art. For those fortunate to have visited the artist at his home at 500 Capp Street, having tea by his fireplace and sharing a conversation are an intimate encounter not to be forgotten, not unlike Ireland's own memories of sitting with Freya Weber years ago.[94] Ireland's process of making the scrubby dirt and concrete objects that have long been a touchstone in his work (p. 8) might also be likened to his rooting for potatoes in the red African earth. For whether digging for tubers or making art, what is important is the process of discovery and the full awareness of the act—the realization that consciousness is not a thing but a process. Ireland's search for diamonds in the desert is also an apt analogy for his ongoing creative quest to find riches in the most unlikely and unexpected places. *Kimberly,* 1989 (p. 109), for example, is titled after the Kimberly diamond mines in South Africa and is a visual metaphor for this experience of discovery. Comprised of an ordinary white kitchen cabinet, upon which sits a dirt-filled enameled basin, and a screened metal window frame lit by a bare lightbulb, the work appears as a small theatrical vignette. What immediately catch the eye are the ceramic Chinese figurines sitting in the dirt-filled tub. Embedded in lumps of concrete and half-covered in soil, the small sculptures appear as partially unearthed treasures, diamonds in the rough, so to speak. What Ireland seems to suggest in this spare and homely work is that in ordinary life, as

well as in art, there are discoveries to be made no matter what form they take. "Frontiers are what artists and explorers deal with if they want to be on the edge . . . there *are* unexplored territories in art. If there are no other frontiers left in the world, the new explorers are the artists, people who continue constantly to look for new territory."[95]

Another African experience is also insightful. During Ireland's many trips to Kenya, the artist would often try to trade inexpensive American jewelry for the Masai's beautiful adornments. But the Masai were too smart to give up their treasures for Ireland's baubles, and he would eventually just give the pieces to them. Yet when he would later return to the tribal villages, Ireland never saw his jewelry worn. Instead, he would find the Masai wearing 35mm film canisters as earrings and parts of automobiles as other jewelry. The lesson to be learned here is that people make surprising and unconventional choices, and whether in life or in art, value systems are relative and malleable. What is one person's junk is another's treasure. Soon after returning from Africa and refocusing his full attention on art in the 1970s, Ireland elaborated on his evolving philosophy. "The notion that the least art is the best art has been with me for a number of years, and almost includes the idea that if another person likes the art then it can't be good. Institutional acceptance of one's effort would indicate yielding to some conventional values. . . . My art is inclined toward the opposing of the wooing beautiful art and wants to support the meaningless effort, the unskilled, the unpretentious, and the unrehearsed, the unserious and amusing."[96]

If art comes from life, as Ireland believes, it is not surprising that references to Africa appear in his work. His regard for ordinary materials and their colors, surfaces, and textures, for example, can be traced to his safari days when he knew well the hides of elephants and rhinos and the Masai huts, known as *manyatta,* made of manure (p. 110). The wallpaper patties in a hallway at 500 Capp Street (p. 44) were also inspired by the dung patties he saw in Africa and Asia that are stuck on walls

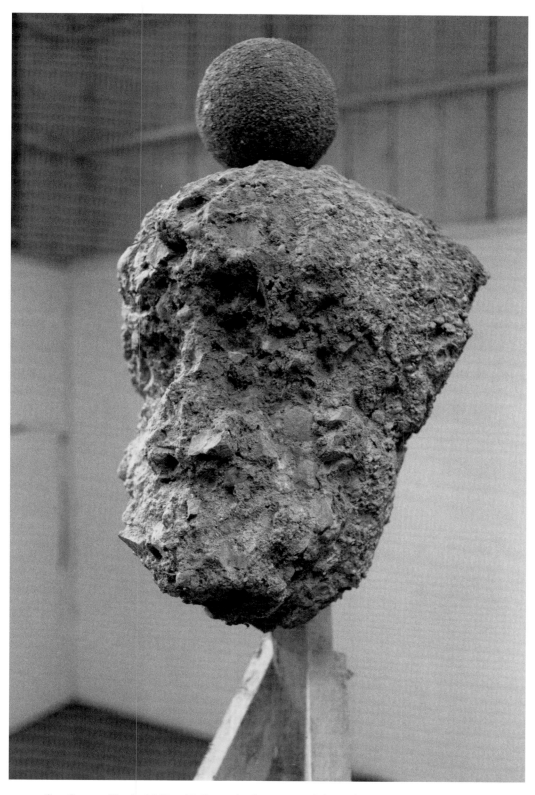

ABOVE: *Cast Concrete Head with Dumbball*, 1993 (no longer extant) (cat. 92)

OPPOSITE: *Dumbball Action*, 1986 (cat. 47)

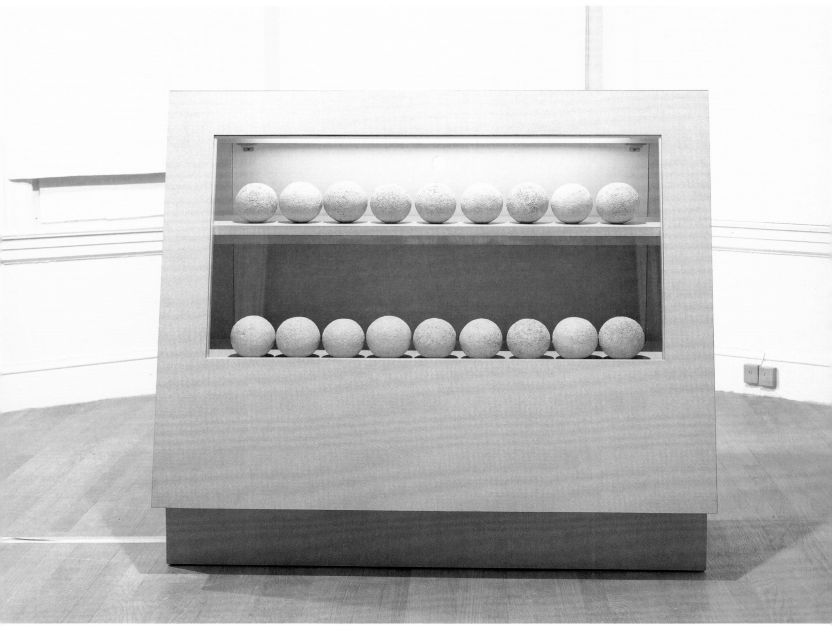

Dumbball Box, 1983 (cat. 39)

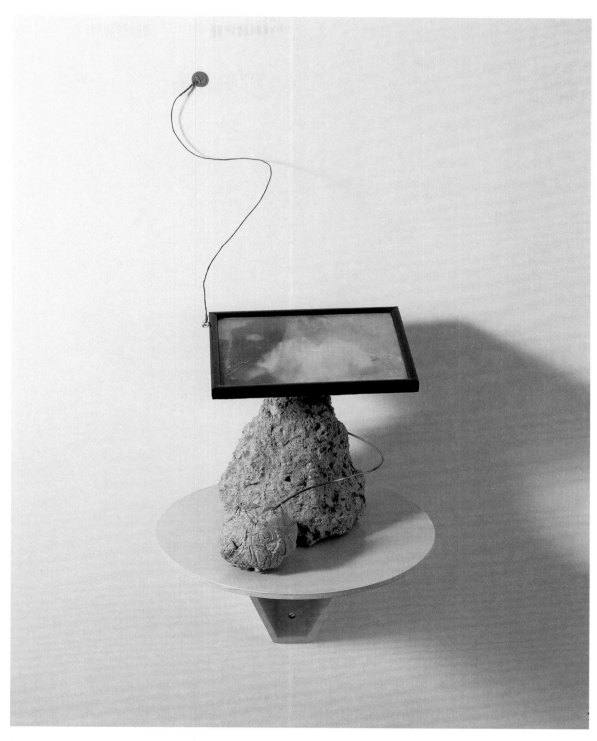

Mixed-Media Piece with Photograph, Dumbball, and Tether on Green Shelf, 1983–89 (cat. 41)

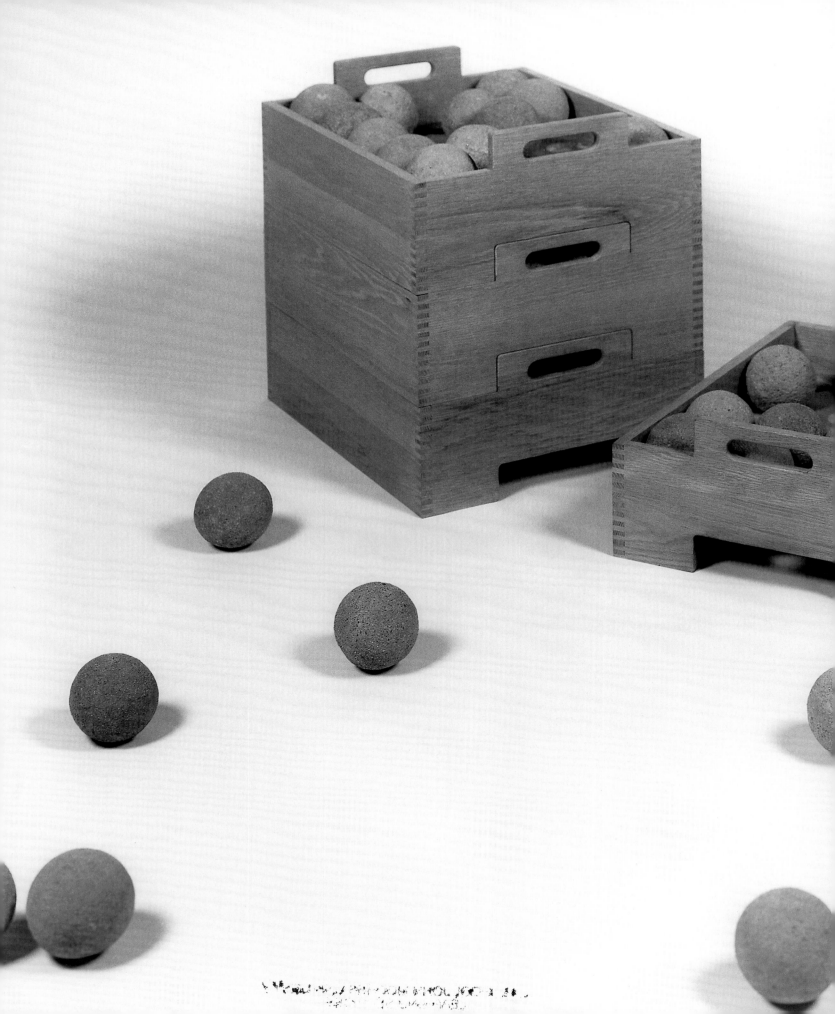

79 Dumbballs with Carriers,
Dedicated to the Memory of John Cage, 1992 (cat. 84)

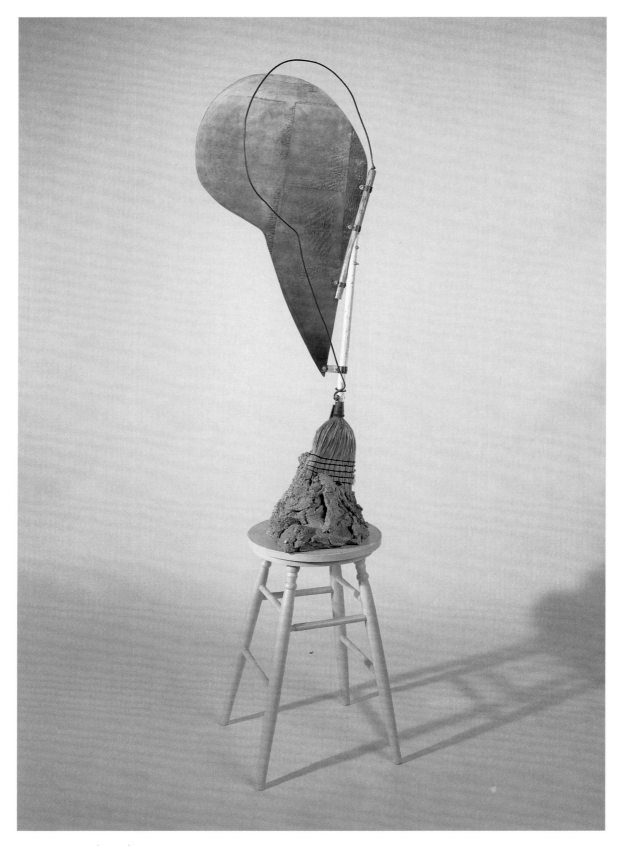

Good Hope, 1991 (cat. 74)

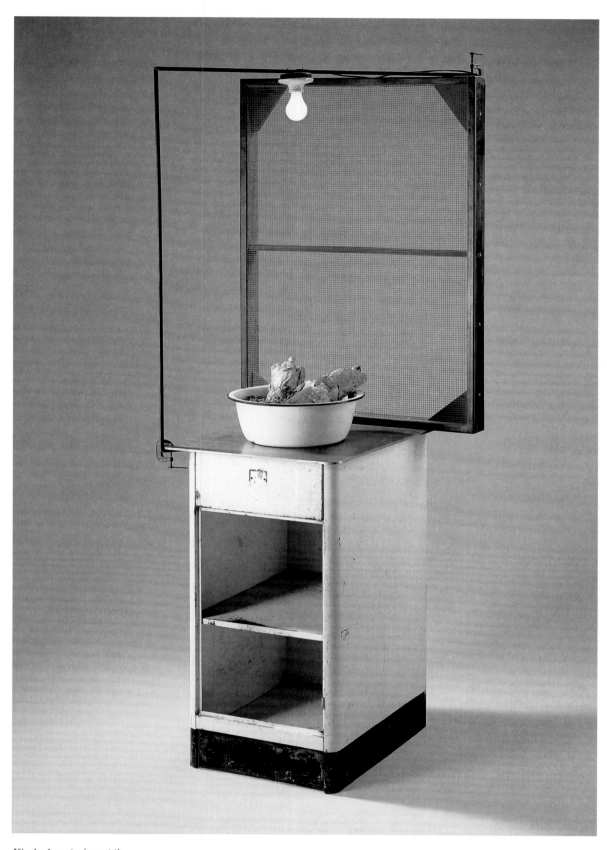

Kimberly, 1989 (cat. 66)

Masai *manyatta* (manure hut), Kenya, 1966–67 (fig. 9)

to dry and used as cooking fuel. References to Africa can also be found in Ireland's sculpture *Elephant Stool with Shade,* 1978/91 (p. 47), balls of wadded-up wallpaper stripped from the walls of 500 Capp Street and neatly stacked on a stool. The title, a double entendre, humorously and subversively refers to both the wooden stool and the dark baseball-size stool of elephants. Ireland especially favors this piece, and when it was later sold, he added a small black canopy, which in South African culture signifies the protection of an important entity moving from one destination to another.

Ireland is certainly not the first artist to refer to or use excrement in his work. In 1961 Italian artist Piero Manzoni, for example, produced *Merda d'artista (Artist's Shit)*, ninety canned tins of his fecal matter that he sold for the daily market price of gold. Among other ideas, Manzoni was parodying the overaesthetisized notion of creativity and the cult of artistic personality. Ireland addresses similar issues in *Elephant Stool with Shade* and other sculptures such as *Three Attempts to Understand Van Gogh's Ear in Terms of the Map of Africa,* 1987 (p. 177).[97] Incorporating a real elephant's ear that recalls the shape of Africa and small wire and concrete sculptures that mimic the ear/map shape, the work can be seen as a tongue-in-cheek reference to artistic identity as represented by Van Gogh's famous cut ear. Yet it also poses a seemingly incoherent riddle not unlike a Zen koan: what exactly *does* Van Gogh's ear have to do with the map of Africa? Ultimately, there may be no rational explanation for the sculpture. Instead, Ireland seems to suggest, as a Zen master might, that we should not take the objective world and its cumbersome artistic intellectualizing and pomposity too seriously. The open-ended nature of the work is meant to be so. "It's almost like the Buddhist story, where you go to the master and he hits you if you don't have the right answer," Ireland explains about interpretations of his work. "So then you get the right answer, and you take it back to him, your mentor, and he hits you again. And you say, 'Why did you hit me? You told me if I produced the answer. . . .' He says, 'Because I changed the question.'"[98]

The chair is another sculptural motif that was introduced at 500 Capp Street and has resurfaced frequently in Ireland's work. As with his decision to work with cement, which he sees as a common material, Ireland is attracted to chairs because of their similar universality, yet multifarious character. Although the basic structure of a chair is common throughout different time periods and cultures, its form—what it is made of, how it is designed and incorporated into daily life—offers an extraordinary range of conceptual experiences. Ireland is especially intrigued by the use of chairs as symbols of social position, whether as seats of power, authority, and ascension (the pope's chair or a throne) or as humdrum signifiers of ordinary life, a point he made clear in his installation *School of Chairs*, 1988 (pp. 114–15), exhibited, significantly, at Berkeley's University Art Museum (now University of California, Berkeley Art Museum). Like a Duchamp readymade, the chair offers a means for Ireland to bridge the wide rift between art and life, to challenge our dualistic way of viewing the world and categorizing what is and is not art. As he observes, "If you want to be an artist and you want to function in the art culture, the challenge, I think, is to see how closely you can stay to real time/space without becoming invisible. I would love the notion that whatever I would do would become virtually invisible as an artwork."[99]

One of the first chairs to enter the artist's oeuvre was *Three-Legged Chair*, 1978 (p. 150), an orphaned piece of furniture left behind by the previous owner of Ireland's home, which he intentionally saved as a work of art. Homely and mute in its injured state, the chair establishes the opportunity to consider that when something is altered and removed from its intended context, it can assume a further, perhaps more valued, significance.[100] Ireland's refusal to pass judgment on his adopted relic is firmly grounded in Duchamp's imperative concerning the "beauty of indifference"—when it comes to art, the very idea of judgment should be suspended. But Ireland's compelling lack of dogmatism can also be traced to the Zen precepts taught by the Taoist Lao Tzu when he advised: "The Wise Man . . . does not divide or judge.

. . . The Wise Man refrains from doing. . . . He studies what others neglect and restores to the world what multitudes have passed by."[101]

Ireland also responds to the tantalizing resemblance that chairs have to sculpture. He is especially intrigued by the idea of taking something functional and creating a situation where its identity supersedes mere utilitarianism. Thus, he has hung a chair high on a wall as though it were an installation piece (p. 44), clamped two metal chairs together at right angles (p. 113), and constructed a chair so large that it appears as a form of architecture (p. 118). This notion of chairs as a form of sculpture was first evidenced in several large, woven chairs that Ireland designed and had manufactured overseas while traveling in Asia in 1978 (p. 45). The idea for the chairs had been percolating since his Hunter Africa days, when he had imagined interpreting the classic look of an overstuffed chair in an entirely different material. At the time, Ireland did not perceive the chairs as a form of art but as a version of marketable colonial furniture, like Chippendale furniture made out of bamboo. But when they were finally produced several years later, they had assumed in his mind the stature of sculpture.

The chairs are intentionally, almost comically, exaggerated in size and possess a larger-than-life visual drama, swallowing up a sitter in their fat curved embrace. Their theatrical quality was inspired by Ireland's longtime interest in theater and the lessons he learned from it: to stimulate an audience and appeal to its senses, theater has to be believable and larger than life. The looming gray bulk of the chairs also suggests elephant-like characteristics. Although not initially aware of the influence, Ireland concedes that lurking within his unconscious and manifested in the chairs are memories of the color, heft, and dramatic physical presence of the elephants he saw on his African safaris.

When Ireland first exhibited the woven chairs in a gallery, he installed them in a dimly lit room, in such a manner that one approached them from behind, thus encouraging the viewer to discover the chairs first as abstract objects and, secondarily, as furniture.[102] To add

to this sense of mental dislocation, Ireland referred to the chairs as paintings. In part this was because he had gone through a laborious painting process to decide what color they should be until he finally arrived at a monochrome gray that, for him, emphasized the chairs' abstract form.[103] But in referring to the chairs as paintings, Ireland was also interested in investigating the phenomenon of illusion as differentiated between Eastern and Western culture. "I was interested in calling [the chairs] paintings because . . . painting in its traditional historic sense is an illusion of something. It's an Eastern idea if you're a devout Buddhist or Hindu [that] you're prepared to believe that everything is illusion. So what's the difference between painting being an illusion and some other object being illusion, as well?"[104]

Ireland has also expressed his regard for the work of Richard Artschwager and his way of making furniture-like sculpture: to take the idea of furniture and make something architectural out of it that is not architecture. This shared sensibility can perhaps be traced to the artists' similar backgrounds. While both initially studied fine art, it was not until they were in their forties, after having worked outside the art field for several years, that each began to articulate his own aesthetic. While Ireland worked in construction, renovating homes and interiors, Artschwager was a tradesman designing and building simple and well-made furniture. Thus, what they have in common is not only a respect for craftsmanship and materials, but a questioning interest in the visual and conceptual transformation of the familiar.

The chair, a recurring motif in Ireland's work since the late 1970s, has taken a particularly pronounced form in his oversized club chairs of the late 1990s. The club chair first appeared in 1996 in an artist apartment at the Addison Gallery of American Art, in Andover, Massachusetts, that Ireland was commissioned to create and for which he conceived all the furnishings (pp. 116, 117). Since that time, he has produced several huge versions of it in drywall, steel, and concrete (pp. 118, 119, 181), some measuring fourteen feet in height. Sometimes constructed in the confines of an interior gallery space,

the mammoth chairs, while wittily theatrical, conceptually address complex notions of how sculpture is perceived and how it can define felt and experienced space. In their simplified and oversized form, the chairs are a visual catalyst for thinking, offering a hybrid psychological and visual experience that falls somewhere between the utilitarian and the purely aesthetic, or what Artschwager defined as "thought experiencing itself."[105]

Ireland's exploration of the notion of thought experiencing itself finds a radically different expression in a number of works addressing artistic ego and identity. Including several prints and a number of sculptures in which his initials "di"—or their reverse, "id"—figure prominently (pp. 168–73), the works collectively reflect the artist's personal and public debate about the role of ego (the conscious, public persona) and id (the primal, instinctual self). Ireland explains that he became fascinated by how some artists sign their work in such a way that it becomes almost as important as the artwork itself, and he made the decision to explore this phenomenon in his own work.[106] Describing the genesis of *Ego*, 1992 (p. 169), a white wood and glass cabinet filled with logs upon which his initials have been burned, Ireland elaborates: "I decided I would meet head-on that whole notion of signing the work and make the whole signatorial aspect of it the inspiration and direction of the work. Or conceptually, I'm saying let's just deal with my initials and forget about form or any other kind of content."[107]

Folded into this investigation of artistic identity are elements of personal history and Ireland's continued interest in identifying social systems that record, through regularized actions, the passage of time. The stack of alderwood used in *Ego*, like Ireland's collection of empty toilet paper tubes gathered over a decade (p. 175), is a very personalized marker of time. The wood was cut by the artist during an annual trip to the Northwest, where he visits his family roots and harvests firewood that he uses at his San Francisco home (pp. 52–53). His initials, branded on the logs like those on branded cattle, unequivocally establish his ownership: they are Ireland's "brand name" wood from his own private acreage.

The cabinet in which Ireland stacked the firewood is also significant. It serves as his personalized version of a vitrine, a cabinet used by museums to display and safeguard specimens and treasures. In the case of *Ego,* it is clear that it is Ireland's identity and ego that are preserved and protected. Presentation cases and cabinetry have been an important element in Ireland's work over the years, beginning with the plain white enameled case he used to store relics gleaned from the stabilization of 500 Capp Street (p. 49). His *Dumbball Box,* 1983, and other pieces such as *Spanish Corner Cabinet,* 1977–97 (p. 131), while quite different in look, reiterate Ireland's preoccupation with presenting his chosen objects—whether jars of string and sawdust, lumps of concrete, or stacks of wood—with as much care and attention as the most valued museum artifact. Context, as Ireland asserts, is extremely important and always to be considered by both the artist and the viewer.

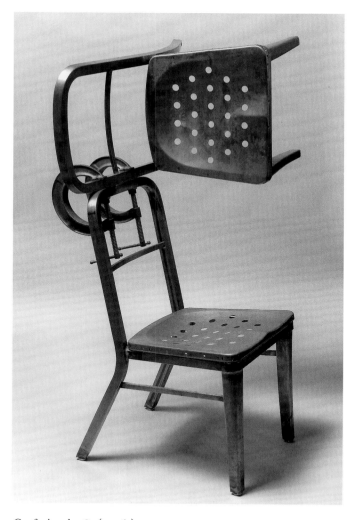

Confessional, 1989 (cat. 65)

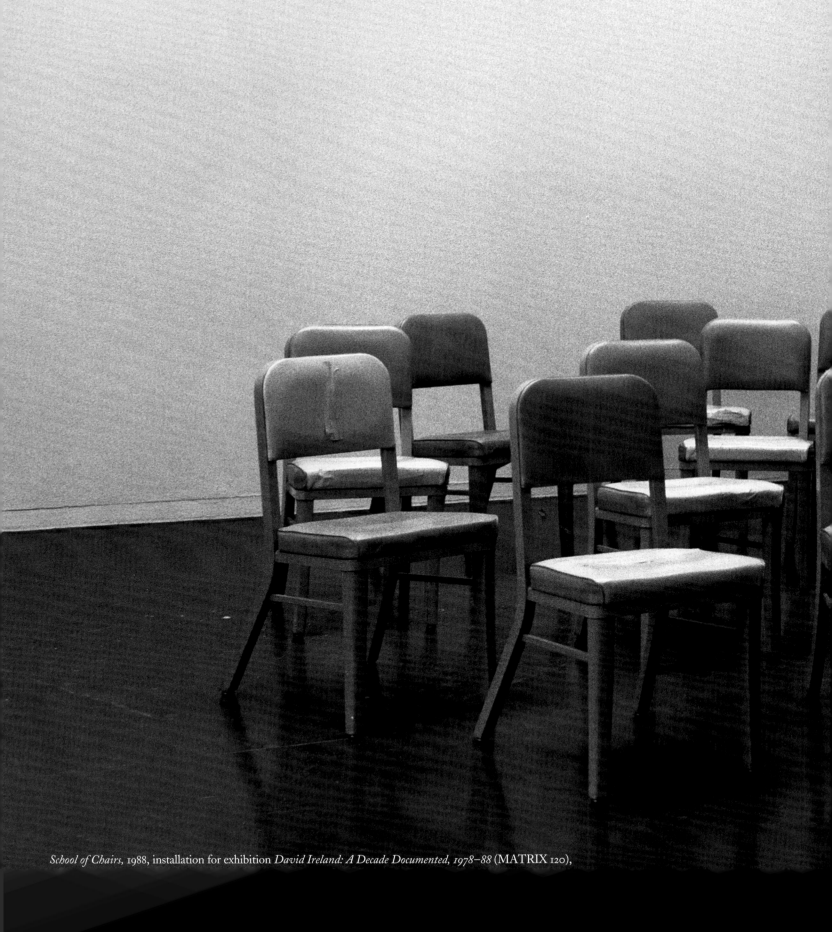

School of Chairs, 1988, installation for exhibition *David Ireland: A Decade Documented, 1978–88* (MATRIX 120),

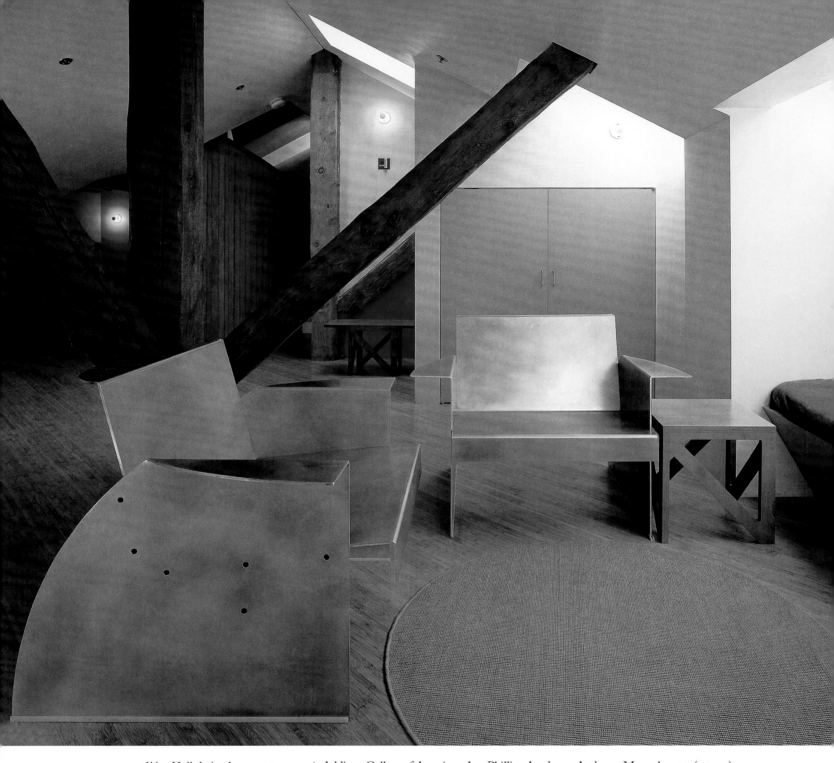

Abbot Hall Artist Apartment, 1993–96, Addison Gallery of American Art, Phillips Academy, Andover, Massachusetts (cat. 99)

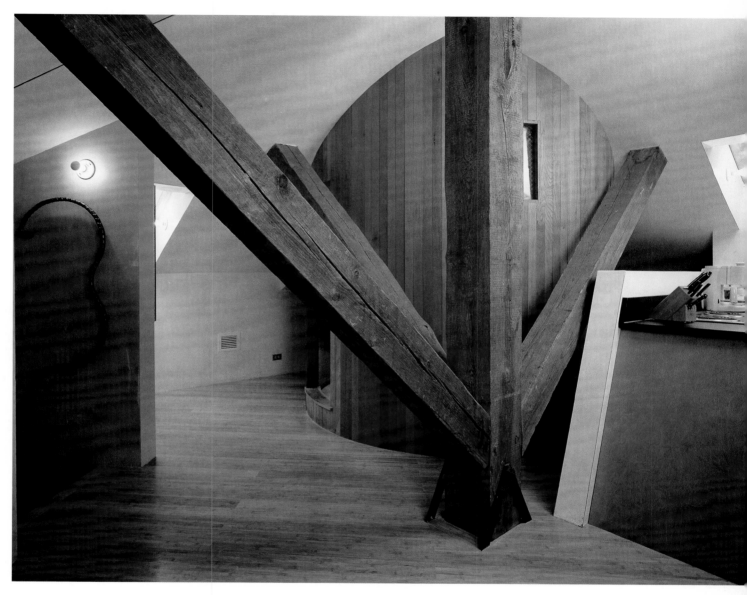

Abbot Hall Artist Apartment, 1993–96, Addison Gallery of American Art, Phillips Academy, Andover, Massachusetts (cat. 100)

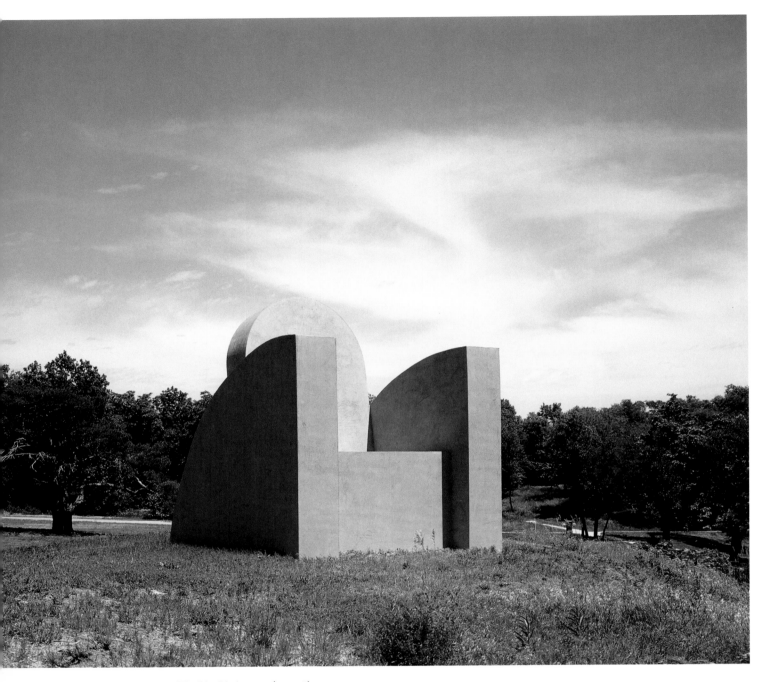

ABOVE: *The Big Chair*, 1999 (cat. 118)

OPPOSITE: *Big Chair*, 2000 (cat. 120)

The Artist's Laboratory

Underlying Ireland's sculptural approach is an insatiable curiosity to work with different materials and explore new processes and ideas. The unbounded sense of possibility that inspires him suggests that for Ireland the process of making art is as much about a kind of speculative laboratory-like research as it is about art, per se. Indeed, Ireland has often referred to his studio as a laboratory and his activities in it as investigations (p. 121). The conceptual pondering and trial-and-error methodology that he brings to his work are not unlike the process of a scientist. Rumination, musings, experimentation, intuition, and chance serve as the petri dishes from which his art grows. As Ireland once stated, "I think as artists we have traditionally tried to break boundaries. Advancement in the art culture has been through investigation and penetration into unknown areas. I think the thing we revere in art, in all forms, is this tradition of breaking through limitations."[108]

The fundamental difference between Ireland's inquiries as an artist and those of a scientist is one of intent: Ireland is more interested in questioning and investigating possibilities for their own sake, rather than solving specific problems—a concept Duchamp referred to as "playful physics." In this regard, Ireland has spoken of his interest in pataphysics, a realm of speculative artistic research conceived by the nineteenth-century French playwright Alfred Jarry. A guiding figure in the surrealist movement and the development of the Theatre of the Absurd, Jarry was fascinated by science and explored this interest in his fictional text *Exploits and Opinions of Doctor Faustroll, Pataphysician.* Jarry was especially intrigued by the work of a group of contemporary English scientists, among them Sir William Thomson, Clerk Maxwell, and Sir William Crookes. Together they shared a sense of eccentric brilliance and inclination to roam freely among the physical sciences, performing what seemed to be bizarre experiments with soap bubbles, gyrostats, and tiny boats driven about in a basin by camphor. For these researchers, as well as for Jarry, science was an adventure that could be domestic, open-ended, and ultimately transcendent. In writing *Exploits and Opinions of Doctor Faustroll,* Jarry established the realm of pataphysics—the science of imaginary solutions. In various chapters, Dr. Faustroll discusses measuring the surface of God, the sun as a cool solid, and the idea of "ethernity," a point of intersection between the propagation of light, the nature of time, and the dimensions of the universe. Despite undercurrents of spoofing and absurdity that run through his text, what Jarry ultimately recognizes is the very essence of creation as symbolized by scientific imagination. In pataphysics, the virtual or imaginary nature of things as seen through the heightened vision of art, science, or poetry opens doors to possibilities previously not considered by the ordinary mind.

In a similar fashion, Ireland systematically toys with the arrangements of things (both physically and conceptually), offering what first appear as unusual hypotheses but which, upon reflection, present plausible and authentic new experiences. For example, Ireland has used a hairdryer as a tool to create sculpture from air. As he explains about the piece, "Sculpture in the classic sense was thought to be any material that's re-formed, so what happens here, you plug [the hair dryer in] . . . and the blowing is re-forming the air around it."[109] He has also explored the idea of dialectics as represented by several "intentional spills," pieces in which the artist has deliberately created an accident by spilling cans of paint in various containers (pp. 128, 129). He has made drawings of the floor plan of his 500 Capp Street home with as much care as he would bestow on any other work of art (pp. 40, 41); and in a work titled *Winter Heat,* he rendered the location of the furnace, the air return, and the different rooms that are heated in his home. "As a conceptual work," Ireland claims, "it couldn't be much better."[110]

OPPOSITE: 500 Capp Street, San Francisco, ca. 1993 (cat. 97)

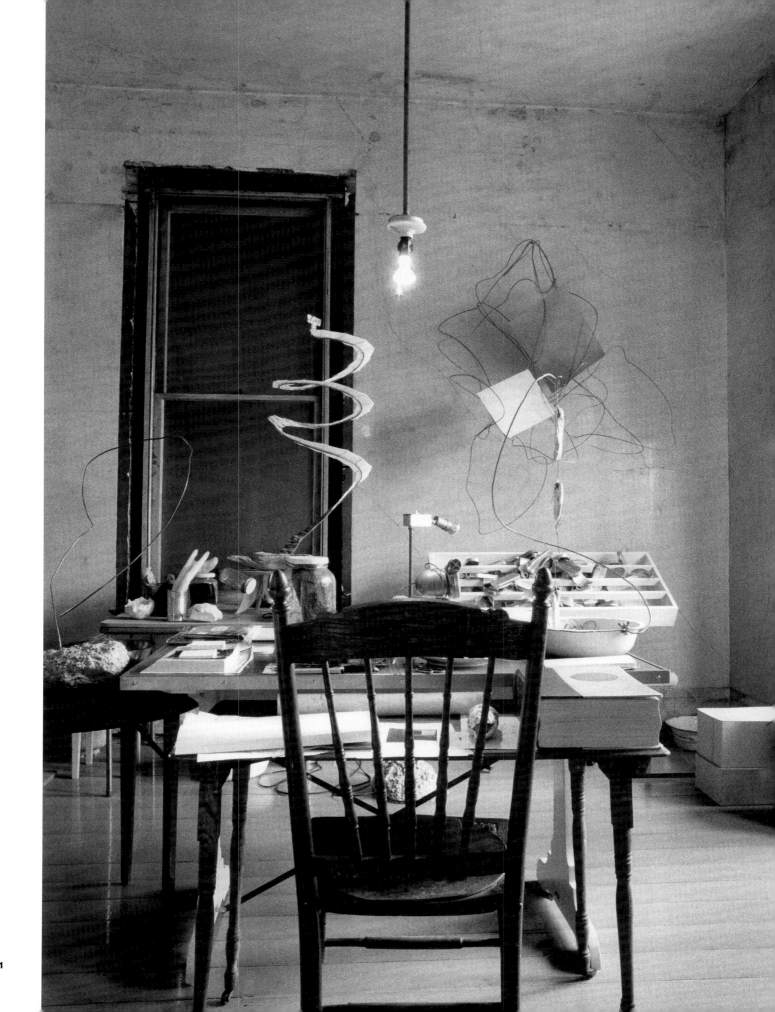

Sound as a dematerialized experience of art has also been a focus of Ireland's ruminations. This was first made apparent in his *Rubber Band Collection with Sound Accompaniment,* 1977, when he recorded the sound of rubber bands being removed from the daily newspaper. When Ireland traveled to Asia in 1978, he intended to collect a library of sounds—the chanting of Buddhist monks, calls to worship, Muslim prayers, the reverberations of temple gongs. But, as he has explained, he was not necessarily interested in the religious or symbolic aspects of these auditory experiences. Rather, he responded to "the shape of a certain sound." "It's like people who do word art, so to speak. They like the shape or the visual-ness of a certain word, and sometimes they'll like the sound of a particular word. A poet will like the sound of a word, or the shape of a word, and he'll use it. And I think when you're doing sound [work], you just like something about the characteristic of the sound."[111]

Ireland has continued to explore this interest in the experience of sound as a form of art. In 1983, for example, he created a work titled *The Sound of Blue,* in which the sound of a propane torch burning blue was amplified and exhibited as an artwork. His 1994 piece *Marcel B.* (p. 132) revisits the idea of sound or, more accurately, the Cagean idea of noise as music. The title also acknowledges the influence of Marcel Broodthaers and, specifically, gives a nod to the Belgian artist's *Pupitre à Musique,* 1964, a crudely made wooden music stand unceremoniously covered with paint and mussel shells, which, in part, served as Ireland's sculptural model. *Marcel B.* is actually a musical instrument to be performed by the following directions: take the cardboard box filled with empty, paint-covered kipper tins and dump them onto the slatted box that serves as a three-dimensional musical stave. The "music" is the sound of the hollow tins landing on the staves, their forms appearing like a jumble of notes marked on a composition sheet. Like earlier Fluxus event scores that featured banal and absurd elements of consumerism and everyday life, such as George Brecht's scored music for motor vehicles or grocery deliveries, *Marcel B.* is characterized by a wit and economy of

action that jolt the viewer into a radically different state of awareness. In its terse immediacy, it advocates the Zen point of view of distinguishing between listening and simply hearing, between seeing and merely looking.[112]

Among other repeated experiments, Ireland has investigated the phenomenon of capillary action whereby liquid, when it comes in contact with a solid, either rises or falls depending on the relative attraction of one element to the other. Intrigued by the variability of capillarity, Ireland has conducted numerous experiments resulting in sculptures such as *Harp,* 1991 (p. 127), in which fabric has been suspended in a container filled with liquid dye. Depending on environmental conditions such as temperature and humidity and the physical construction of each experiment (how much liquid was used, the height of the suspended fabric), the capillary action could be quite variable. Ireland's choice of the materials from which *Harp* is composed—a white enameled basin and stool, sterile cheesecloth, wire, and a gray metal C-clamp—was very deliberate. It was a way, he has explained, to emphasize the scientific nature of the piece, to suggest the psychological experience of going to the doctor or dentist. Ironically, Ireland assigned a title to the work that is contrary to the antiseptic look that he was after. The title is based on the unplanned harplike shape of the wire and cheesecloth and the sense of ethereal translucency as light passes through the gauzy fabric, evoking light transmitted and diffused through the strings of a harp. "Under some particular conditions," Ireland observes, "it could almost be musical."[113]

The contrast between the title and the medical look of *Harp* emphasizes how one experience can lead to a different and often opposite mode of perception. As Duchamp explained of his own sometimes perplexing titles: "The titles are not the pictures nor vice versa, but they work on each other. The titles add a new dimension; they are like new or added colors, or better yet, they may be compared to varnish through which the picture may be seen and amplified."[114] Ireland's title for the sculpture may also refer to the Taoist fable of the taming of the harp, in which a highly prized harp produces

beautiful music for only one person who plays it. This object lesson in aesthetics and the philosophy of life acknowledges the mutual state of receptiveness essential to appreciating art. The viewer has to cultivate the right attitude for receiving the message, and the artist must know how best to express it.

Also noteworthy about *Harp* is the brilliant golden yellow dye used in the piece. The progression of the liquid color drawn up the suspended veil of cheesecloth is a visually sensuous record of flux and fluidity. It also offers a marked contrast to much of Ireland's otherwise dull-colored sculptures. Indeed, beginning in the early 1990s with works such as *Harp*, vivid color has appeared more frequently.

When queried about this change, Ireland admits that he puzzles about it, but in the end accepts where his intuition takes him. As he has described it in colloquial terms, it is like wearing two hats at the same time.[115] This yin/yang quality of opposites, a relatively consistent motif in Ireland's work, was first made evident in the contra-distinction found in his two houses on Capp Street: the aged and evocative golden patina of 500 Capp Street and the cool minimalism of 65 Capp Street. The contrast, as the artist admits, baffled many admirers of his Victorian home. But in Taoist and Zen thought, it is said that true understanding can be reached only through the comprehension of opposites. As one master explained, Zen is the art of feeling the polar star in the southern sky. Given Ireland's frequent assertion that art is a vast and open-ended proposition where one point of view is not necessarily more valid than another, he has come to terms with his acceptance of this duality. "The quest for justification," he states, "is not to be worried about."[116]

In point of fact, color was an important element in Ireland's earlier work, such as *Folded Paper Landscape*, 1973; *Architecture*, 1974; and *Untitled Landscape*, 1974 (pp. 16, 17, 19). In the mid-1970s, upon returning to San Francisco after his pivotal stay in New York, he also worked briefly with a palette of rich red and yellow enamel paint, covering some of his concrete pieces with thick layers of each hue. What resulted were

monochromatic images in which the immateriality of color appears almost palpable.

Given the open-ended nature of much of Ireland's art and his own general disinclination to define it, the issue of determining the significance or symbolism of color in his work may appear a thorny one. Yet, as the artist concedes, color has always been conceptually important to him.[117] The red and yellow he chose for his concrete paintings, for example, reveal his deep connection to Eastern thought. In Buddhist tradition red symbolizes activity, creativity, and life itself; in Hindu culture yellow signifies light, life, and truth. The particular hue of golden yellow that distinguishes *Harp* also stands for wisdom, revelation, and the state of the initiate as represented by the saffron-colored robes worn by Asian priests. Ireland's overriding choice to use mostly "noncolors," such as white, brown, and gray, represents a focused attention on making art without artistic connotations. As in traditional Zen art, which is largely colorless, it is a way of connecting with the true nature of experience without the distraction of superficially imposed elements. When color does appear in some of Ireland's earlier sculptures, such as the green in *Three Attempts to Understand Van Gogh's Ear in Terms of the Map of Africa*, it often has an anonymous institutional character, reinforcing Ireland's embrace of the mundane aspects of life.

The rich, saturated color of Ireland's more recent work can be seen in a series of small abstractly painted images and photographs that resulted from his 1993 trip to Skellig Michael (pp. 90, 91). The artist explains that he chose the color green to symbolize the land of Ireland and red to represent the sacrificial blood of Christ. The yellow and red that appear in *Flag of Spain*, 1992–94, and *Spanish Corner Cabinet*, 1977–97 (pp. 129, 131), signify the colors of Spain's flag and, according to the artist, refer to his travels in that country and the found artifacts that he incorporated into these sculptures.

In even more recent pieces, including *Cake Dome Vitrine*, 2000–01, and *Y.K.'s Corner*, 2001 (pp. 134, 135), Ireland has been working with the intense ultramarine

blue associated with Yves Klein. Combining blue pigment with a medium called Fixall, Ireland is revisiting his interest in process and making evident the means of creation itself. Like cement, Fixall is a powdered medium that, when mixed with water, becomes a liquid, and then transforms into a solid in about thirty minutes. The infinite ways this common hardware store material can be manipulated and allowed to slump and dry endlessly fascinates the artist. "I'm looking to expose the viewer to the fact that all things are potential materials for art," Ireland has explained. "It's something I have been doing for twenty years. If you do something for that long, it must be important to you."[118]

Ireland's decision to work with a blue so strongly identified with Klein acknowledges his regard for the French artist's ideas about using color to liberate the senses and intensify human experience. Despite the oft-cited theatricality of much of Klein's work (having nudes roll in blue pigment and then "paint" their bodies on paper), the artist was deeply spiritual and influenced by Zen as well as Rosicrucian, occult, and alchemical theories. But Klein's spiritualism, like Ireland's, was decidedly undogmatic and rooted more in a belief in the importance of transcending limits and conquering unexplored territories. His repeated use of deep blue in his monochrome paintings was a means of evoking the indefinable sense of space and the boundlessness of the universe and, in turn, intensifying the actualities of experience. As he often expressed in a favorite quote taken from the writer Gaston Bachelard: "First there is *nothing*, then there is a *deep* nothing, then there is a blue *depth*."[119]

In a work such as *Y.K.'s Corner*, Ireland expresses his shared interest in the heightening of human awareness, although his means are radically different. The piece consists simply of a blue blob of Fixall, not more than nine inches long and three inches across, installed in the corner of a room. The idea behind the work, which is one Ireland has previously addressed, is to alter or aggravate an environment and, through this process, intensify the viewer's consciousness of space and existence. It is

an exercise giving visual form to Lao Tzu's lesson about the importance of emptiness. The usefulness of a water pitcher, as signified in Ireland's sculpture *No Mind in Things*, 1989 (p. 136), dwells in the void where water may be put, not in the form of the pitcher or the material of which it is made. This awareness of emptiness is Lao Tzu's metaphor for the uncluttered mind that is critical for the attainment of enlightenment—and it is this that Ireland strives to make clear with his homely blue knurl stuck in an empty corner of a room. Emphatically rejecting the glorification of the art object, Ireland wants to deobjectify it, to reemphasize the belief that art does not depend on visuals alone, but on the full sensibility of experience that affects the viewer. As the Zen monk Te-shan Hsüan-chien observed: "Only when you have no thing in your mind and no mind in things are you vacant and spiritual, empty and marvelous."[120]

Throughout his years working at 500 Capp Street and subsequently in the Oakland studio that he established in 1990 (p. 190), Ireland has continued to experiment with new ideas and reexamine old ones. Indeed, altering previous work and recycling objects from one sculpture into another are done frequently by the artist, freely and without constraint. His *Broom Collection*, 1978, for instance, was later given a boom to help stabilize the work and was retitled to reflect this fact; an empty white cabinet that was exhibited in one gallery installation appears in another filled with logs. Ireland has also often talked of his interest in reconstituting the capillary action in *Harp* and, at one time, the concrete-filled pitcher used in *No Mind in Things* was exhibited vertically in an installation titled *Cascade*, 1989. Such gestures clearly underscore the highly experimental approach that Ireland brings to his work and the Zen belief that no form or experience is absolutely fixed. "One of my pleasures is to have the privilege to move things around until [I] find a place that [I] think the work is resolved at the moment," Ireland has commented. "[It] doesn't mean that it won't change in the next moment or next period of time. It's the idea that you keep looking for a different resolve, are constantly on the lookout, even

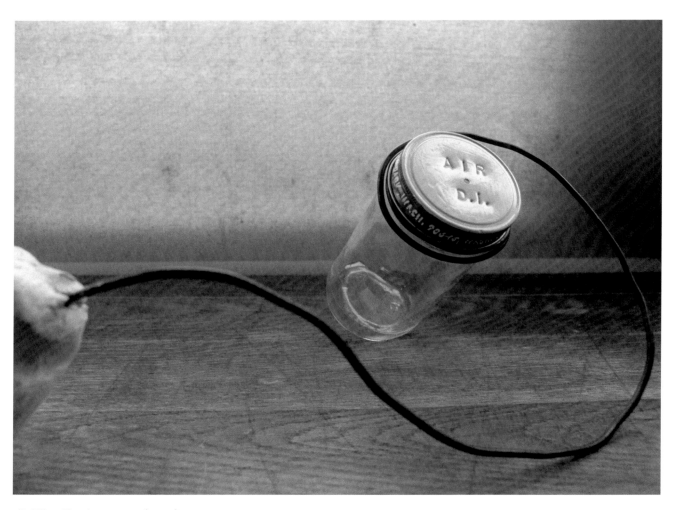

Air Where You Are, ca. 1990 (cat. 71)

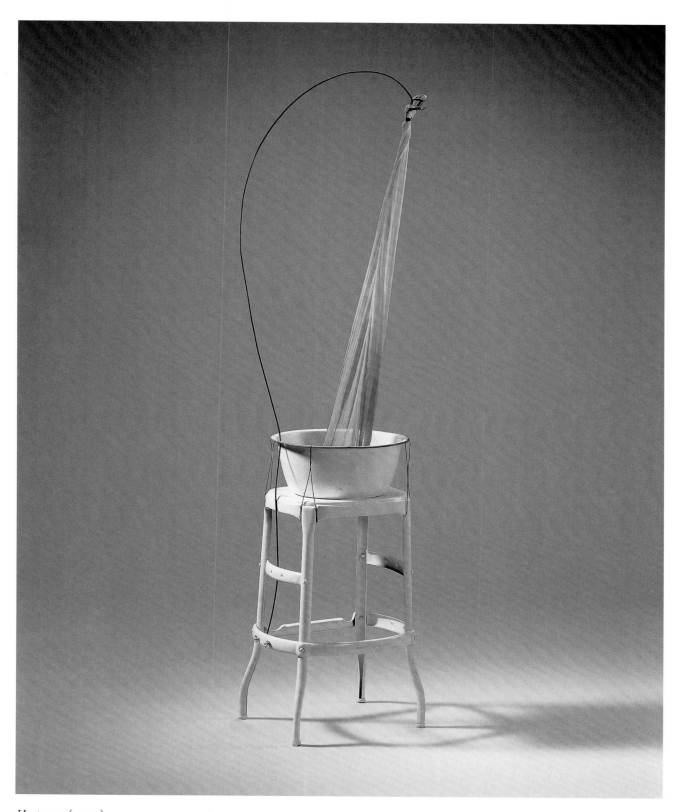

Harp, 1991 (cat. 75)

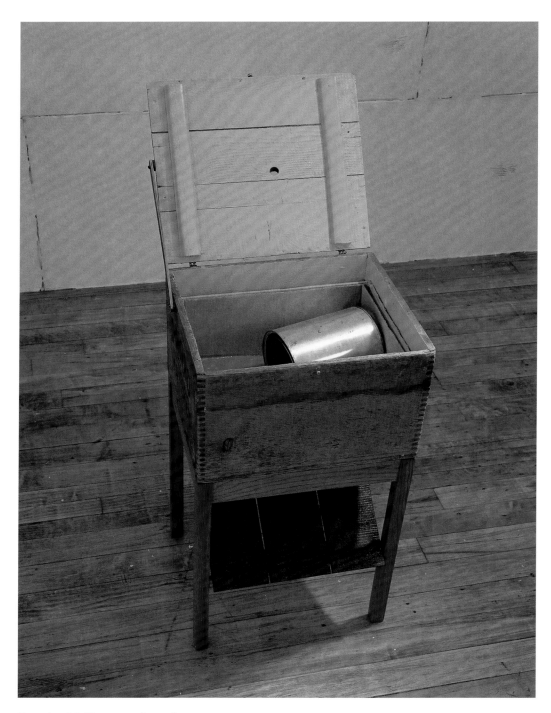

Intentional Spill, 1990–91 (cat. 72)

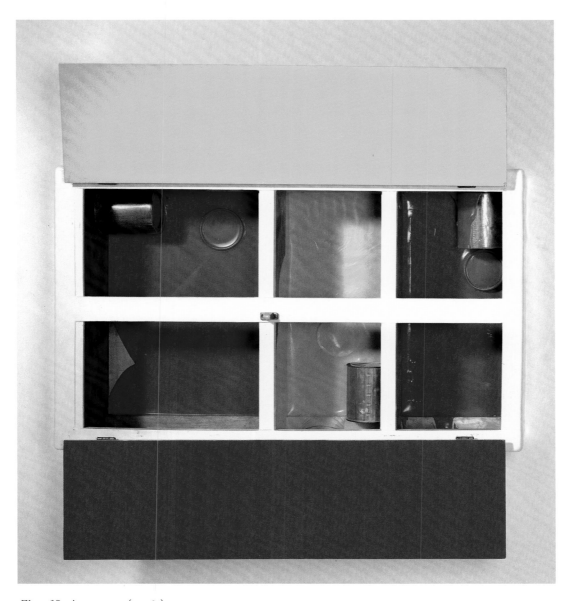

Flag of Spain, 1992–94 (cat. 87)

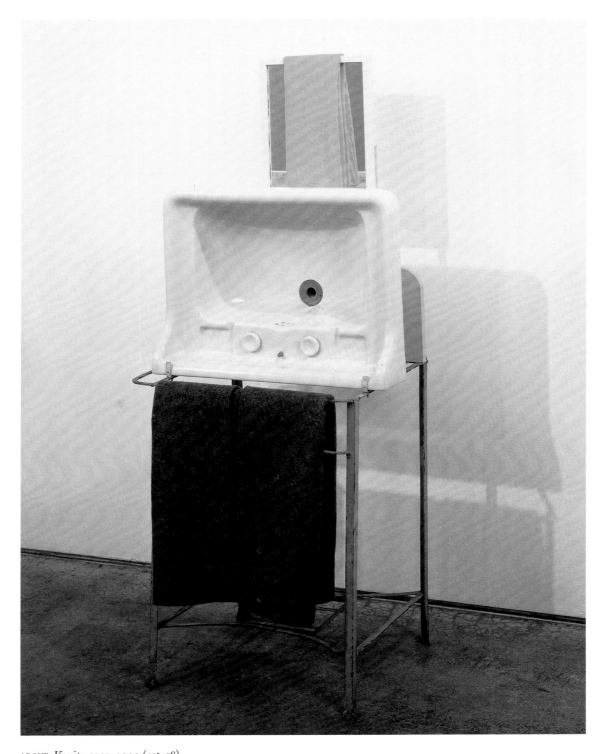

ABOVE: *Vanity*, 1991–2000 (cat. 78)

OPPOSITE: *Spanish Corner Cabinet*, 1977–97 (cat. 28)

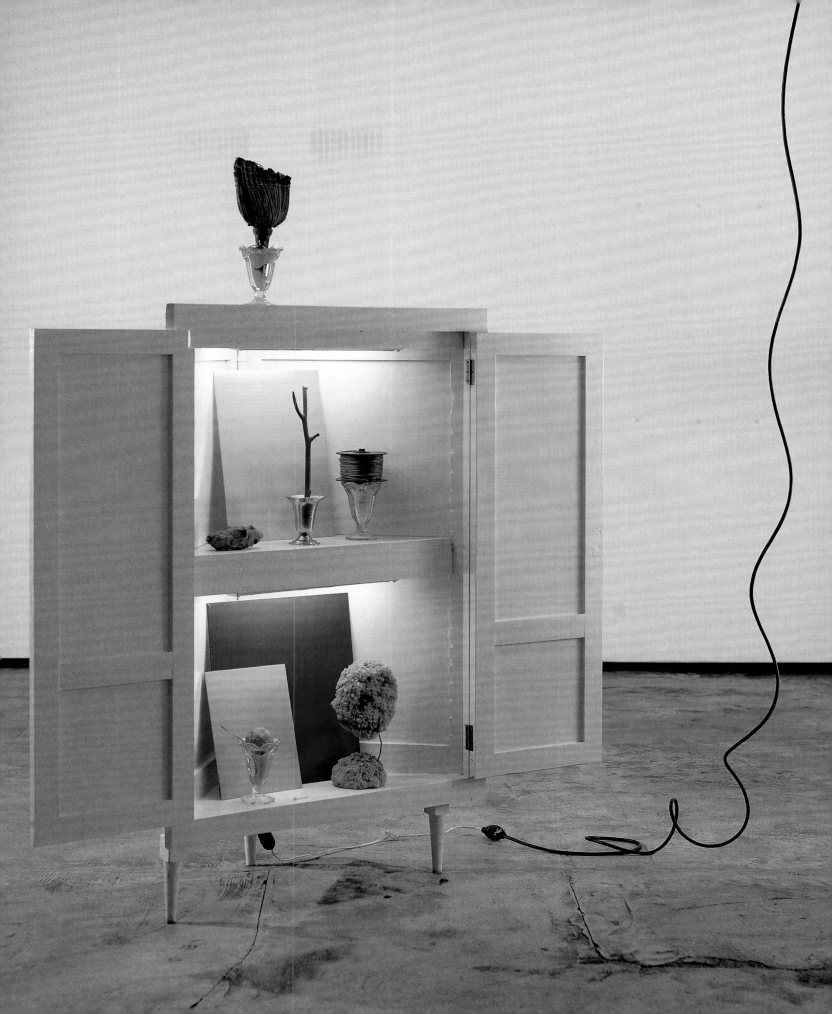

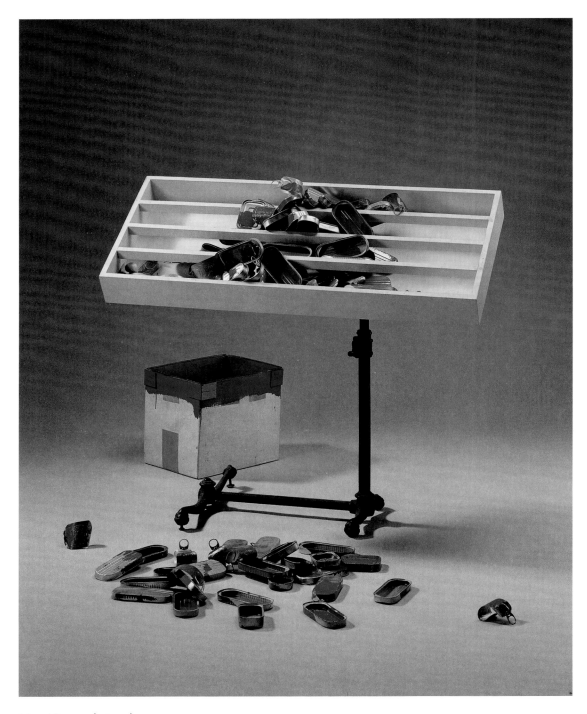

Marcel B., 1994 (cat. 102)

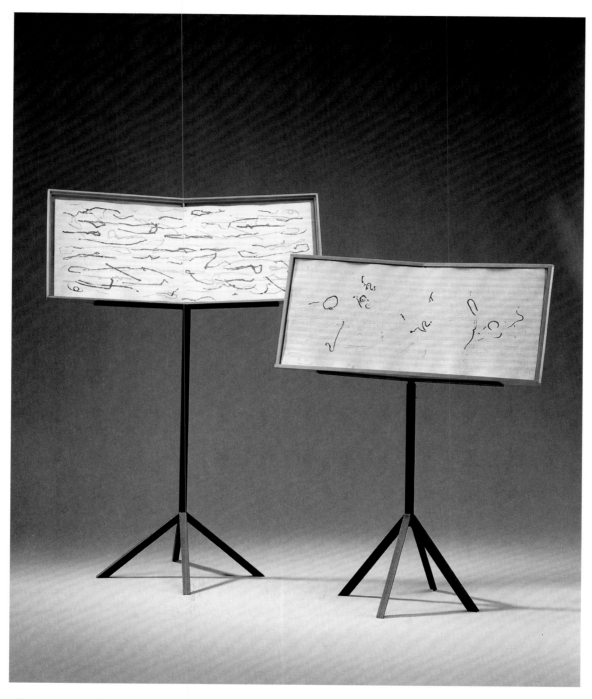

A Variation on 79, Side to Side Passes of a Dumbball, Dedicated to the Memory of John Cage (1912–1992), 1993 (cat. 96)

Cake Dome Vitrine, 2000–01 (cat. 124)

Y.K.'s Corner, 2001 (cat. 134)

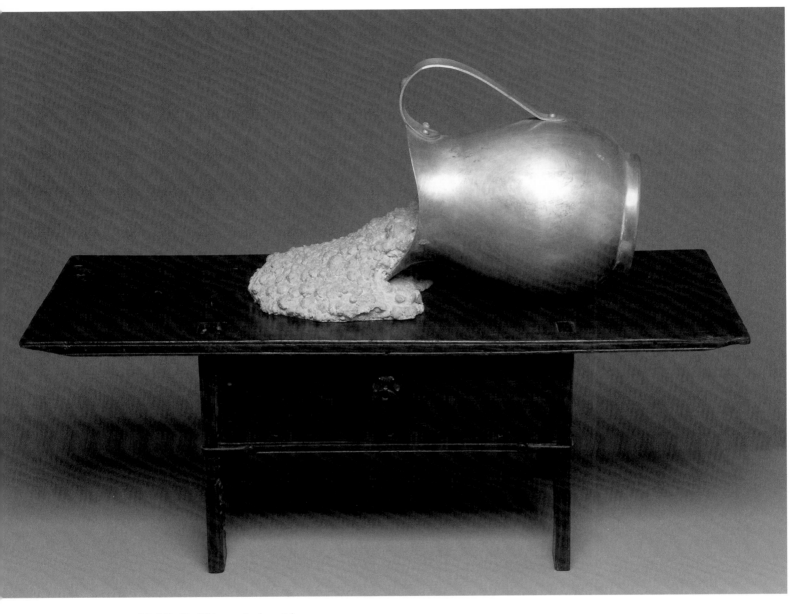

No Mind in Things, 1989 (cat. 67)

though you don't know you're on the lookout."[121] This is the "unknowing space" so important to Ireland's creative process. As he affirms, "I like to not know because that's when I can move ahead."[122]

IN SURVEYING THREE DECADES of Ireland's work, how best can it all be characterized? Unlike some artists, Ireland has no identifiable signature style with which he can immediately be linked. His manifestly frank and often seemingly uncultivated work seems also to bypass concerns for craft, technique, and the finesse so often associated with the visual arts. Nor is it easy to track his work in a chronological and evolutionary manner as art historians and curators are habituated to do. But truth be told, such concerns are far from Ireland's thoughts and intentions. Indeed, the artist has an extraordinary tolerance for ambiguity, sometimes admitting that he, himself, is unclear about the meaning of his art and where it is taking him. He readily admits, as well, to intentionally defying the traditional values associated with the fine arts. As he commented very early in his artistic career, "You have to understand that you can only do something for the culture by giving it what it can't swallow. When you give it what it can swallow, then you are only trying to get approval for yourself; you're doing nothing for the culture."[123]

More than twenty-five years have passed since Ireland made these observations, yet the heart of his words still ring true to his intent. In a recent interview he elaborated: "What makes a piece successful for me is when the viewer is totally ill-equipped to understand why a piece of concrete that I find on the street should be significant. . . . When I see them getting close to understanding it, then I want to push it farther away from their grasp. You're on the cutting edge and you want to continue to be on it, maybe at some sacrifice to yourself. If you believe in something, that belief should get richer for you all the time. If someone comes up and says, 'This is beautiful,' then I think, 'What can I do to make it not beautiful?' We take to our experiences our histories, where we come from, where we've been. I

think the idea is to challenge those things that allow us to participate in a piece of work."[124]

As Ireland makes clear, his entire creative energy has been aimed at expanding and intensifying human awareness—revealing the art of being in the world. Above all, he wants to awaken within himself and the viewer the capacity to see, feel, and think very differently from the way one is normally accustomed to. His outlook is based on an unending curiosity about the world and the ultimate acceptance of it. The commonplace, could we but see it, he suggests, is just as extraordinary as the highest aesthetic consciousness conceivable.

What Ireland is critically involved with, whether working on a grand or a small scale, is a mental construct that does not allow him to segregate and value one particular thing over another. How reasonable is it, he queries, for art to be part of the world and yet not directly involved with it, actually somehow superior to it? If we are unable to accept the world as it is, this is because our senses are closed and our minds are filled with preconceptions. Thus what we *expect* of Ireland's art is often contradicted by what we actually *experience* in his work, which can be surprising, crudely crafted, and puzzling, at best. But if the world is accepted to be perfect as it is—which Ireland believes it to be—it is not necessary to demand that it should improve or be different. In turn, art is no longer required to provide a surrogate or alternative experience for us.

Many will find this philosophy hard to accept, and for those willing to acknowledge Ireland's wisdom, his work sometimes still remains elusive and baffling. Even Ireland admits that his search for clarity has been an ongoing challenge, as his art is based on an intuitive process that cannot always be rationally explained. Permeating his work and thought process is the denial of the existence of absolute values and the renunciation of the notion that art must be reasonable and logical. What matters more is the artist's will to discover. For Ireland, the challenge is not so much a matter of making art as it is the allowance of vision.

Notes

1. David Ireland, quoted from *Inside 500 Capp Street: An Oral History of David Ireland's House,* a videotaped oral history conducted in the fall of 2001 by Suzanne B. Riess, Regional Oral History Office, The Bancroft Library, University of California, Berkeley, p. 55. Courtesy of The Bancroft Library and San Francisco Museum of Modern Art. This oral history provides an important body of information about the artist's life and work, particularly as it focuses on his home at 500 Capp Street in San Francisco. Quoted information that appears in this text was taken from the final draft of the oral history reviewed by the artist and being prepared for 2003 publication. I am very grateful to Ms. Riess for generously sharing this information with me and to Richard Greene for his support of the project. The oral history transcript and one-hour videotape are made available through The Bancroft Library.

2. "Talking with David Ireland/An Art of Ideas," *West* (San Francisco) 1 (winter 1994/95), p. 15.

3. Ireland made these observations in an undated letter to his parents (personal archive of the artist).

4. Author's interview with the artist, 16 May 2002. My deep appreciation to David Ireland for the numerous discussions we had over an extended time period as I prepared for this publication and exhibition.

5. Ireland made these observations in an undated letter to his parents (personal archive of the artist).

6. Unpublished interview with the artist by Denise Domergue, 27 November 1982 (personal archive of the artist).

7. Ireland described these activities in an undated letter to his parents (personal archive of the artist).

8. Laszlo Moholy-Nagy, *Vision in Motion* (Chicago: Paul Theobold and Company, 1961), p. 57.

9. Ireland in a lecture at the San Francisco Art Institute, 17 March 1987. An audiotape of the lecture is in the school's archive. I am grateful to Jeff Gunderson for making it available for my research purposes.

10. "David Ireland Interview," *Headlands Art Center* (Sausalito, Calif.) 2 (winter 1986), n.p.

11. Author's interview with the artist, 16 May 2002.

12. Ireland lecture at the San Francisco Art Institute, 17 March 1987.

13. Author's interview with the artist, 24 May 2002.

14. Ernest Hemingway, quoted in Linda Wagner-Martin, ed., *A Historical Guide to Ernest Hemingway* (New York: Oxford University Press, 2000), p. 10.

15. Ireland had initially hoped to attend graduate school at Stanford University, where Nathan Oliveira was teaching.

16. Suzanne B. Riess interview, p. 97.

17. "Talking with David Ireland/An Art of Ideas," *West,* p. 15.

18. Unpublished interview with the artist by Karen Nelson and Karen Tsujimoto for the Oakland Museum of California, 17 August 1999, n.p.

19. Ireland has sometimes referred to these as "anthiotic shapes," although no such term actually exists.

20. Suzanne B. Riess interview, p. 153.

21. Quoted in Robert Storr, *Robert Ryman* (London and New York: Tate Gallery and The Museum of Modern Art, 1993), p. 18.

22. Tom Marioni, "1979 Manifesto," *Tom Marioni Sculpture and Installations 1969–1997* (San Francisco: Self-published, n.d.), p. 13.

23. Sol LeWitt, "Paragraphs on Conceptual Art," in Alexander Alberro and Blake Stimson, eds., *Conceptual Art: A Critical Anthology* (Cambridge, Mass.: MIT Press, 2000), p. 15.

24. Ibid., p. 13.

25. See Joseph Kosuth, "Art after Philosophy," in *Conceptual Art: A Critical Anthology,* pp. 158–75.

26. Unpublished interview with the artist by Trudi Richards, August 1976, p. 1 (personal archive of the artist). Richards interviewed Ireland in preparation for his 1976 exhibition at the Whatcom Museum of Art and History, Bellingham, Washington. Part of the interview was edited and included in the exhibition brochure. The original transcript of the audiotape is heavily edited and inconsistently marked with page numbers. When page numbers appear in the transcript, they are the ones referred to in this and subsequent citations.

27. Ibid., pp. 8–9.

28. Ireland has indicated that he was not influenced by the work of artists such as Mark Tobey, Morris Graves, and Kenneth Callahan, despite his connections to the Pacific Northwest and these artists' strong associations with Eastern thought.

29. Letter from the artist to Frances Hill, 25 January 1975 (personal archive of the artist).

30. Shunryu Suzuki, *Zen Mind, Beginner's Mind,* 28th ed. (New York: Weatherhill, 1992), p. 21.

31. Interview with the artist by Trudi Richards, *David Ireland* (Bellingham, Wash.: Whatcom Museum of Art and History, 1976), n.p.

32. Ibid.

33. Quoted in Alan Watts, *The Way of Zen* (New York: Pantheon Books, 1957; reprint, New York: Vintage Books, 1989), p. 115.

34. Alan Watts, *The Spirit of Zen* (New York: Grove Weidenfeld, 1958), p. 19.

35. Thomas Albright, "Vivid, Bright Bay Art," *San Francisco Chronicle,* 22 August 1974, p. 44.

36. In New York Ireland met up with his San Francisco friend Frances Hill, who was then working as an actress.

37. Trudi Richards interview (unpublished), p. 9.

38. Suzanne B. Riess interview, p. 156.

39. David Ireland, artist's statement in *18 Bay Area Artists* (Berkeley: University Art Museum, University of California, 1977), p. 12.

40. Trudi Richards interview in *David Ireland,* n.p.

41. Portions of this manuscript have been adapted from my essay "Art Redefined: The Work of David Ireland," that appeared in the exhibition catalogue *David Ireland: A Decade Documented, 1978–1988* (Santa Cruz, Calif.: Mary Porter Sesnon Art Gallery, University of California, 1988).

42. Alan Watts, *Still the Mind* (Novato, Calif.: New World Library, 2000), p. 95.

43. Trudi Richards interview (unpublished), n.p.

44. Ibid.

45. The heading "You can't make art by making art" appeared on a poster produced for Ireland's 1980 exhibition at the Libra Gallery, Claremont Graduate School (now University), Claremont, California. An earlier version of this conundrum was considered by Duchamp when he posed the question, "Can one make works which are not works of art?"

46. Trudi Richards interview (unpublished), p. 15.

47. Quoted in Alan Watts, *The Way of Zen,* p. 79.

48. Quoted in Thomas Albright, *Art in the San Francisco Bay Area, 1945–1980: An Illustrated History* (Berkeley and Los Angeles: University of California Press, 1985), p. 255.

49. Trudi Richards interview in *David Ireland,* n.p.

50. Karen Nelson and Karen Tsujimoto interview, 17 August 1999, n.p.

51. Author's interview with Marioni, 7 June 2002.

52. Audiotaped interview with the artist by Diana Krevsky, 1983. An edited version of this interview, "David Ireland's Art/Sound/Ideas," was aired on 8 March 1983 as part of the weekly series "Art Scene/Art Sound," KUSF-FM, San Francisco. I am grateful to Diana Krevsky for making the tapes available for my research purposes.

53. Quoted in Diane Dorrans Saeks, "At Home with Artist David Ireland," *San Francisco* 23 (July 1981), p. 71.

54. Ibid.

55. Ireland has also made a punning Duchampian reference to both the 500 Capp Street house and television set: "Here is the house 'stripped by its bachelor.' Here is the television set 'stripped by its bachelor.'" Suzanne B. Riess interview, p. 120.

56. Quoted in Diane Dorrans Saeks, "At Home with Artist David Ireland," p. 71.

57. Suzanne B. Riess interview, p. 10.

58. Quoted in Arturo Schwarz, *The Complete Works of Marcel Duchamp* (New York: Delano Greenidge, 2000), p. v.

59. Ibid., p. 32.

60. Ibid., p. 33.

61. Quoted from text written by Ireland that appeared on a 1978 exhibition poster announcing an open house at 500 Capp Street.

62. "David Ireland Artist's Statement," *Visions of Paradise: Installations by Vito Acconci, David Ireland, and James Surls* (Cambridge, Mass.: MIT Committee on the Visual Arts, 1984), n.p.

63. Ireland lecture at the San Francisco Art Institute, 17 March 1987.

64. In a 1982 San Francisco performance, Ireland detailed to the audience the trials and tribulations of his real-estate scheme which ultimately went awry and ended up costing more than he anticipated. Like 500 Capp Street, the performance piece reveals how Ireland merges life and art experiences.

65. Capp Street Project eventually relocated to different facilities in San Francisco, and the house was sold to a private party.

66. Thomas Albright, "The House as a Work of Art," *San Francisco Chronicle,* 24 November 1983, p. 75.

67. James Turrell, "Mapping Spaces (1987)," in Kristine Stiles and Peter Selz, eds., *Theories and Documents of Contemporary Art* (Berkeley and Los Angeles: University of California Press, 1996), p. 574.

68. Dan Flavin, "Some Remarks . . . Excerpts from a Spleenish Journal (1966)," in *Theories and Documents of Contemporary Art,* p. 125.

69. Quoted in Robert Atkins, "David Ireland's House," *Journal: A Contemporary Art Magazine* (Los Angeles Institute of Contemporary Art) 4 (spring 1983), p. 58.

70. Quoted in Denise Domergue, "By Artists/For Artists," *House & Garden* 157 (August 1985), p. 134.

71. Denise Domergue made this observation when writing about *Jade Garden* in the August 1985 issue of *House & Garden,* p. 132.

72. Quoted in Robert Atkins, "Light Motif," *California Magazine* 8 (September 1983), p. 88.

73. Quoted in Bill Berkson, "David Ireland's Accommodations," *Art in America* 77 (September 1989), p. 185.

74. Quoted in Robert Atkins, "Life Studies," *Elle* 4 (December 1988), p. 52.

75. "David Ireland Interview," *Headlands Art Center,* n.p.

76. Ibid.

77. Artist's statement in "David Ireland," *The Visual Artists Awards* (Pasadena, Calif.: Flintridge Foundation, 1998), p. 14.

78. Marie-Louise Lienhard, "You Can't Make Art by Making Art," *David Ireland in Switzerland: You Can't Make Art by Making Art* (Zurich: Helmhaus, 1991), n.p. I am grateful to Ms. Lienhard for providing a translation of her essay for my research purposes. This text also appears in *Parkett* 29 (1991).

79. Robert Smithson, "A Sedimentation of the Mind: Earth Projects," *Artforum* 7 (September 1968), p. 46.

80. Ibid., p. 50.

81. Ireland lecture at the San Francisco Art Institute, 17 March 1987.

82. Robert Smithson, "A Sedimentation of the Mind," p. 45.

83. Quoted in Jane Levy Reed, "David Ireland: Skellig," *David Ireland: Skellig* (San Francisco: Ansel Adams Center for Photography, 1994), n.p. My thanks to Ms. Reed for sharing her research with me.

84. Quoted in Steven Jenkins, "A Conversation with David Ireland," *Artweek* 25 (7 April 1994), p. 16.

85. "Talking with David Ireland/An Art of Ideas," *West,* p. 21.

86. The vitrine is one that Ireland acquired from the Field Museum of Natural History, Chicago, and which came from its inventory of retired and outdated exhibition furniture.

87. Author's interview with the artist, 23 March 2001.

88. Quoted in Thomas McEvilley, "Mute Prophecies: The Art of Jannis Kounellis," *Jannis Kounellis* (Chicago: Museum of Contemporary Art, 1986), p. 118.

89. Kenneth Baker, "Two New Outlooks on Conceptual Art/Idea-Centered Pieces Make a Comeback," *San Francisco Chronicle,* 31 July 1996, p. E1.

90. "Talking with David Ireland/An Art of Ideas," *West,* p. 19.

91. While preparing for this essay, the artist expressed his preferred spelling of the word "dumbball."

92. Suzanne B. Riess interview, pp. 47–48.

93. David Ireland, "Memoir: Transvaal (1957)," *The Three Penny Review* 4 (spring 1983), pp. 26–27.

94. Partaking of a cup of tea is also integral to Zen and Taoist practice.

95. Quoted in Caroline Drewes, "The Lighthouse: Artist David Ireland Resides within His Art," *San Francisco Examiner,* 7 January 1987, p. E7.

96. David Ireland, *18 Bay Area Artists,* p. 12.

97. When Ireland exhibited this work in 1987 at the San Francisco Art Institute (p. 78), the elephant ear was installed in a reversed position. The artist has subsequently decided that the ear should be installed to mimic the shape of Africa (p. 177).

98. Suzanne B. Riess interview, p. 212.

99. Lawrence Rinder, "'Get off the Knowing . . .': An Interview with David Ireland," *University Art Museum Calendar* (Berkeley) (November 1988), p. 3.

100. See Jennifer Gross's essay for a detailed discussion of two stories that Ireland wrote to accompany the chair.

101. Lao Tzu, *The Way of Life,* trans. R. B. Blakney (New York: Mentor Books, 1964), pp. 102, 117.

102. The chairs were shown in the 1983 exhibition *David Ireland: Tableau* at the Leah Levy Gallery in San Francisco.

103. The chairs also exist in a red version splattered with yellow paint.

104. Denise Domergue interview, n.p.

105. Quoted in Richard Armstrong, *Artschwager, Richard* (New York: Whitney Museum of American Art and W. W. Norton, 1988), p. 13.

106. Ireland has specifically mentioned Robert Ryman's work in this regard.

107. Unpublished transcript of a 1995 lecture by the artist at the Nora Eccles Harrison Museum of Art, Utah State University, Logan. I am grateful to Susanne Lambert for providing the transcript for my research.

108. "Talking with David Ireland/An Art of Ideas," *West,* p. 19.

109. Suzanne B. Riess interview, p. 92.

110. Ibid., p. 14.

111. Diana Krevsky interview.

112. Ireland "played" the piece in a San Francisco group performance, *The Art Orchestra,* organized by Tom Marioni and presented at the California Palace of the Legion of Honor in 1997. For the performance Marioni gathered together a number of Bay Area artists and colleagues, each of whom made his or her own instrument. In the performance Ireland simply dumped the tins directly on the floor.

113. Karen Nelson and Karen Tsujimoto interview, 17 August 1999, n.p.

114. Quoted in Arturo Schwarz, *The Complete Works of Marcel Duchamp,* p. 83.

115. Author's interview with the artist, 13 June 2002.

116. Ibid.

117. Ibid.

118. Quoted in Pamela Feinsilber, "Portraits Power/Power Portraits," *San Francisco* (February 2000), p. 26.

119. Quoted in Sidra Stich, *Yves Klein* (Stuttgart: Cantz Verlag, 1994), p. 78.

120. Quoted in Alan Watts, *The Way of Zen,* p. 131.

121. Suzanne B. Riess interview, p. 118.

122. Ibid., p. 129.

123. Trudi Richards interview (unpublished), n.p.

124. Suzanne B. Riess interview, p. 202.

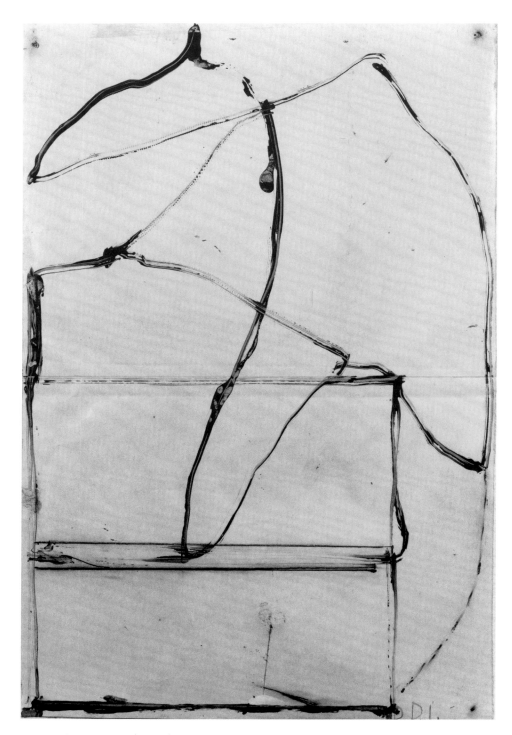

Meandering Line, 1999 (cat. 119)

Wire Wall Drawing, 1996 (cat. 110)

Caramel with Rounded Edges, 2001 (cat. 128)

Drawing with Splotches, 2000 (cat. 121)

26 Holes, 2001 (cat. 131)

Perimeter of Holes, 2001 (cat. 130)

Caramel Point, 2001 (cat. 127)

Two Hole Drawing, 2001 (cat. 132)

Jennifer R. Gross

CONSIDER THE OBJECT AS EVIDENCE

IN 1978 DAVID IRELAND created an object, *Three-Legged Chair* (p. 150), its history woven from fact and fiction, its form a humble conflation of literary and sculptural artifice brought together to identify found value and poetic expression. This work had a provisional status as art in the eyes of most of his peers as it was neither formally nor conceptually pure, but a hybrid of these two artistic approaches, which were seen at the time as representing conflicting aesthetic values. Ireland's object was built less by his hand than by his desire to answer questions about art and life. This method of realization, the following of processes formed by an idea of what art could be in direct response to the material world, would become the mainstay of Ireland's artistic practice over the next twenty-five years.

This three-legged chair, while missing the lower half of one of its spindle legs, possesses two distinctive features of Ireland's mature work. It is an object with a history singled out by the artist's choice and one whose primary identifying characteristic as art lies not in its ability to enthrall the viewer in a physical or metaphysical experience but rather in its conceptual competency as it provokes a series of questions and a number of associative perceptions. The chair's distressed dark surfaces bubble, and along with its missing seat and leg, provide a visual sign of the object's past. At the same time its brightly painted yellow spindle and the red book chained to it signal Ireland's unassuming poetic claim on an otherwise ordinary object. Why this chair? What is its

value? Time has impressed itself upon this object, leaving it worn and flawed. Is it therefore offering primarily historical evidence, as a relic of a more significant past life, or does it offer a present experience of life, a perch for our cultural curiosity?

This aesthetically re-cognized object had been re-dressed, although not restored. The painted spindle joins the two adjacent dowels but does not extend to the floor. However, the wholeness of the upper joint, emphasized by its color, provides just enough stability for the chair to support itself, seemingly in defiance of gravity. Its current aesthetic objectivity stands as the contemporary correlative to its past usefulness.

Propped against the back of the chair and the remaining frame of the seat is a red book entitled *David Ireland's House,* a volume that, according to Ireland, holds two stories, "one which was told to me and one which I experienced." Even after reading both stories, the viewer is unsure how Ireland differentiates between that which is heard and that which is experienced. These parallel narratives about things that are missing a leg offer little clarification of the history or meaning of the chair. Despite this, the two accounts do achieve something. They create an intellectual platform from which the viewer is able to consider the value of this object within the context of systems that exist outside aesthetics. The red herring of knowledge gives way to experience. Ireland has set us up to consider if art is cognizable or recognizable by the subjective standards the viewer brings to its forms. He has completed his task as an artist in that he has offered up this object as evidence of experience past, present, and future.

OPPOSITE: *Three-Legged Chair,* 1978 (cat. 29)

The book's first story tells of Ireland's reclamation of the chair as an artifact from the now famous reliquary, his home at 500 Capp Street in San Francisco. The previous owner, an accordion maker named Mr. Greub, had a penchant to collect homely detritus. In his renovation of 500 Capp Street, Ireland's initial focus was to rid the house of Mr. Greub's presence, until the artist discovered how compelling these objects were as evidence of inhabitance and subjective systems of valuation. Mr. Greub's Benjaminian practice of accumulation led Ireland for the first time to create objects that were sourced in the history of the house and its artifacts rather than his own personal experience. The best known of these pieces is Ireland's broom sculpture, a collection of thirteen or so years' worth of brooms assembled in a circle as an homage to their cumulative effect on the world. These worn tools are relics of Mr. Greub's labor; by reconfiguring them into a circle, Ireland turned them into a timepiece that marks the sum of incidental time and effort expended to make the house a habitation. Ireland's contribution was to make this "work" visible, to evoke a clearer representation of the fleeting reality that already existed in the worn brooms.

(It is important to note that much confusion has arisen regarding the centrality of 500 Capp Street to Ireland's oeuvre. Since the house was the primary source for his work for so many years and because he recycles materials sourced in the house from one work to the next, many have viewed the house as the locus and inspiration for all of his work. Although interpretations of Ireland's architectural interventions have emphasized their preservationist aspect, he has more frequently reenlivened older structures with historically mindful but thoroughly modern reinterpretations. Only his reclamation project at the Headlands Center for the Arts (1986–87) in Sausalito, California, has emulated the historical ambiance of the house. In fact, Ireland's approach to 65 Capp Street, begun immediately after 500 Capp Street, seems the complete inverse, almost obscuring any trace of the original structure.)

BUT LET US RETURN to the three-legged chair and its first narrative. This story reads like a sociologist's research notes taken to decipher the value systems of an unfamiliar civilization, interspersed with the interjections of an armchair jockey's psychological analysis of the players:

I told you that I would tell you of my determination to find out how this particular chair came to have a short leg, and you should know at the outset that it is a little complicated.

You see this house, my house, was owned for forty years by an accordion maker, his name is Paul. He is my elder and I still call him Paul, however not to his face.

Paul and his first wife came here many years ago from Switzerland. In fact, I thought they might be Swiss even before I knew it for sure because I found a Swiss coffee mug in that kitchen that Paul had left when he moved out. I suspected that Paul and his wife did not travel much. It was simply a feeling that I had. A neighbor told me that Paul was mean to his wife and he never gave her a new coat. When I heard that I knew that they could not have traveled much, even to Switzerland. They saved money though, and the same neighbor told me that Paul had a lock on the thermostat. He did this and he yodeled with a Swiss band at the Russian River on weekends. I asked Paul once if he had ever heard of some yodelers called the Moser Brothers. He said that he had, only they were Austrian.

When Paul moved out of the house I helped him lower a safe down the stairs. It was large and very heavy. I didn't want to help and I did. I did not want to tell Paul that I had a bad back or complain because he might be sore that I was buying his house. Paul tied a rope around the safe and we tried to slide it on boards down the stairway. I was holding the safe from below while Paul held it from above with the rope. When the going got difficult, Paul let go of the rope and I had to move quickly aside while the safe crashed into the wall and gouged out another piece of plaster. I still did not tell Paul that I was mad.

Paul moved to Menlo Park, and he took everything with him from the house that he thought was valuable. He left everything else with me. Since he was Swiss he overlooked taking the Swiss coffee mug. I would not have left it.

I called Paul several times in Menlo Park to ask him about things having to do with the house. What I was really after was information about a set of chairs that he had left me and particularly about one with a short leg. You must remember that Paul was a grouch and I had bought his house, and he was touchy. Once when I called I pretended that I wanted to know how to get onto the roof, and all the while that Paul was talking about the roof, I was wishing that he was telling me about the chair with the short leg. You would never call a European simply to ask about a chair, and certainly not one with a short leg.

Time was moving on, and if Paul had had three cataract operations there was no telling what would be next. Actually I was getting quite interested in the cataract operations, and for a short time I found my interest in the operations pulling a little ahead of my concern for the chair with the short leg. After recovering from this impulse, I decided that I would make my final call to Paul. I recognized too that I would not be able to call him forever, and I had to stop dithering and make my move.

When Paul answered my call, I went right past the usual formalities and my former interest in his cataracts and said, "Mr. Greub, you left a chair in the house, and it has a short leg; can you tell me about it." There was a long pause and I thought that maybe Paul would not answer, and I was thinking too that he might never answer because he was sorry that he had sold me his house. I was afraid of this, and still I knew that I had to take the chance. After all what could he do? He had signed the papers long ago. Finally, at the end of that space where you contemplate your entire life, Paul answered. And he said, "It doesn't matter." In the course of the next long pause I decided I would not tell Paul that he had left the Swiss coffee mug.[1]

This detailed account of the life of the three-legged chair seems quite believable. Based in Ireland's experience of purchasing and inhabiting 500 Capp Street, his attempt to find meaning in the origin of this object is transformed into a recounting of two individuals' mismatched systems of valuation and the thwarted attempt to reconcile them. In the end, the moral of the story

reveals that only Ireland's current interest, his identification of the chair, makes the object important and imbues it with meaning. The chair's history before his recognition is separate and seemingly irrelevant. The theme of perceptual awareness as a form of social morality, a system of valuation, arises again and again in Ireland's work and is emphasized as the artist's primary responsibility. The object gives evidence of what we wish to remember or find reconciliation with, and it is the physical presence of the chair as the result of the artist's choice that makes Paul's story, his life, significant to people he will never meet.

The second story in the red book strikes the reader as a real tale, one that Ireland is much more likely to have heard than experienced—that is, unless the reader happens to know that Ireland's life has been an artfully woven interface between the ordinary and the exotic. Once one knows that the artist was both an insurance salesman and an African safari guide and trader, what initially seems to be a fictional account registers as a melding of possible experience and engaging myth.

> [It] was a fellow art student years ago who told me that he knew of a tribe of dogs in Africa that only had three legs, and so when I got to South Africa, which I immigrated to in the fifties, after I had been there about six months, I said, "Come on, Mike, let's get this thing straightened out right now about the three-legged dogs," and so he said, "Okay, let's. When Easter vacation comes up, we'll go to 'Bechuanaland,' which is Botswana now, and I'll show you the three-legged dogs." So we in fact did go on a safari quest of the three-legged dogs. And we found a tribe of Ndebele type Africans with wonderful painted huts and there were maybe fifty dogs wandering around the village and all of them had three legs. And it turned out that they amputate a leg when the dog is born so that it doesn't run away.[2]

Like the three-legged dogs, Ireland's amputee chair is not about to run out of reach of its imbued significance. Held in place by the artist's will, more than by its connection to 500 Capp Street, it remains on hand as a

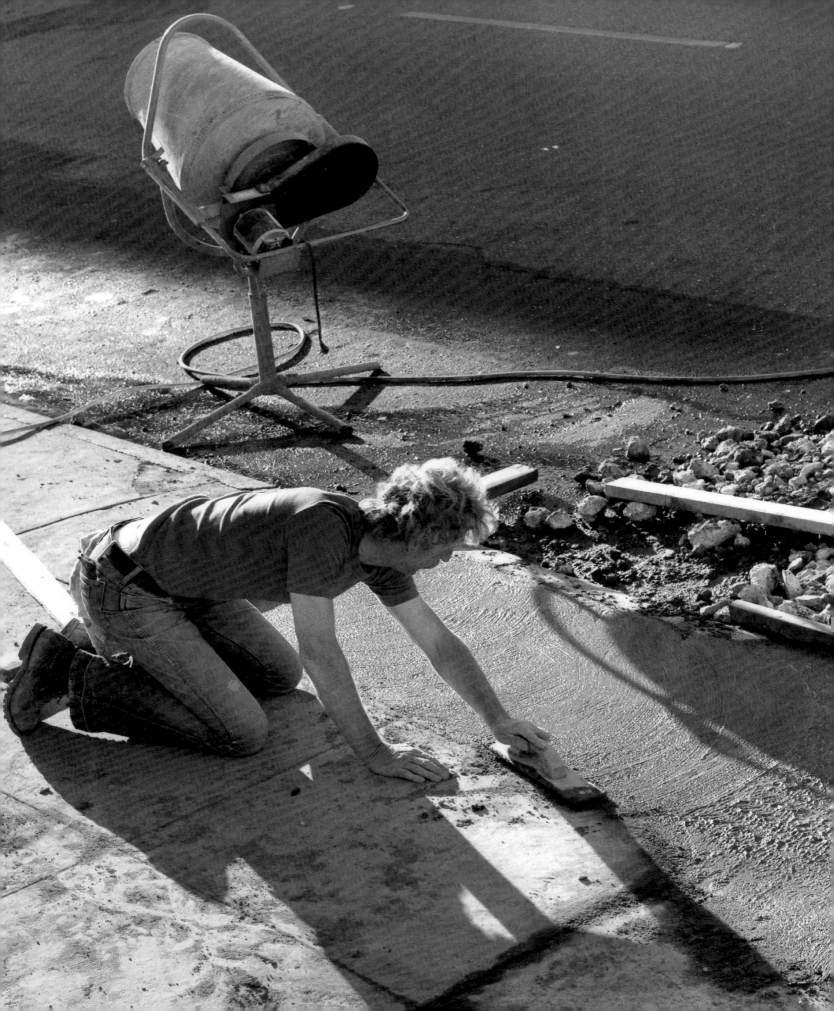

lame artifact of our culture, set aside by the artist's choice and thus placed into the history of art. Ireland's recounting of the chair's history in the two stories swings in tone from the plodding methodical inquiry of an insurance salesman to the intent quest of a hunter of exotic culture. Time will probably never clarify which history was told and which was experienced, but together they tell a truth about the experience of value in both art and life.

NOT LONG BEFORE IRELAND made this work, he had returned to San Francisco after living in New York for almost a year, ready at the age of forty-five to hunker down and hang his shingle as an artist, a commitment he had managed to put off for twenty or so years, as he meandered through art school, military service, world travel, marriage, fatherhood, insurance sales, as well as African trading and safari touring. The authenticity of living in the world has always been far more immediate to Ireland's experience of perception than the mysticism of the silent studio chamber. This pull toward the cultural authenticity of the human condition over the un-livedness of traditional art practices informed his approach to 500 Capp Street. Originally, he simply planned to tear down a number of walls to create a studio. His cleaning efforts, however, revealed the integrity of the building's form, which began to seduce him and educate him about its history. Within the context of the house, Ireland explored method and materials, as he had in his previous work, and came to see his alterations of the house as an artistic process. Through his demolition choices and artful sorting of trash, Ireland consciously distinguished between accumulation, recognition, intervention, destruction, and restoration.

OPPOSITE: Sidewalk repair, 500 Capp Street, San Francisco, 1976 (cat. 22)

The first work that honored his identification of the ordinary as an idea for art was the repair of the sidewalk outside 500 Capp Street in 1976 (p. 154). His preparation of the site, mixing and pouring of concrete, and subsequent restoration of the sidewalk were recorded on video by the artist Tom Marioni in order to document an event that would disappear underfoot. The work came about as a result of Ireland's annoyance when, as a new homeowner, he was called upon by the city to repair the sidewalk at his own expense. Ireland's profound sense of irritation at having this responsibility impinge on his studio time goaded him into questioning whether there was any difference between an artist's and someone else's repair of the sidewalk. The attitude brought to the activity, he concluded, determined whether it was art or not.

This realization became Ireland's personalization of Marcel Duchamp's well-worn dictum "This is a work of art because I say it is." Duchamp was the first artist to recognize that art should be based on something other than an arrangement of forms determined by taste. Yet, while Duchamp applied this principle to the selection of objects as an artistic enterprise, Ireland has extended it to sanction ordinary decisions and actions as aesthetic endeavors. For Ireland, the artist's nominal authority is less important than his ability to effect choice as a formative action that can render value into visible form. That he considers the assertion of ego a hindrance to creativity is clear in one of his assignments to graduate art school students:

METHODS OF INSINCERITY:
Attempt to do something not pre-meditated.
Intend non-intent.
Present something as a non-object.
Attempt to not focus your attention on what you
 are doing.
Be unconscious of all previous steps.[3]

He has refined these ideas into his own dictum identifying the problems imposed by the conscious mind on the making of art: "You can't make art by making art."[4]

ALREADY IN 1972 TO 1974, while in graduate school, Ireland had begun to question the role of the artist in the creative process. He started to weigh the relative value of the images created by his gesture and those generated by outside forces, such as entropy, as they acted upon materials. The images that had resulted from a series of anti-form drawing exercises in cement he had conducted continued to reflect his control and aesthetic while the images bubbling up from the cohesion and dissipation of the unfixed cement and dirt mediums were experienced by the artist as discoveries. He struggled to accept the idea that all choices—even one as simple as the selection of a material, not just those that resulted in a balanced, formally resolved image—could be considered the work of an artist. At the same time he was aware of how difficult it was to let go of the notion of the artist as a unique progenitor possessing a signature use of gesture, color or shape indicating his or her authorship.[5] Ireland's playful engagement with his discomfort at letting go of these emblems of the creator and creativity became a recurring theme in his work.

Questions about the artist's role and the nature of the art-making process permeated the San Francisco art scene in the early 1970s. There were exhibitions of temporal art and performance pieces by such non–Bay Area artists as Vito Acconci, Carl Andre, Mel Bochner, Daniel Buren, Sol LeWitt, Bruce Nauman, Barry Le Va, and Richard Tuttle. Moreover, in 1972 five Bay Area artists—Jim Melchert, John C. Fernie, Paul Cotton, Terry Fox, and Howard Fried—were invited to participate in *Documenta V* in Kassel, Germany. Their exposure to the work at *Documenta* expanded the discussion of Fluxus artists' work, especially that of Joseph Beuys, who attended *Documenta* for one hundred days and initiated his idea for a *Free International University* as an extended concept of art.

When Ireland moved to New York in 1974, he became exposed to an even broader range of artistic practice than he had encountered in San Francisco. While living in New York, Ireland studiously went to different galleries in an attempt to find new images for his work. What he saw convinced him that there were no magical formal moves that would help him create an image that would change the world. As he describes it:

> I had been going to different galleries, seeing everyone working in different materials, trying to find new images, new arrangements of line, of color, different formats. And in observing all this it occurred to me that an arrangement of lines, shapes or materials that was going to bring all art lovers, all mankind, to their knees was not to be found. That it was indeed folly to be searching for the painting, the drawing, that was going to do it. That realization was a wonderful thing because it freed me of the burden of looking for *the* image. All I had to do was accept some other things in place of the pursuit. That was when I started the *94-Pound Series*. From a 94-pound sack of cement, I made similar drawings each day until the material was exhausted. After that, I started the 94-pound discard, which was discarding a piece every day until they were gone.[6]

Working on paper and canvas with clay, cement, or dirt, Ireland evaluated his marks, his imprint on the world, weighing the value of his experience of the process of making art against the realization of an end product. In creating this "non-image" series, Ireland came to choose concrete as his central medium for a number of reasons. He admired its universality and also how it did not call attention to itself as an important or particularly aesthetic material. The gray color of concrete, combined with its cultural associations, made it a perfect "non-painting" surface. Concrete also possessed an alchemic allure. The ability to transform it from a solid to a liquid and back signified the type of transformation of the real Ireland hoped to achieve in his work (p. 157).

The non-image series expressed Ireland's discomfort with the disparity between the veracity of experience available through art and that attainable in the everyday real world. His presentation of the nondescript material of concrete, free from the presence of the artist's body or mark, was Ireland's flat footed way to call attention to matter and away from his presence in his art. Through this practice Ireland was putting off the precedent set by

David Ireland with cement drawing, New York, 1975 (fig. 10)

abstract expressionists like Jackson Pollock, who implicated their bodies into their work to insert the real into their paintings, work that dominated Ireland's New York museum-viewing experience. His initial use of concrete to add a grainy textural experience to the visual consistency of the monochromatic field of the painting surface gave way to recognition that the rectangular work hanging on the wall in front of him was an object that he was already experiencing as a painting, that it was already both in the real world and art. Through this revelation Ireland came to understand that every object considered within the realm of aesthetics is measured against a formal standard set by painting and is consequently experienced as illusion. As he later explained, with reference to his "elephant chairs" (p. 45):

> I had this thought of translating a traditional object into another material. . . . I called [these "elephant chairs"] paintings and I showed them so that when you came into the exhibition space, the chairs were lined up so you could only see them from behind. You saw them as objects rather than subjectively and you had to go up and walk around them and mingle with them before you could identify them as chairs. They were seen initially as objects. They were in a dark room, illuminated by spotlights. So they were these hulks that looked more like elephants than anything. But I was interested in calling them paintings because it was that painting in its traditional historic sense is an illusion of something. It's an eastern idea if you're a devout sort of Buddhist or Hindu, you're prepared to believe that everything is illusion. So what's the difference between painting being illusion and some other object being illusion as well. It's all illusion. So I felt privileged to call this painting the same as illusion. I started treating them as paintings in building up the surface in a variety of colors and I made quite an issue of painting them. . . . I didn't want you to have to look at the chair in the context of a normal scale chair.[7]

Ireland pursued other formal strategies to strip away the artifice of habitual art viewing and to bring the viewer closer to the ordinary. The small rectangular windows or focal points that he cut out of the picture plane of his monochromatic works from the mid-1970s integrated the window *onto* art *into* it, luring the viewer's eye through the visual field to the wall on which the work was mounted (pp. 26, 27, 30). In this way Ireland emphasized the place of art in the world, since both sides of the picture plane could be recognized as residing in the same physical space as the viewer. When the art (the cement or wax-paper surface) was the literal frame for the focal point of the art experience—a hole, or a void— the illusionary experience of the work became a visual double-negative. The literalness of these windows onto "the world" confounded normal art viewing—formally and conceptually integrating a sense of play between the real and the aesthetic.

In subsequent projects Ireland has drawn viewers' attention away from engagement with art they are prepared to see and toward the discovery of seeing itself. Ireland's wallpaper patties, which he calls "untitled identified objects," are the clearest example. These mud or wallpaper splats are usually installed in a corner, high up on a wall, so they are not noticed as art (p. 44). According to Ireland, they were inspired by the manure patties he saw on his travels in Asia: "The children, probably, put these patties on the sunny side of their house, and then when the sun bakes them they pop them off and they start a fire with them and cook their next meal, so they're kind of recycling."[8] Ireland's patties are also recycled materials used as "fuel," but in this instance in order to spark an aesthetic experience. These patties are so thoroughly abject, so clearly useless, that they release us from our limiting expectation of aesthetics. Often, out of desperation, viewers come to look closely at anything near the patties in an attempt to make sense of such base objects as art.

Ireland's patties have a great affinity to Richard Artschwager's blps, with which Ireland was certainly familiar. (In 1967–68 Artschwager taught for a term at the University of California at Davis.) As one art writer has explained, "A blp is a pointer that indicates 'look here.' It calls attention to its surroundings, which, no matter how raucous or sedate, seamy or banal, suddenly

find themselves the subject of a second glance, and even possibly worth remembering."[9] In Artschwager's words, "The fact that it is literally useless is one of the blp's most important functions. . . . It is a mindless invasion of the social space by a logo-like, totally useless art element. It is small, has high visibility, relentlessly refuses to give up its uselessness. It is an instrument for useless looking. Being of small size and high visibility it converts the immediate surrounding over to The Useless. That is its 'function.' It gets about as close to pure art as one can get."[10]

Ireland's own interest in the power of the incidental actually began when he was an undergraduate art student in 1951, when he made a Christmas tree mobile (p. 160) that his parents permitted him to hang in their living room for the holiday. It was extremely significant to Ireland that his parents invited him to bore a hole in the ceiling of their home so that he could so prominently display his art. The aura of this moment of the integration of his life and his art stayed with him for years: "Every Christmas after that I could always go and rub my finger over that little hole in the ceiling, the hole was patched, but I could see that little bump in the spackle where it had been patched, and I could say 'Yes, that's where the mobile was.' And I could rub the ceiling."[11] The magic of that moment moved into Ireland's field of vision the potential for art to aesthetically engage the real world.

Through his discovery that there was no ultimate image to pursue in art, Ireland became conscious of his art as a procedure that was the result of a series of choices made in response to materials. Works by artists who had addressed similar concerns, such as Eva Hesse, Lynda Benglis, Barry Le Va, Robert Morris, Richard Serra, and Robert Smithson, were widely exhibited and discussed in the late 1960s and early 1970s in New York. The exhibition *Anti-Illusion: Procedures/Materials,* curated by James Monte and Marcia Tucker at the Whitney Museum of American Art in 1969, encapsulated the issues of process and experience explored in such works. These themes were popularized in the art

community through Robert Morris's series of essays titled "Notes on Sculpture," published in *Artforum* in February and October 1966, June 1967, and April 1969.[12] Morris's writings provided a rallying point and springboard for discussion for the few devout object makers working amid the sea of performance and conceptual artists active during this period.

THE RECONCILIATION of the dysfunction between life and art was also the rallying point of artists in the Bay Area in the 1970s—although, unlike their East Coast counterparts, who exhumed this issue through process and material, these artists based their inquiries more consistently in theater and non-object-oriented conceptual performance. It was upon Ireland's return to San Francisco from New York, through his friendships with such artists as Tom Marioni, Terry Fox, and Paul Kos and their knowledge of Fluxus and performance art, that he became increasingly engaged with mediating between his newfound interest in concepts and the making of objects. Under the influence of Fluxus, formal and conceptual art making in the Bay Area had come to be considered generally as a problem-solving process. For a painter or sculptor, this notion was manifested through choices involving medium, composition, and color; for a conceptual artist, it involved following through on a plan or idea. Carrying out this strategy was thought to free art making of subjectivity. The vitality of the Bay Area art community was celebrated in the exhibition *Space/Time/Sound—1970s: A Decade in the Bay Area,* held at the San Francisco Museum of Modern Art from December 21, 1979, to February 10, 1980. As the curator, Suzanne Foley, explained,

> The individualism of the frontier west, tempered by an Oriental sense of wholeness, provokes a diverse art community. . . . It also has roots in the "Beat Generation" of the 1950s which sought subjects for art in the mundane and experiential. Therefore, the strongest characteristic of Bay Area conceptual art is its interface with everyday life.

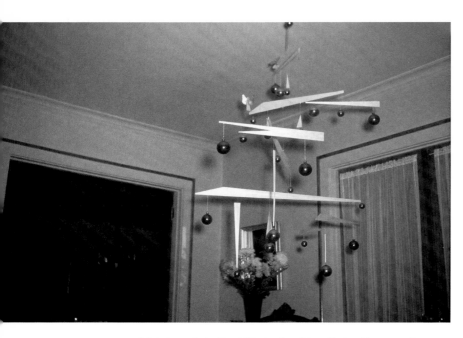

Mobile made by David Ireland and installed at his parents'
Bellingham, Washington, home, 1951 (fig. 11)

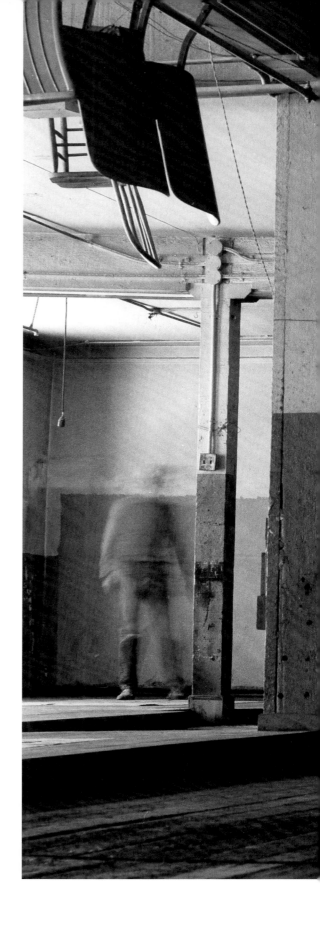

Tom Marioni, *The Restoration of a Portion of the Back Wall,
Ceiling, and Floor of the Main Gallery of the Museum of Conceptual
Art*, San Francisco (with David Ireland and chair installation by
Vito Acconci), 1976 (fig. 12)

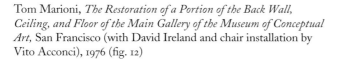

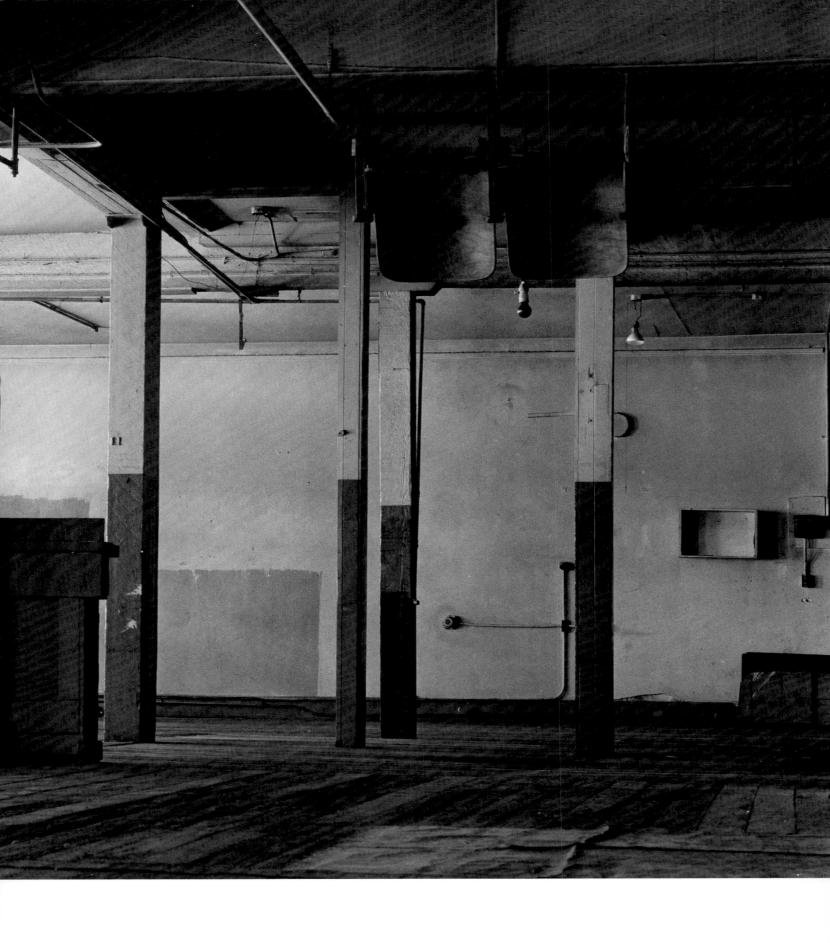

Confluxus, 1977, installation for exhibition
18 Bay Area Artists, University of California,
Berkeley Art Museum (cat. 26)

Artists attracted to conceptual modes focus their work on the process of evolving an idea rather than on making an end product or object. The ideas are realized in different formats—site installations, art activity, performance pieces—presented live, in text, through photograph or videotape. This work represents the search for and definition of new tools, new materials, and new formats for making art. Yet the work remains within the mainstream of art expression because the issues dealt with are those of the painter or sculptor, issues of how to express visually the artist's understanding of himself as a human being and of the society in which he lives.[13]

During the 1970s in the Bay Area the choice of where art was taking place was as important as the actions and format through which they were realized and even resulted in Lynn Hershman's founding of the Floating Museum (1975–78), an institution that operated outside traditional museum and gallery situations to create opportunities for artists to present intermedia performances and installation events. Ireland's decision to use 500 Capp Street as a material resource for his art fit within this context, as did his 1976 piece with Tom Marioni, *The Restoration of a Portion of the Back Wall, Ceiling, and Floor of the Main Gallery of the Museum of Conceptual Art* (pp. 160–61).

Marioni in particular strongly influenced the development of Ireland's work in the 1970s, as Ireland readily acknowledges: "I've gotten a lot out of Tom, being an inspiration for sure, a person who is very complete and knows where he fits, knows what he's doing."[14] In addition to establishing the Museum of Conceptual Art, Marioni was active as an artist, using the alias Allan Fish. His most renowned piece, *The Act of Drinking Beer with Friends Is the Highest Form of Art,* took place at the Oakland Museum on October 26, 1970. Using money he had been given to create an exhibition, Marioni invited people to drink beer and socialize in the museum when it was closed. The piece demonstrated Marioni's view of performance art as a conceptual practice—that "the *act* of art [in this case the drinking of the beer] was the art," and that the result, the object (in this case the debris,

which remained on view for ten days), is only a record.[15]

Marioni's actions as both an artist and curator paved the way in San Francisco for the influence of the Fluxus belief of the irrelevance, even counter-productivity, inherent in the creation of art objects.[16] Not only did art objects feed capitalism's materialism, but their commercialization robbed them of any social significance. As the Fluxus artist George Maciunas had written in 1964,

> Fluxus objectives are social (not aesthetic). . . . Fluxus is strictly against the art object as a dysfunctional commodity whose only purpose is to be sold to support the artist. At best it can have a temporary pedagogical function and clarify how superfluous art is and how superfluous ultimately it is itself. . . . Fluxus is against art as a medium and vehicle for the artist's ego; the applied arts must express objective problems which have to be solved, not the artist's individuality or ego. Therefore, Fluxus has a tendency toward the spirit of the collective, toward anonymity and anti-individualism.[17]

Fluxus artists even condemned the egoism that they believed played a significant part in the choices of materials and methods integral to process-driven art. Ireland, however, remained suspicious of any usurping of art making that is effected by the pursuit of ideals, whether moral or aesthetic. He stayed committed to the tenet that the artist's primary obligation is to steward the real over the ideal. As an undergraduate student in the early 1950s, in an assignment to critique a textbook chapter titled "Observations on Prominent Figures Advocating Formal Expression," Ireland wrote in defense of formalism and in defiance of the author's lauding of idealism:

> Mead [the author] appears to treat his criticism of "formalism" more severely than the other philosophies of expression. I see no apparent reason for his emphasis upon formalism as escapist, undemocratic, and as . . .[???] My observation to this point is to see those who advocate the theories of representation(alism) and emotion are more subject to his fore-mentioned terms; that is I find no better term than "escapist!" For those who seek "ideals" within representative expression it seems that

those who dwell upon associations and little nostalgic memories, acknowledging only the pleasing aspects of the material world, would definitely be avoiding the true realizations of experience. Also those of the "emotionalist" theory should come under the heading "undemocratic." In that this type of expression seems to be primarily concerned with the artist's passions and emotions overlooking the structure within the creation.[18]

DESPITE THE DISPARITIES in what Ireland heard and saw in the East and West Coast art communities, he did share one source of inspiration with both process and conceptual artists: the work and writings of John Cage. Two primary principles that were the bedrock for Cage's work were especially influential: his deliberate use of chance compositional methods (Ireland's intentional paint spills [p. 128] are a direct response to this Cagean principle) and his recognition of everyday objects and ordinary actions and situations. Cage's adoption of systems simultaneously to create freedom in creativity and remove the arbitrary nature of decision-making appealed to a broad array of artists. As Robert Morris succinctly describes, "On the one hand, he democratized the art by not supplying his ordering of the relationships; on the other, by his insertion of chance at the point of decision about relationships, he turned away the engagement with 'quality'—at least at the point of structural relationships where it is usually located."[19]

Also influential was the way Cage's music actively engaged the everyday "real" world. The poignant pauses, the silent moments, in his work created opportunities for an awareness of ordinary human experience within the arena of art, including the sounds of traffic and the hum of building systems where the work was being performed.

Cage can be seen as a dynamic channel for the voice of another advocate for concrete art, the philosopher John Dewey. It was around Dewey's theories that Cage, Merce Cunningham, Robert Rauschenberg, and Buckminster Fuller had rallied at Black Mountain College in the 1950s. Dewey's pointed identification of the need to integrate common human activity into aesthetics, as translated in the work of these artists, informed an art world revolution that extended from Happenings to conceptual, process, and performance art. In his classic *Art as Experience,* Dewey made a strong case for a theory for art Ireland could be committed to:

> The chief problem for artists and theoreticians is that of recovering the continuity of esthetic experience with normal processes of living. . . . Even a crude experience, if authentically an experience, is more fit to give a clue to the intrinsic nature of esthetic experience than is an object already set apart [as art] from any other mode of experience. . . . A conception of fine art that sets out from its connection with discovered qualities of ordinary experience will be able to indicate the factors and forces that favor the normal development of common human activities into matters of artistic value.[20]

Ireland had the opportunity to talk with Cage on a number of occasions, and the depth and effectiveness of Cage's commitment to the recognition of the real in art set a standard by which Ireland could measure his own work. Ireland's first encounter was when Cage visited the Bay Area to print with Kathan Brown at Crown Point Press. Ireland reminisced at the time of Cage's death in 1992,

> I can't remember when I first met John Cage. It was either at one of the many parties that Kathan Brown had for him at her home or at Crown Point Press when it was in Oakland. There was an occasion when I stopped at the press with Tom Marioni and John was working there. He wanted to show me the print that he was working on, and I was anxious to see it. While looking at the print John looked at me over the top of his glasses and said, "Do you see all of those little specs and knicks?" and I said, "Yes." He said, "They are supposed to be there."[21]

For Ireland as well as others, Cage's attitude and actions were refreshing in an art community that had become overly analytical of its every move and decision. Cage's aesthetic and philosophical realism provided a

uniquely American example of practical methods for the disruption of individual and institutional habits in the making of art. Unlike his Fluxus counterparts, Cage, with his seasoned pragmatism, engaged the concrete world with arbitrary systems rather than using concrete systems to engage the world in an arbitrary experience.

As the reputation of 500 Capp Street grew in the late 1970s, Ireland encountered criticism for his application of Cagean processes to the practice of making objects. He confronted this critique directly by beginning to show his work in public exhibition arenas. *Confluxus* (pp. 162–63), an installation piece created in 1977 at Berkeley's University Art Museum (now the Berkeley Art Museum), specifically addressed his practice as a conceptually motivated object maker. Building on a revelation he had had while making a work in Los Angeles the previous year, *A Painting on a Wall in a Room Being the Same Material as the Floor* (p. 54), Ireland covered a wall of the gallery with Play-Doh and scraps of torn-up prints from his printmaking endeavors. As it slowly accumulated these absurdly "anti"-aesthetic materials, *Confluxus* transformed the gallery wall from a site of ephemeral gestures into a monumental object with physical as well as visual presence. Countering the tenets of Fluxus art, Ireland had created an object— an unavoidable object due to its scale—that was neither commercially viable nor imbued with ego. His defiance of the impurity ascribed to such an endeavor was witty and unassailable. The title of the piece also functioned as a direct rebuke of Fluxus, suggesting that the group's desultory practices were a rip-off of the creative process, denying artists the chance to build on their experiences in the world in a real, tactile way. (Ireland's objectivism paralleled contemporary trends in poetry, where form took on an active tense in the creative process rather than functioning as mere metaphor.)

Ireland later played up the idea of the ego as a stumbling block to "pure" idea by adding his initials "D.I." to forms that were readily recognizable as variations on Marcel Duchamp's readymades. Ireland's self-deprecatingly campy *Duchamp's Tree*, 1996 (p. 167),

and rotary *Initial Machine*, 1992 (p. 171), along with the branding of thousands of logs with his initials, humorously address the inconsequential effects of the assertion of the ego, despite his better judgment, in the face of his ever-present, aggressively active and playful id. By publicly confronting his ego, he confirms his choice, the dominion of his value, as that which makes art. This is particularly clear in the split logs branded with his initials and sent forth from his studio into an exhibition. They literally bear the mark of their origin out in the world and are thus distinguished as art, Ireland's art, even when separated from the context of the studio or exhibition installation. If imitation is the highest form of flattery, Ireland has been consistent throughout his career in not only lauding Duchamp, through his consistent adaptation of Duchamp's forms to create his own work, but re-enlivening Duchamp's ideas by re-presenting Duchamp's notion of choice as an item in Ireland's own artistic tool belt. The art consciousness this arouses in the viewer, as well as the discomfort Ireland's mimicry provokes, is another way to identify and set aside the artiness of known art forms in order to free the object for a real encounter with the viewer.

As Ireland's work became more consistently situated within the public sphere during the 1980s, through commissions and site-specific installations, he continued to show that he could sustain a balance between conceptually driven processes and the creation of a finite object. Ireland's unwavering commitment to the object as evidence of conceptual processes did much to broaden the definition of conceptual art for the next generation of Bay Area artists.

The basic premise of Ireland's commitment as an artist is to create a visual experience that articulates his own engagement with the world in a way that makes that encounter available to others. As he has stated on a number of occasions, "The artist is the one who makes the choices (the choices about what is or isn't art). And choices . . . Maybe someone doesn't see it the way you do—you say, 'I really want you to see this work,

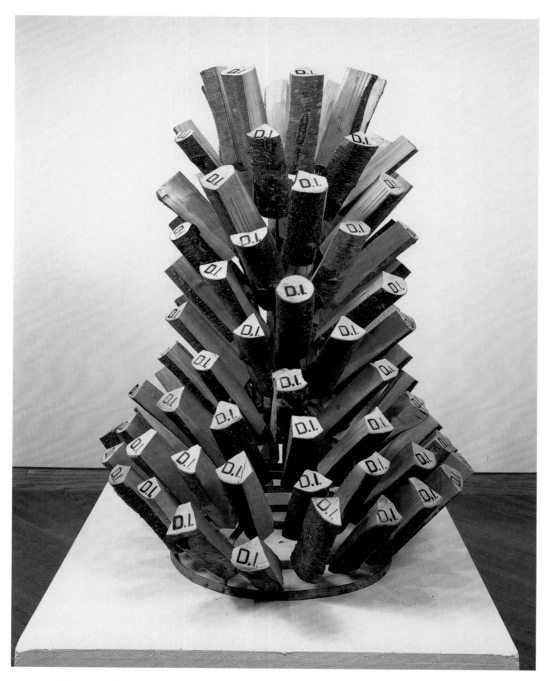

Duchamp's Tree, 1996 (cat. 109)

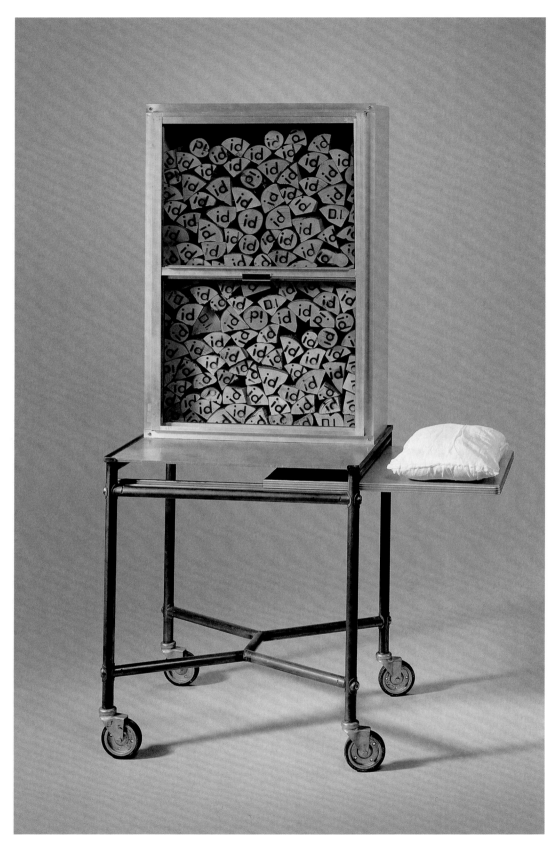

Other Id, 1992 (cat. 82)

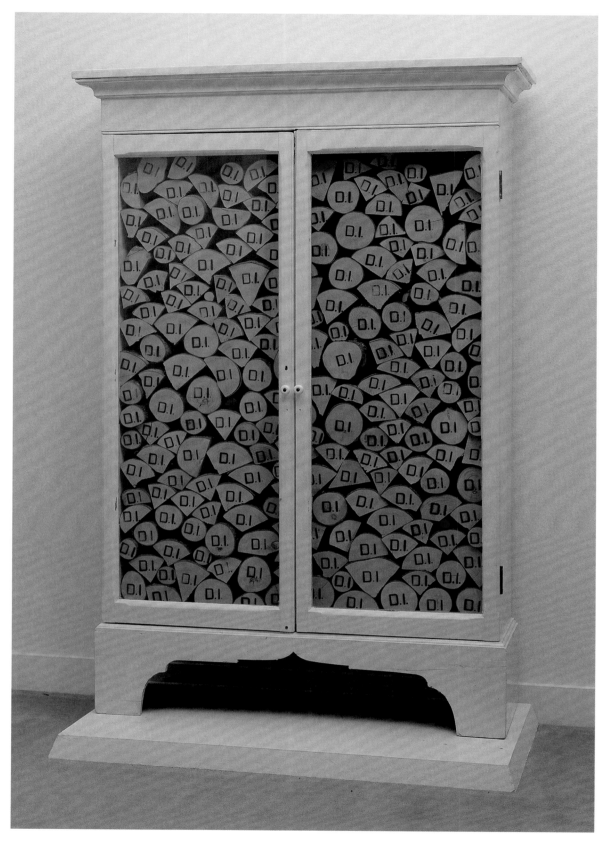

Ego, 1992 (cat. 79)

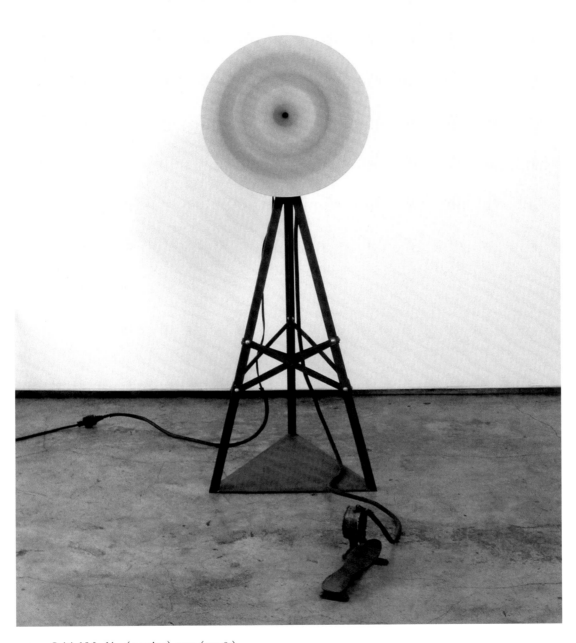

ABOVE: *Initial Machine* (rotating), 1992 (cat. 81)

OPPOSITE: *Initial Machine*, 1992 (cat. 80)

D.I., 1995 (cat. 104)

D.I., 1995 (cat. 103)

so maybe I'll alter it a little bit so you can see it the way I see it.'"[22] In that his commitment is as much to visualization as it is to expression, it has a major caveat: Ireland understands that all art is most like painting in that it is experienced as an illusion. He undermines the implicit nature of art as illusion by continually re-presenting objects that are conceived around art's limitations or shortcomings (its ability to image fact or experience) as a means to reveal that art is not a useful tool to see or know anything but ideas about itself.

A wonderful example of this is Ireland's play with the form of an ear: *Three Attempts to Understand Van Gogh's Ear in Terms of the Map of Africa,* 1987 (p. 177). Ireland may have been inspired by his own ear or that of an African elephant, but the ear shape is a resonant one in art history, evoking reflection on the fate of Van Gogh, who lost his ear to the uncontrollable creative forces that inspired his art and have been mythically asserted as having driven him mad. As he methodically mapped the ear form, both in three dimensions with wire and in two dimensions with glass, paper, and cardboard cutouts, Ireland became intimately acquainted with the ear's shape and discovered that an elephant's ear resembles the shape of the continent of Africa. Both through the title and the pairing of the elephant's ear and wire drawings, Ireland heightens the viewer's awareness that Van Gogh, Africa, and elephant are connected not so much in the world or history as in the artist's experience.

Beyond clearly identifying his works as art on a conceptual level, as with a reference to Van Gogh or a Duchampian simulation, Ireland makes the art-ness visible through formal conceits. At times he defies logic by asserting the three-dimensional qualities of painting or the two-dimensional attributes of sculpture or architecture in order to wrestle illusion back into the viewer's experience. His bald application of primary colors suggests that his endeavors have something to do with painterly surfaces. For a brief period after his trip to Skellig Michael in Ireland in 1993, the artist painted a number of items green because he believed they begged

for Ireland-ish recognition. His consistent construction of paintings—more recently they are bits of cardboard painted a primary color—as well as his longstanding practice of constructing reliquaries and altarpieces, confirms his understanding that the ordinary can be inserted into the discourse of the aesthetic through formal means. A wonderful example of this is *A Decade Document, Withcomet, Andcomet, Andstool* from 1980–90 (p. 175), in which toilet paper rolls in a vitrine simultaneously evoke a Renaissance altarpiece and a Catholic confessional. The decade of household purification to which the work attests on first encounter gives way to an evocation of the whispered unburdening of a thousand "dirty little secrets" washed away with a little Comet and a lot of elbow grease.

Throughout his oeuvre Ireland has tried to create a balance between perfect form and the integrity of the object, whether it is a house or a toilet paper roll. His method is to preserve a constant exchange between what he asserts and what the work asserts in kind, a give-and-take between Ireland and the object, with the knowledge that formal interests will have the final say. As he expresses it, "You make your final judgment of [the artwork] formally. You don't say, 'Well it was a killer of an idea, but the work isn't looking real super.' The test of the work should be whether it expresses the concept, but when it comes down to whether to choose an apple or a pear, you're probably going to choose the one that looks the best."[23]

Ireland's use of formal conceits to counter the illusion in art can also be seen in his epic "landscape painting" for his 1997 exhibition at the Maine College of Art in Portland. Ireland was invited to respond to the history of the Porteous, Mitchell, and Braun department store, once the centerpiece of the city's commercial district. The building had been purchased and renovated by the college, and its ground floor display area was to be transformed into a contemporary art gallery. Ireland felt a natural affinity for this space with its long history of displaying goods for observation, valuation, and purchase, and he saw the college's commitment to make

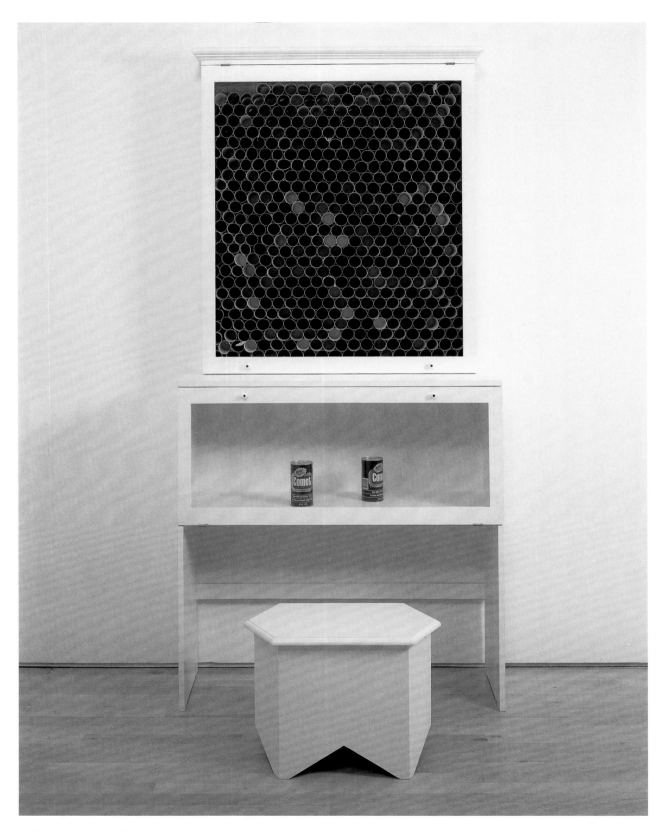

A Decade Document, Withcomet, Andcomet, Andstool, 1980–90 (cat. 34)

ABOVE: *Ear Painting,* 1990 (cat. 70)

OPPOSITE: *Three Attempts to Understand Van Gogh's Ear in Terms of the Map of Africa,* 1987 (cat. 56)

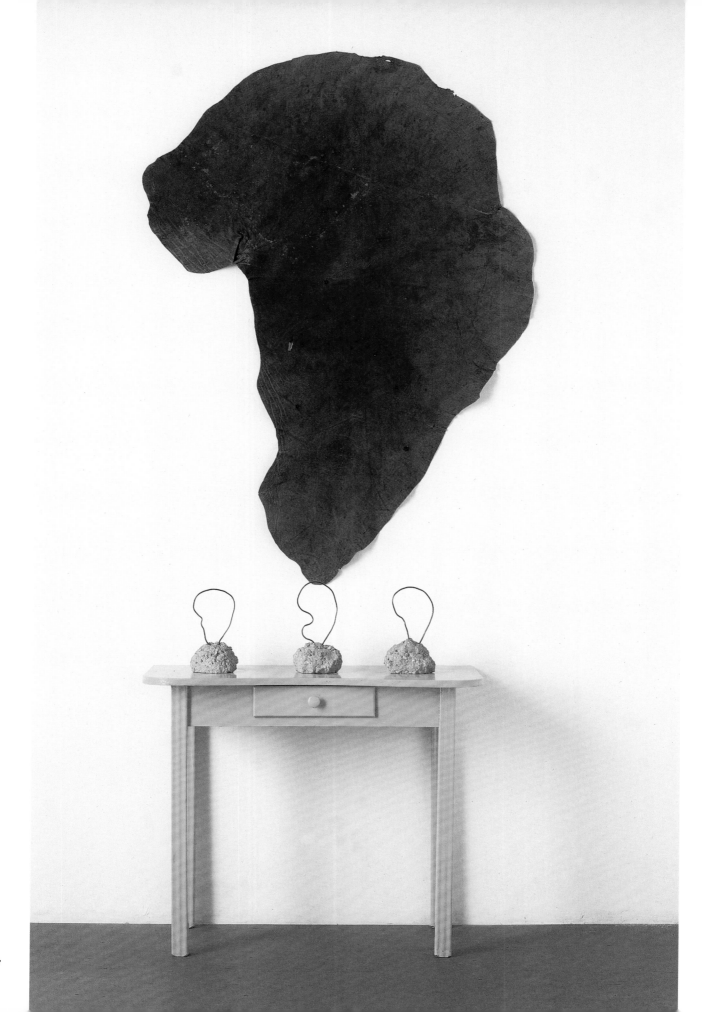

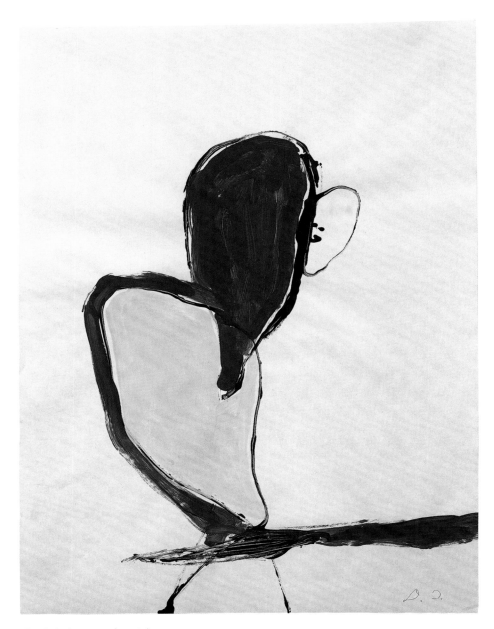

Ear Painting, 1990 (cat. 69)

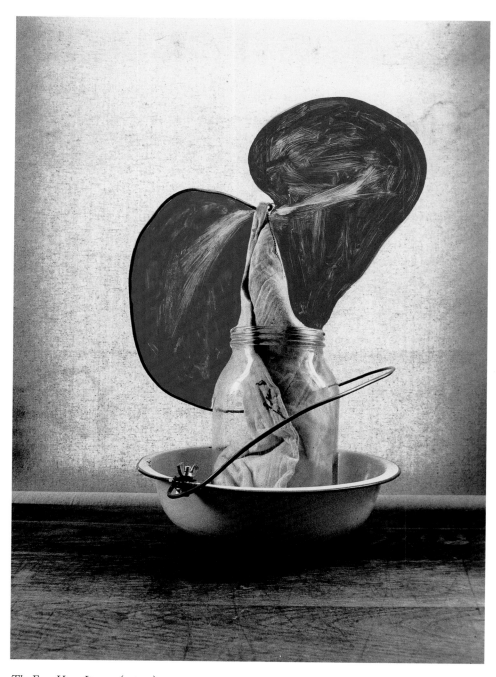

The Ears Have It, 1993 (cat. 95)

the building the center of a revitalized downtown area as congruent with his belief that culture can occupy a natural place in real life. Ireland's response to the space was multifaceted. He introduced a series of windows along the landings of the building's main staircase to affirm the physical proximity and visual accessibility of the space to be occupied by art. He built one of his large chairs (p. 181), approximately fifteen feet high, which mediated between the cavernous space of the building and the physical space of the viewer. Inserting a literal footnote to the contemporary experience of the building, he installed a frieze of found photographs of the history of the building at ankle height. He also introduced a number of other sculptural elements, including *Duchamp's Tree* (p. 167).

The mesmerizing centerpiece of the exhibition was what appeared to be a painting centered on the wall farthest from the entrance (pp. 182–83). It glowed hauntingly with a cool blue light, its bright gold "frame" drawing the viewer's eye to an arctic ice floe, more than reminiscent of a well-known painting of that subject by the nineteenth-century German romantic painter Caspar David Friedrich. On closer inspection, however, this image revealed itself to be a precariously piled mass of construction materials behind a window. The wall in which the window was mounted demarcated the gallery space from the second half of the enormous first floor, which had not yet been renovated. Ireland had captured art as illusion in a magnificent and startling manner. On the near side of the picture plane the viewer encountered a painterly experience, but on closer observation this was revealed as sculpture in an unattainable but real space. This work in progress, both Ireland's and the building construction crew's, was presented as a romantic landscape within the gallery space and as a real construction project in the world. The shared subject of this artwork/ real work was the equalization of the labor of both the artist and the construction worker and the celebration of the artistry and beauty inherent in both endeavors.

Ireland's desire to integrate aesthetic experience into lived spaces can also be seen in projects like *Jade Garden,*

1984–85 (pp. 64, 65), and the artist apartment at Andover, 1993–96 (pp. 116, 117). In these projects it is sometimes difficult to determine where the architecture stops and the art begins as Ireland has designed furniture as well as lighting and bathroom fixtures. He has also addressed the function of exhibition spaces as preserves for aesthetic experience by showing furniture or architectural elements he has designed for the exhibition space along with his sculpture, further obscuring the line between his art, the art world, and the real world. Talking about the literal structures, such as a reading room and brochure holder, that he built into his 1988 exhibition at the University Art Museum, Berkeley, Ireland explained:

> If you want to be an artist and you want to function in the art culture, the challenge, I think, is to see how closely you can stay to real time/space without becoming invisible. I would love the notion that whatever I would do would become virtually invisible as an artwork. But you can make yourself so obscure that you don't exist. It would be nice to feel that you could cancel any notion of formalness. It's almost a learned thing, you can go around with this learned observatory ability, and it would be nice to get beyond that so that you're looking at things that haven't become clichéd. That's why it's so wonderful to get into the unknowing space where you have people saying, "I don't know what it is, but it's certainly not art." Where it doesn't have any vestige or characteristic that they are accustomed to seeing as art—context as well as the object itself. It would be wonderful to remove the museum—all of the things that are somehow forming our expectations. You'd get into some new territory.[24]

In blurring the boundaries between art and the everyday world, Ireland does not necessarily abandon beauty. On the contrary, he gravitates toward beauty, which seems a clear manifestation of his poetic and nostalgic view of the world. His editing gaze presents and preserves the under-recognized humble forms that daily service human need. These items and the memories and familiarity they carry have been incorporated

Big Chair, 1997, installation view from exhibition *David Ireland*, Institute of Contemporary Art, Maine College of Art,
Portland, 1997 (cat. 112)

Window Wall, 1997, installation view from exhibition *David Ireland,* Institute of Contemporary Art, Maine College of Art, Portland, 1997 (cat. 114)

Snow Pour, 1992, Minneapolis Sculpture Garden, Walker Art Center (cat. 85)

into his work over and over again. Recognizing that his personal aesthetic tends toward good formal design, Ireland mediates his choice of objects in three main ways:

1. He may select objects widely recognized as possessing aesthetic merit through their original design but then dumb down their beauty, most often by integrating dirt or concrete.

2. He may pick an object that is readily recognizable as detritus but is elevated and protected through its presentation in a reliquary vitrine or as an exhibited object set off on a pedestal or with a spotlight. In testimony to his use of the transformative capabilities of the context of art on objects, Ireland explains the effect of putting one of his cardboard monchromes into a vitrine: "The vitrine is something that protects things. It isolates, if you want that. It separates an object from another object, or includes one object with another object. . . . I think that this makes [the cardboard monochrome] sculpture, that it no longer has painting connotations, it more has sculptural connotations. . . . Taking a painting off the wall and putting it in a cabinet, I think it's immediately no longer a painting, now it is sculpture. And it is sculpture by reason of conceptual idea."[25]

3. He creates objects that are either formless, formed less, or de-formed, such as his potatoes/turds, *Dumbballs* (p. 98), photograph aggravations, and performance residue (for example, *Snow Pour*, 1992 [p. 184]).[26] Referring to these underrefined pieces, Ireland explains, "I'd been trying to make a non-shape. . . . I wanted to make something that wasn't overbearingly designed. I wanted it not to be designed, but that it just become very close to natural—you know, your hand being the mold. Both hands—there are still little bits of my impression."[27] In relation to the *Dumbballs,* he says, "Some of my things appear spare. And spare of, let's say, intellectual input, and they don't show a finished craft that

we customarily associate with art making. And I've been interested in stripping intelligence from things, so that they don't appear overpowered. . . . I call them *Dumbballs* because I think they can be made without imposing a person's superior intelligence on the object. And what they are is concrete which I make in the customary mixture. And then you form it like you're making a snowball, and you just pass it from one hand to the other, in sort of a motion— over a period of about fifteen hours, because concrete sets very slowly when it's in motion—and you end up with a perfectly round sphere. So that's why I call them *Dumbballs,* because you can close your eyes, a child can make them, you know, a genius can make them, someone of very low intelligence level can make them, and so they're dumb balls. And really the intelligence is the process."[28]

Ireland's efforts are in a sense attempts to protect what he values from the ravages of time and neglect, but what is unusual about his relationship to the work is its lack of finality. Ireland sees the elements that compose his objects as fodder from the flow of culture. His house and studio operate more like a tinker's cart than a repository for cultural artifacts. Ireland makes the best choices for an object up until the time it is removed from his life. When it arrives at a gallery or museum, it still runs the risk of being physically altered and recontextualized through its incorporation and translation as an element in a larger installation plan. When the exhibition is complete, the work is disassembled and returned to Ireland's studio for reintegration into his culture. The only time a work is finalized is when it is acquired by a museum or individual and leaves the studio permanently. At that point Ireland's influence over the object ceases and it becomes a cultural artifact, the fate of which he does not control.

Ireland is, of course, a collector himself, and 500 Capp Street is a form of collecting institution. Ireland knows there is a certain vanity in this endeavor, almost as much as there is in making art. His work has been a

career-long commitment to the tradition of *vanitas,* still lifes that denote the ephemeral nature of all human undertaking. Over time he has taken his role as an arbiter of culture more and more as his essential charge as an artist. Ireland's collecting of artifacts is his own modest way of staving off the effects and insults of time on his life. He also acts as a cultural preservationist who, through the act of recognition, helps preserve or revive objects as sentimental as his grandfather's chair or as history-laden as abandoned public monuments. As he explained in an interview, keeping his grandfather's chair in his house, rather than taking it to some flea market, allows it to "have a more honorable past." Seeing the chair among all the other relics in his house, future generations might think, "Well, this is quite special. This may end up in the [San Francisco] Museum of Modern Art. Who knows?"[29] In a related way, his 1991 installation at Zurich's Helmhaus brought forgotten monuments, with their history, back into the present by displaying them as art objects. The statues, which Ireland discovered in a graveyard for the city's retired public monuments, embodied images that had been rendered obsolete by a shift in cultural values. Ireland restored these objects to their function as art, creating a flow of intertwined forms wending their way across the floor and through the gallery (pp. 82, 83), right up to the inner edge of the windowsill, where they abruptly stopped. Only within the context of the art exhibition did they have any veracity and vitality as culture. A more contained but equally expressive version of the same idea is *Angel-Go-Round* of 1996 (pp. 96–97), in which a motorized statue of an angel, her arm raised in a gesture of blessing, sweeps in a circle over a pile of garden statuary.

Ireland's identification of these seemingly lost or unseen artifacts is his way of assimilating them, and art, back into the mainstream of culture. In this way his art is a form of historical materialism, as distinct from historicism, the role of which is, as described by Walter Benjamin, "to set to work an engagement with history original to every new present. It has recourse to a consciousness of the present that shatters the continuum of history."[30] For Benjamin, the true collector—counter to the collector we know in capitalist society—resists the demands of capital by rendering "useless" the objects he forms into a collection and is thus able to unravel the secret historical meaning of the things he or she accumulates:

> In the act of collecting it is decisive that the object be disassociated from all its original functions in order to enter into the closest possible relationship with its equivalents. This is the diametric opposite of use, and stands under the curious category of completeness. What is this "completeness"? It is a grandiose attempt to transcend the totally irrational quality of a mere being-there through integration into a new, specifically created historical system—the collection. And for the true collector every single thing in this system becomes an encyclopedia of all knowledge of the age, of the landscape, the industry, the owner from which it derives. . . . Collecting is a form of practical memory and, among the profane manifestations of "proximity," the most convincing one.[31]

Ireland's gathering and assembling of artifacts, those that he has determined as art and those that he has not, identify them as useless (remember *Three-Legged Chair*), thus freeing them to be experienced unfettered by any previously applied or implied value.

Ireland's work has a deep affinity with that of Marcel Broodthaers.[32] Broodthaers, like Ireland, came to his career as an artist later in life. He began in 1964 with works that were prompted by his response to American pop art. Broodthaers, like Ireland, had a sense of irony regarding his function as an artist in society. The statement he issued on the occasion of his first exhibition about his decision to become an artist is often quoted: "I, too, wondered if I couldn't sell something and succeed in life. . . . The idea of inventing something insincere finally crossed my mind, and I set to work at once."[33] Broodthaers, who had been a poet, was accustomed to his art having no commercial value. In 1966 he and his family settled in a house in Brussels where they occupied four floors. He eventually turned almost all the furnishings into works of art, not only because they were

an inexpensive medium at hand but also because these objects were immediately recognizable for their role in human traditions and use. The startling word in Broodthaers's statement is obviously *insincere*. His attempt to make art was an attempt to be sincere about his insincerity. Broodthaers's conscious selection of a series of objects in his newfound role of artist, his emphasis on naming their perfection in his eye as art, was audacious. He was unqualified in every respect—no art school experience, little knowledge of art history, no training in connoisseurship—and yet his choice to place these objects back in the world as art secured their closer scrutiny. Broodthaers, like Ireland, intends to manipulate the viewer's assessment, to change cultural value. (It is worth noting here that Ireland has hung in his studio a photograph of Joseph Beuys, which—across the crown of Beuys's signature hat—bears Ireland's "sincerity" stamp: "Nothing sincere without this stamp." Ireland has marked many of his correspondences and drawings with this stamp since the 1980s—in this case defying the dubious effect of Beuys's legacy on the credibility of conceptual art.)

At the same time Ireland is a confirmed cultural romantic and has been all his life—not a natural romantic such as Henry David Thoreau but a cultural romantic akin to Herman Melville, Studs Terkel, or Thomas Hart Benton. Ireland is interested in getting at the gumption of the American experience, its get-dirty, felt reality. He has always possessed the romantic's incongruous ability to be emotionally and spiritually immersed in his or her subject and yet be intellectually analytical and skeptical of the value of his or her own enterprises. It was Ireland's desire for a hands-on opportunity to engage cultural romanticism that led him to study set design as an undergraduate in the 1950s and later to serve as a trader and safari guide in Africa.

Ireland's sparse archives contain an illustrated textbook page that looks as though it were torn from a book on the history of Africa and stands as evidence of his anthropological sentimentality. The image is of an ancient ruin tumbled by the effects of time (p. 188).

All that remains is a pile of rocks that is rapidly being reassimilated by nature. The text under the image reads:

> Among the traces of a superior ancient civilization are the ruins discovered at Zimbabwe. These ruins, and the weapons, implements, and indications of considerable knowledge of the arts and sciences are in no way connected with any of the present races, but point to the superior peoples of past ages.

This illustration, with its text, encapsulates the moralizing tale that motivates Ireland's art. He desires to preserve a connection between his life, his world, and the future by gathering implements, ruins, and knowledge and saving them as evidence of his culture, "the crumbs of [his] humanity."[34] This is a highly nostalgic and romantic enterprise. Art culture, by virtue of its greatest weakness, its static hermetic function as a preserve, is where Ireland can reserve not only the result of his aesthetic quest but the record of his pursuit.

LET US RETURN to the two stories of the three-legged chair. One was told and the other was experienced. The first, as narrated by Ireland, involved research, a logical inquiry made in order to evaluate the facts gleaned from reliable sources. It created a context in which the chair might be understood as a cultural artifact. The second narrative recounted a lark, a quest, undertaken through a sense of adventure in order to understand something through a tenuously related experience. Both endeavors were actually hunts for meaning; both failed to bag their quarry.

Ernest Hemingway, in *Green Hills of Africa*, drew a comparison between his work as a writer and safari hunter of rhinoceros. Describing a few days on the safari, he wrote,

> [We] made camp, Pop warning them to be quiet, and we sat under the dining tent and were comfortable in the chairs and talked. That night we hunted and saw nothing. The next morning we hunted and saw nothing and the next evening the same. It was very interesting but there were no results.[35]

A few pages earlier he recounted his experience as an author,

> What I had to do was work. . . . To work was the only thing, it was the one thing that always made you feel good, and in the meantime it was my own damned life and I would lead it where and how I pleased. And where I had led it now pleased me very much. . . . All I wanted to do now was get back to Africa. We had not left it, yet, but when I would wake in the night I would lie, listening, homesick for it already.[36]

The work of an author had a certain satisfaction for Hemingway but did not parallel his safari experience. The useless pursuit of signs over time is the engaging occupation of the hunter and, I suggest, a certain artist. Much as the hunter searches the mud for the trail of his or her trophy, following what has been learned of its nature from previous experiences with similar species, so, too, the artist pursues an idea, a cultural crumb, a process, or a thing of beauty. David Ireland believes all choices made in this quest are perfect and necessary as determined by context and time, and the resulting artifact attests to the vitality of the hunt for experience. He asks us to consider his objects as evidence.[37]

Textbook illustration of ancient ruins on the Lundi River, Mashonaland, Zimbabwe (fig. 13)

Notes

1. David Ireland, "Inseparable Text for: Chair with Short Leg or All the Swiss That's Fit to Print. 1978. Revitalized, 1986," in *WPA Document* (Washington, D.C.: Washington Project for the Arts, 1986), p. 54.

2. David Ireland, unpublished transcript of lecture at the San Francisco Art Institute, 17 March 1987, pp. 11–12.

3. Unpublished notes, David Ireland's personal archive.

4. From poster produced for Ireland's 1980 exhibition at the Libra Gallery, Claremont Graduate School (now University), Claremont, California.

5. Denise Domergue, unpublished transcript of a conversation with David Ireland at 500 Capp Street, 27 November 1982.

6. From a discussion between Trudi Richards and David Ireland, August 1976, San Francisco; printed in *David Ireland* (Bellingham, Wash.: Whatcom Museum of Art and History, 1976).

7. Domergue, pp. 3–4.

8. David Ireland, quoted from *Inside 500 Capp Street: An Oral History of David Ireland's House,* a videotaped oral history conducted in fall 2001 by Suzanne B. Riess, Regional Oral History Office, The Bancroft Library, University of California, Berkeley, p. 136. Courtesy of The Bancroft Library and San Francisco Museum of Modern Art. Quoted information that appears in this text was taken from the final draft of the oral history reviewed by the artist.

9. Ingrid Schaffner, "A Revised Short History of the Blp," in *Richard Artschwager: Up and Across* (Nurnberg: Neues Museum, 2001–2), p. 78.

10. Richard Artschwager, in *Art & Design* 8 (May–June 1993), p. 80.

11. Ireland, unpublished transcript of lecture at the San Francisco Art Institute.

12. These are reprinted in Robert Morris, *Continuous Project Altered Daily: The Writings of Robert Morris* (Cambridge, Mass.: MIT Press, 1993).

13. Suzanne Foley, Introduction, in *Space/Time/Sound: Conceptual Art in the San Francisco Bay Area: The 70s* (San Francisco: San Francisco Museum of Modern Art, 1981), pp. 8–9.

14. Ireland, *Inside 500 Capp Street,* p. 113.

15. Foley, *Space/Time/Sound,* p. 7.

16. Ireland, *Inside 500 Capp Street,* p. 99. Ireland identifies Marioni as a Fluxus artist although he also states Marioni might not call himself one.

17. Letter quoted in Benjamin H. D. Buchloh, "Robert Watts: Animate Objects—Inanimate Subjects," in *Experiments in the Everyday: Allan Kaprow and Robert Watts—Events, Objects, Documents* (New York: Miriam and Ira D. Wallach Art Gallery, Columbia University, 1999), p. 9.

18. David Ireland, unpublished writing assignment, Ireland's personal archive.

19. Robert Morris, "Some Notes on the Phenomenology of Making" (1970), in *Continuous Project Altered Daily,* p. 75.

20. John Dewey, *Art as Experience* (New York: Capricorn Books, G. P. Putnam's Sons, 1958), pp. 10–11.

21. Unpublished note, 1992, Ireland's personal archive.

22. Ireland, *Inside 500 Capp Street,* p. 161.

23. "Talking with David Ireland/An Art of Ideas," *West* (San Francisco) 1 (winter 1994/95), pp. 13–21.

24. Lawrence Rinder, interviewer, "'Get Off the Knowing . . .': An Interview with David Ireland," *University Art Museum Calendar* (Berkeley) (November 1988), p. 3.

25. Ireland, *Inside 500 Capp Street,* p. 9.

26. For *Snow Pour,* Ireland dug a trench for his body in the snow, fitting the trench to his body by alternately lying down and digging. After the trench was completed a concrete truck came and filled the slot with concrete.

27. Ireland, *Inside 500 Capp Street,* p. 20.

28. David Ireland, unpublished transcript of interview with Diana Krevsky and unidentified third person, 1983, p. 7.

29. Ireland, *Inside 500 Capp Street,* p. 7.

30. Walter Benjamin, in *Das Pasagen-Werk* (Frankfurt am Main: Suhrkamp, 1982), vol. 1, p. 280.

31. Ibid.

32. Ireland keeps the Walker Art Center monograph on Broodthaers prominently displayed in his living room, and a number of the works that bear a similarity to Ireland's work, or which Ireland has emulated, are clearly marked.

33. Michael Compton, "In Praise of the Subject," in *Marcel Broodthaers* (Minneapolis: Walker Art Center, 1989), p. 25.

34. Ireland, interview with Krevsky, p. 6.

35. Ernest Hemingway, *Green Hills of Africa* (New York: Charles Scribner's Sons, 1935), p. 74.

36. Ibid., p. 72.

37. Author's interview with the artist, May 2002.

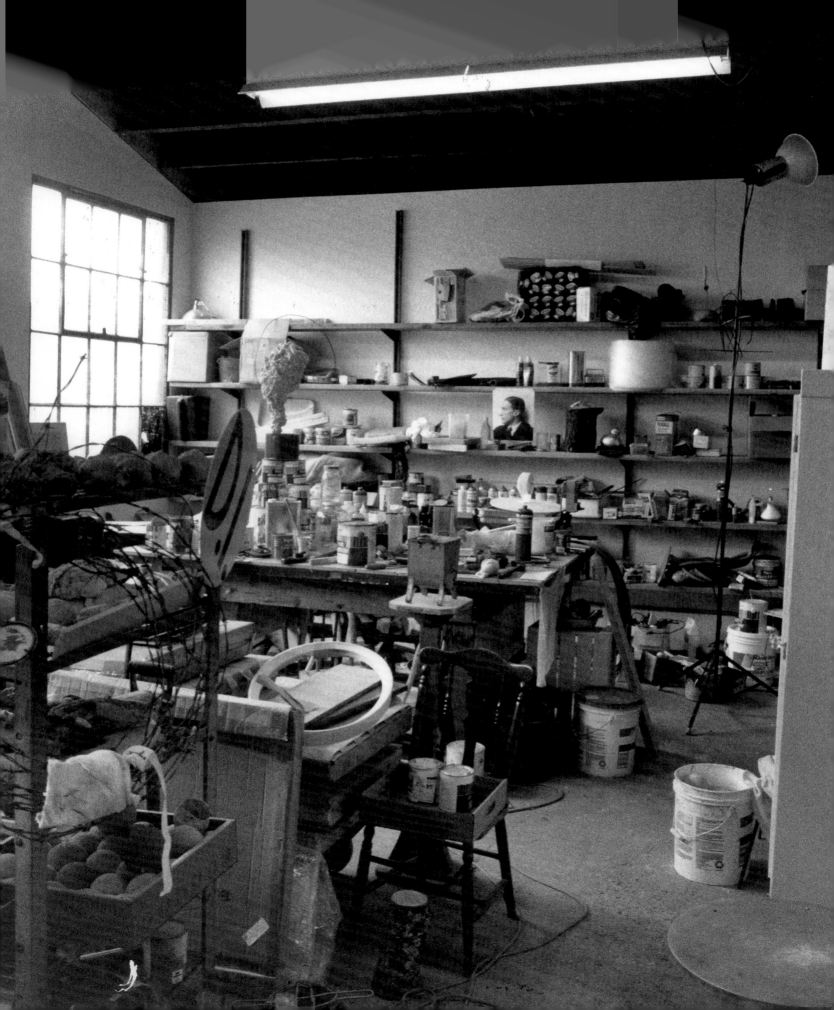

CHRONOLOGY

1930 AUGUST 25. David Kenneth Ireland, Jr., born in Bellingham, Washington, to Martha Quam and David Kenneth Ireland. He is the third of four children.

1948 Graduates from Bellingham High School.

1948-50 Attends Western Washington College of Education (now Western Washington University), Bellingham, with a concentration in art and mathematics.

1950-53 Attends California College of Arts and Crafts (CCAC), Oakland. Studies theater and industrial design with Eric Stearne, printmaking with Nathan Oliveira, and sculpture with Robert (Bob) Winston, among others.

1953 JUNE. Receives Bachelor of Applied Arts degree in industrial design and printmaking from CCAC.

AUGUST. Drafted into the U.S. Army.

1953-55 Serves as sergeant and instructor in chemical warfare in U.S. Army, stationed in Fort Leonard Wood, Missouri.

1955-56 Works as illustrator and color coordinator for architect Galen Bentley in Bellingham, focusing on schools and commercial properties.

1956 Travels to Europe for the first time, visiting England, Scotland, France, Switzerland, and Italy with friend Jack Rykken.

1956-57 WINTER. Travels to Johannesburg, South Africa, and reconnects with fellow CCAC graduate Michael Lacey. Stays for approximately a year working in advertising with Lacey and as a draftsman for the architectural firm of Cook & Cowen. Travels throughout southern Africa.

1958 WINTER. Returns to Bellingham.

1959-65 Works as insurance broker for his father's firm, Ireland & Bellingar, in Bellingham. Simultaneously establishes Hunter Africa, an import business and gallery for African artifacts.

OPPOSITE: David Ireland's studio, Oakland, California, 1990–91 (fig. 14)

Lamps designed by David Ireland (right and third from right) and Rudi Marzi, installed at Fraser's, Berkeley, 1952–53 (fig. 15)

1961 Marries Joanne Westford, a native of Bellingham.

1962 Son Ian born.

1964 Daughter Shaughn born.

1964-65 Co-films and produces with Gene Estribou an independent African wildlife film, *Mara,* shown in major film festivals throughout the United States.

1965 Relocates Hunter Africa to San Francisco and settles with family in Tiburon, just north of the city.

1965-72 Operates two businesses in San Francisco's North Beach area: Hunter Africa, a wildlife design studio, and David Ireland, Ltd., Safaris, which provides wildlife photography and hunting tours to Kenya. Maintains second office in Nairobi.

David Ireland with Jutta and Jack Rykken (left to right), Bellingham, Washington, 1962 (fig. 16)

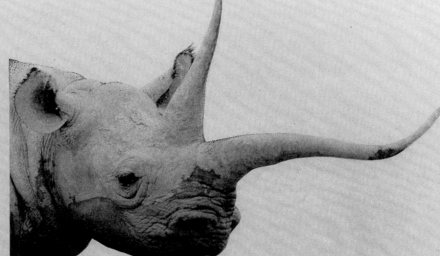

November 19, 1970

Two way of talking about Kilimanjaro

Mount Kilimanjaro.
She gets called Kili out here.
Sometimes in the morning when it is clear and a bit crisp you know
that you can touch her, but not quite.
Oh yes, and after a snow she is like a freshly flowered loaf.
Kili is orange in the morning and after that has mixed for day with
the Amboseli dust she gets a shroud of peach. I never liked that
color, but I love Kilimanjaro.

The second way of talking about Kilimanjaro.

Long ago before there was much of anything to speak of, understanding
or heart-felt paths, the Masai chiefs would order their Moran warriors
to the top of this great mountain to collect the brilliant white rock
that was yellow with first light and yielded to darkness under an
orange color crown. The Moran's returning in half a fortnight would
explain before their heads would fall that they had gathered the
cold white rock, but it had disappeared in their very hands as they had
come for their favour.

Letterhead for David Ireland's Hunter Africa business, San Francisco, 1970 (fig. 17)

Makes ten trips to Kenya and Tanzania for safaris and filming of wildlife. Also visits Hawaii, India, Thailand, Hong Kong, Japan, and Western Europe.

1970 Marriage with wife Joanne ends in divorce.

1972 Closes Hunter Africa and safari business. Continues to live in San Francisco area.

1972–74 Begins graduate studies at San Francisco Art Institute (SFAI) on GI Bill. Studies focus on print-making, with an emphasis on lithography. Thesis portfolio is on monoprints, and graduate advisor is Kathan Brown, then chair of the print department. Also studies under Robert Fried, Gordon Kluge, and Richard Graff. Meets Terry Fox, Howard Fried, Paul Kos, Tom Marioni, and other Bay Area artists.

Concurrent with graduate studies at SFAI, attends Laney College in Oakland. Studies plastics technology and lithography with Gerald Gooch and serves as teaching assistant in lithography.

Maintains studio on Union Street in old Hunter Africa storefront.

1973 Teaching fellow in printmaking at SFAI.

Attends workshop with Garo Antresian in Oakland.

1973–75 Begins to exhibit prints in local and national venues, including John Bolles Gallery, San Francisco; Palo Alto Cultural Center, California; *Davidson National Print and Drawing Competition,* Davidson College, North Carolina; and *2nd Hawaii National Print Exhibition,* Honolulu Academy of Arts.

1974 MAY. Receives Master of Fine Arts degree from SFAI.

OCTOBER. Moves to New York. Maintains a studio on East Fifty-ninth Street and also works at Hunter College. Completes *94-Pound Series* made of cement, a turning point in his work.

DECEMBER. Returns briefly to San Francisco and Bellingham, before beginning trip around the world.

1975 Travels to Australia, New Guinea, Thailand, Burma, Singapore, Malaysia, India, Nepal, Afghanistan, and England.

MARCH. Returns to New York.

SUMMER. Returns to live in San Francisco.

NOVEMBER. Purchases 1886 Victorian house at 500 Capp Street in Mission District of San Francisco.

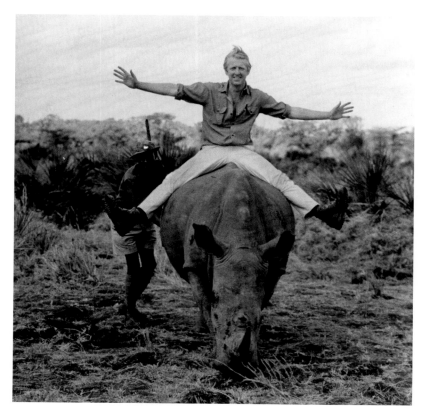

David Ireland in Kenya, 1969 (fig. 18)

David Ireland's Union Street studio, San Francisco, ca. 1972–74 (fig. 19)

David Ireland in the Annapurna mountain range of the Himalayas, Nepal, 1975 (fig. 20)

1976 JANUARY. At the invitation of Tom Marioni, founder and director of Museum of Conceptual Art in San Francisco, works on a piece titled *The Restoration of a Portion of the Back Wall, Ceiling, and Floor of the Main Gallery of the Museum of Conceptual Art,* another turning point in Ireland's work.

Begins work on his home at 500 Capp Street, with a new sense of vision.

SEPTEMBER. Solo exhibition, *David Ireland,* opens at Whatcom Museum of Art and History, Bellingham. Exhibits paintings and prints from 1970 to 1976.

1978 FEBRUARY. First public viewing of 500 Capp Street.

Receives National Endowment for the Arts (NEA) Visual Artists Fellowship grant.

1978-79 Travels to Singapore, Malaysia, Borneo, Thailand, and Hong Kong on NEA grant. While abroad, designs chairs and has them fabricated in Hong Kong.

1979 Purchases house at 65 Capp Street in San Francisco's Mission District and begins major renovation.

1980 DECEMBER. First exhibition in New York, *David Ireland in New York,* a one-day presentation at White Columns. Exhibits a readymade suitcase with studio objects accompanied by audio cassette.

1982 MARCH. First public viewing of 65 Capp Street, in the exhibition *David Ireland's Houses,* coordinated by Leah Levy Gallery in San Francisco, which also features 500 Capp Street.

NOVEMBER. Performs a piece based on his experience of purchasing 65 Capp Street, *Real State,* at La Mamelle, San Francisco, in conjunction with exhibition *The N.O. SHOW (National Offense).*

Art patron Ann Hatch purchases 65 Capp Street and establishes Capp Street Project, a nonprofit artist-in-residence and exhibition space that opens in 1983.

1982-85 Included in a series of new furnishings exhibitions at the Triton Museum of Art, Santa Clara, California; The Katonah Gallery, New York; and Limn Gallery, San Francisco, among others.

1983 Travels to England, Ireland, and France.

Receives second NEA Visual Artists Fellowship grant.

Douglas Dunn and Dancers' performance of *Dances for Men, Women, and Moving Door,* Marymount Manhattan Theatre, New York, 1986, with stage sets designed by David Ireland (fig. 21)

1984 JULY. Solo exhibition, *Currents: David Ireland,* opens at New Museum of Contemporary Art, New York.

1984–85 Collaborates with Robert Wilhite and Jerry Monteith on commission for Washington Project for the Arts, Washington, D.C., to design an apartment for visiting artists, titled *Jade Garden.* The apartment, with interior created by Ireland and furniture by Wilhite, formally opens in February 1985.

1985 Travels to England.

1985–88 Completes *Inside Outside,* a commission for visitors' waiting room at the State Reformatory in Monroe, Washington.

1986 Designs sets and costumes for Douglas Dunn and Dancers' performance of *Dances for Men, Women, and Moving Door,* at Marymount Manhattan Theatre, New York, and Festival d'Automne, Centre Georges Pompidou, Paris.

1986–87 Works on *Newgate,* an entryway installation to a landfill preservation area at Candlestick Point State Recreation Area, San Francisco. The piece is one of several selected as part of a project with the California State Department of Parks.

While artist-in-residence at Headlands Art Center (now Headlands Center for the Arts), Sausalito, California, develops and implements revitalization plan for the center's main offices in Building 944 of Fort Barry, part of a complex of abandoned army barracks built in 1907. With assistance from Mark Thompson, fellow artist-in-residence and project renovations manager, and twenty-four artist interns, nearly four thousand square feet of derelict space are transformed into public meeting rooms.

1987 MARCH. First public viewing of Headlands Art Center.

Participates in *Light Up Philadelphia,* a series of proposed, but never completed, installations by various artists for the city of Philadelphia, commissioned by Fairmont Park Art Association.

APRIL. Receives Adaline Kent Award from SFAI, which also hosts a solo exhibition, *David Ireland: Gallery as Place.*

Receives Louis Comfort Tiffany Foundation grant.

FALL. Teaches at SFAI, where he returns frequently thereafter.

David Ireland, New York, 1988 (fig. 22)

1988 MAY. Creates *Pittcairn,* large-scale outdoor sculpture for *Sculpture at the Point,* a site-specific sculpture exhibition organized by Three Rivers Arts Festival, under the auspices of the Carnegie Museum of Art, Pittsburgh.

Collaborates with San Francisco architect Mark Mack to design and produce furniture for Headlands Art Center.

Receives Engelhard Award from Institute of Contemporary Art, Boston.

Receives Award in the Visual Arts from Southeastern Center for Contemporary Art, Winston-Salem, North Carolina. Participates in accompanying exhibition that premieres at Los Angeles County Museum of Art, and then travels nationally.

OCTOBER. Solo exhibition opens, *David Ireland: A Decade Documented, 1978–1988,* organized by Mary Porter Sesnon Art Gallery, University of California, Santa Cruz. Exhibition premieres at University Art Museum, University of California, Berkeley (now Berkeley Art Museum), then travels to sister University of California campuses at Santa Cruz and Irvine.

DECEMBER. *Projects: David Ireland* opens at The Museum of Modern Art, New York.

1989 Receives Eureka Fellowship in sculpture from Fleishhacker Foundation, San Francisco.

Receives award from *Architectural Record* for planning and design of rooms at Headlands Center for the Arts.

1990 Meets Paco Prieto and establishes a studio in Prieto's Oakland work complex.

Completes commission for Pacific Enterprises corporate office at First Interstate World Center, Los Angeles, an interior wall treatment of stairwell connecting several floors.

Collaborates with architect Frederick Fisher on commission for Security Pacific Bank Gallery, San Francisco, an interior and structural wall treatment.

Receives Design 100 Editorial Award from *Metropolitan Home.*

1990-93 Develops and partially implements conceptual scheme for *The Generator Room,* a project to stabilize interior of a late nineteenth-century powerhouse in the historical Boott Cotton Mills along the Merrimack River in Lowell, Massachusetts. With volunteers and students from University of Massachusetts, works to stabilize powerhouse; project is never completed due to lack of funds.

1991 MAY. Receives honorary Doctorate of Fine Arts degree from CCAC.

1992 FEBRUARY–MAY. Designs sets, costumes, and sound for Douglas Dunn and Dancers' production *Stucco Moon (Douglas Dunn/David Ireland Project),* performed at The Dance Center at the Ninety-second Street Y, New York; University of Minnesota, Minneapolis; Dance Place, Washington, D.C.; Portland State University, Oregon; and in 1994 at LaMaMa E.T.C., New York.

APRIL. Participates in San Francisco Museum of Modern Art's groundbreaking ceremony and creates an "archaeological relic" from event.

1993 MAY. Travels to Skellig Michael, a remote island off coast of Ireland, with independent curator Jane Levy Reed.

Designs set and visual components for Douglas Dunn and Dancers' performance of *Dance for a Past Time,* at The Perth Institute of Contemporary Arts, Australia.

SUMMER. Participates as faculty member at artist-in-residence program, Skowhegan School of Painting and Sculpture, Maine.

1993-96 Collaborates with architect Henry Moss and master craftsman John Sirois on visiting artist apartment for Addison Gallery of American Art, Phillips Academy, Andover, Massachusetts. Apartment formally opens in September 1996.

1994 MARCH. Solo exhibition based on travels to Ireland, *David Ireland: Skellig,* opens at Ansel Adams Center for Photography, San Francisco.

Collaborates on *500 Capp,* a multiple with text by John Ashbery, photographs by Abe Frajndlich, and objects by the artist, produced by Kaldeway Press, Poestenkill, New York.

1996 Receives Arts Achievement Award from KQED's *San Francisco Focus* magazine and Stolichnaya.

OCTOBER–DECEMBER. Travels to Italy as Resident Visual Artist at American Academy in Rome.

1998 JUNE. Receives 1997–98 Visual Artists Award from Flintridge Foundation, Pasadena, California.

Receives first annual Modern Masters Award from Marin Museum Association, California.

Collaborates with architect Mark Mack as one of six teams of architects and artists to design cottages for Montalvo Center for the Arts' artist-in-residency complex, Orchard of Artists, Saratoga, California. Cottages scheduled to formally open in 2004.

1999 MAY. Receives honorary Doctorate of Fine Arts degree from SFAI.

Completes *The Big Chair,* a fourteen-foot-high concrete chair commissioned by Karen and Robert Duncan, Lincoln, Nebraska.

2000 Completes *Big Chair,* a twelve-foot-high steel club chair commissioned by IKEA, Emeryville, California.

2003 Receives commission from Western Washington University Outdoor Sculpture Collection, Bellingham, in partnership with the Washington State Arts Commission Art in Public Places Program. Proposal is for a thirteen-foot-high steel club chair.

SELECTED EXHIBITION HISTORY

Solo and Two-Person Exhibitions

1976 Whatcom Museum of Art and History, Bellingham, Washington. *David Ireland.* 10 September–7 November. Brochure; interview with artist by Trudi Richards.

1978 500 Capp Street, San Francisco. *David Ireland's House on View.* 3–12 February. Poster; statement by artist.

1979 500 Capp Street, San Francisco. *David Ireland Exhibition: South China Paintings.* 26 October–3 November.

1980 80 Langton Street Gallery, San Francisco. *David Ireland's House.* 19 July–2 August. Off-site exhibition featuring 500 Capp Street. Brochure; essay by Judith L. Dunham.

Libra Gallery, Claremont Graduate School, Claremont, California. *David Ireland: You Can't Make Art By Making Art.* 6–17 October.

White Columns, New York. *David Ireland in New York.* 6 December (one-day exhibition).

1981 Leah Levy Gallery, San Francisco. *David Ireland's House.* 20 January. Open house at 500 Capp Street, San Francisco.

65 Capp Street, San Francisco. *For Sale: Real Art/ A Work by David Ireland with Alonzo Green.* 19 and 26 July.

1982 Leah Levy Gallery, San Francisco. *David Ireland's Houses.* 28 March. Open houses at 65 Capp Street and 500 Capp Street, San Francisco.

1983 Leah Levy Gallery, San Francisco. *David Ireland: Tableau.* 9 April–31 May.

American River College Art Gallery, Sacramento. *David Ireland.* 15 September–6 October.

Capp Street Project, San Francisco. *65 Capp Street, San Francisco, a Work by David Ireland.* 5 November–9 December. Inaugural opening of Capp Street Project.

1984 New Museum of Contemporary Art, New York. *Currents: David Ireland.* 28 July–9 September. Brochure; text by Robert Atkins.

Mo David Gallery, New York. *David Ireland.* 14 September–7 October.

1986 Gray Gallery, Jenkins Fine Arts Center, East Carolina University, Greenville, North Carolina. *David Ireland.* 28 April–2 May.

1987 San Francisco Art Institute. *David Ireland: Gallery as Place.* 8 April–9 May. Catalogue; foreword by Mark Van Proyen, essay by Richard Pinegar.

1988 Damon Brandt Gallery, New York. *David Ireland: Multiple Implications.* 19 March–16 April.

University Art Museum, University of California, Berkeley. *David Ireland: A Decade Documented, 1978–1988.* 12 October–11 December. Organized by Mary Porter Sesnon Art Gallery, University of California, Santa Cruz, 10 January–19 February 1989; traveled to Fine Arts Gallery, University of California, Irvine, 26 March–30 April 1989. Catalogue; foreword by Rolando Castellón, essays by Karen Tsujimoto and Melinda Wortz. Brochure (MATRIX 120) for University of California, Berkeley; essay by Karen Tsujimoto.

The Museum of Modern Art, New York. *Projects: David Ireland.* 10 December 1988–15 January 1989. Brochure; essay by Linda Shearer.

1989 The Fabric Workshop, Philadelphia. *David Ireland.* 1–28 February. Brochure; statement by artist.

Durham Arts Council, North Carolina. *Reformatory Furniture by David Ireland.* 7 June–2 July. Organized by Durham Arts Guild. Catalogue; essay by Donnalee Frega.

Germans Van Eck, New York. *David Ireland.* 16 September–7 October.

1990 Hirshhorn Museum and Sculpture Garden, Smithsonian Institution, Washington, D.C. *David Ireland: Works.* 25 July–4 November. Brochure; introduction and interview with artist by Ned Rifkin.

Gallery Paule Anglim, San Francisco. *David Ireland.* 6 October–3 November.

1991 Damon Brandt Gallery, New York. *Ireland: Proximities.* 6 April–18 May.

Helmhaus, Zurich. *David Ireland in Switzerland: You Can't Make Art by Making Art.* 28 June–4 August. Catalogue; essay by Marie-Louise Lienhard.

1992 Walker Art Center, Minneapolis. *Ann Hamilton/ David Ireland.* 22 March–5 July. Brochure.

Ruth Bloom Gallery, Los Angeles. *D.I. Ego Id.* 11 September–17 October.

1993 Mattress Factory, Pittsburgh. *David Ireland: Installation.* 27 February–31 July. Brochure.

Laura Carpenter Fine Art, Santa Fe, New Mexico. *David Ireland.* 27 March–28 April.

1994 Ansel Adams Center for Photography, San Francisco. *David Ireland: Skellig.* 16 March–17 April. Catalogue; essays by Andy Grundberg and Jane Levy Reed.

1995 Jay Gorney Modern Art, New York. *David Ireland.* 2–23 December.

1996 The Arts Club of Chicago. *David Ireland.* 10 April– 28 June. Catalogue; essay by Michael Anania.

Center for the Arts, Yerba Buena Gardens, San Francisco. *The Addition and Subtraction of Skin: Works by Dorothy Cross and David Ireland.* 18 June–18 August. Brochure; curator's statement by René de Guzman.

1997 Institute of Contemporary Art, Maine College of Art, Portland. *David Ireland.* 23 January–23 March. Catalogue; essays by Jennifer R. Gross and Robert Storr.

American Academy in Rome. *David Ireland: Roma Italia.* 27 May–20 July. Catalogue; director's preface by Caroline Bruzelius, foreword by Peter Boswell.

1998 Gallery Paule Anglim, San Francisco. *Ex Cathedra.* 7 March–11 April.

2000 Freedman Gallery, Albright College Center for the Arts, Reading, Pennsylvania. *David Ireland: Everyday Art.* 4 February–10 March. Brochure; essay by Christopher Youngs.

Jack Shainman Gallery, New York. *David Ireland: Reflections.* 18 March–15 April.

2001 Gallery Paule Anglim, San Francisco. *David Ireland and Gallery Paule Anglim Contemplate the de Young Museum.* 1–31 March.

Christopher Grimes Gallery, Santa Monica. *David Ireland: Episode.* 8 September–13 October. Announcement; excerpted text from essay by Linda Shearer.

Group Exhibitions

1972 De Anza College, Cupertino, California. *Bay Area Regional Graphics Competition.* Dates unavailable.

1973 Honolulu Academy of Arts. *2nd Hawaii National Print Exhibition.* 27 April–27 May. Catalogue.

Illinois Wesleyan University, Bloomington. *Seven Bay Area Printmakers.* Dates unavailable.

1974 Stowe Gallery, Davidson College, Davidson, North Carolina. *Davidson National Print and Drawing Competition.* 17 March–19 April. Catalogue; introduction by Herb Jackson, juror's statement by Walter Darby Bannard.

John Bolles Gallery, San Francisco. *Gail Wong, R. F. Stepan, Porter Lewis, David Ireland.* 7 August– 6 September.

San Francisco Art Institute. *Works on Paper by Fifteen Bay Area Artists.* 25 October–1 December. Brochure; introduction by Philip Linhares.

1975 Palo Alto Cultural Center, California. *Edition of One: Monoprints by Bay Area Artists.* 7 June–16 July. Catalogue.

San Francisco Art Institute. *The Annual.* Series of weekly solo exhibitions by various artists in rented San Francisco storefront space. 12 September 1975– 27 August 1976; Ireland's exhibition 20–27 August 1976. Catalogue; introduction by Tom Marioni, statements by artists.

1976 Walnut Creek Civic Arts Gallery, California. *Surface and Image.* 5 May–19 June. Brochure; introduction by Jeanne Howard, juror's statement by Philip Linhares.

Los Angeles Institute of Contemporary Art. *18 Bay Area Artists.* 18 May–25 June. Traveled to University Art Museum, University of California, Berkeley, part 1: 1 February–13 March 1977; part 2: 19 March–24 April 1977. Catalogue; introduction by Catherine Robyns, statements by artists. Catalogue published by University Art Museum, University of California, Berkeley.

1982 San Francisco International Airport, North Terminal Connector Gallery. *Artists' Furniture.* 21 June–17 September. Catalogue; curators' statements by Elsa Cameron and George Gannet, essays by Denise M. Domergue and Eudorah M. Moore.

Belca House, Kyoto. *Elegant Miniatures from San Francisco and Kyoto, Japan.* Dates unavailable. Traveled to San Francisco Museum of Modern Art, 14 July–25 September 1983.

1983 Leah Levy Gallery, San Francisco. *Painting, Sculpture, Light.* 1 February–25 March.

Limn Gallery, San Francisco. *New Art Furniture from the Bay Area.* 23 September–11 November.

1984 The Katonah Gallery, Katonah, New York. *Forms That Function.* 22 January–4 March. Brochure; statement by Patterson Sims.

Hayden Gallery and MIT Campus, Massachusetts Institute of Technology, Cambridge. *Visions of Paradise: Installations by Vito Acconci, David Ireland, and James Surls.* 24 March–29 April. Organized by MIT Committee on the Visual Arts. Catalogue; essay by Gary Garrels, statements by artists.

1985 Triton Museum of Art, Santa Clara, California. *New Furnishings: A Survey of Post Modern Bay Area Furniture Design.* 8 June–28 July. Catalogue; essay by Marc D'Estout and Jo Farb Hernandez, statements by artists.

Mo David Gallery, New York. *Late Night.* 8 November–8 December.

San Francisco Art Institute. *Inspired by Leonardo.* 20 November 1985–25 January 1986.

1986 Pro Arts, Oakland, and Art Department, San Francisco State University. *Hotel Project.* 3 July–17 August. Installations at 1640 Seventh Street, Oakland.

1987 San Francisco Airports Commission. *The Right Foot Show.* 5 October 1987–15 January 1988. Brochure.

1988 Three Rivers Arts Festival, an activity of the Carnegie Museum of Art, Pittsburgh. *Sculpture at the Point.* 15 May–26 June. Catalogue; director's statement by John R. Brice, curators' statements by Gary Garrels and Jock Reynolds, statements by artists.

Los Angeles County Museum of Art. *Awards in the Visual Arts 7.* 26 May–17 July. Organized by Southeastern Center for Contemporary Art, Winston-Salem, North Carolina; traveled to Carnegie-Mellon University Art Gallery, Pittsburgh, 11 September–9 October; Virginia Museum of Fine Arts, Richmond, 13 December 1988–29 January 1989. Catalogue; foreword by Ted Potter, essay by Dr. Donald Kuspit.

Santa Barbara Contemporary Arts Forum, California. *Home Show: 10 Artists' Installations in 10 Santa Barbara Homes.* 10 September–9 October. Catalogue; introduction by Betty Klausner, essays by Dore Ashton and Howard S. Becker, statements by artists and participating homeowners.

Art Department Gallery, San Francisco State University. *Countervision: Pioneers in Bay Area Art.* 16 November–9 December. Brochure; statement by Sylvia Solochek Walters, introduction by Judith Bettelheim.

Rosa Esman Gallery, New York. *Scale (small).* 29 November–31 December.

Damon Brandt Gallery, New York. *Howard Fried, Terry Fox, David Ireland, Tony Labat, Michael Osterhout, Alan Scarritt.* 8 December 1988–14 January 1989.

1989 Gallery Paule Anglim, San Francisco. *Solid Concept.* 10 January–4 February. Brochure; essays by Jacqueline Crist and Constance Lewallen.

Wight Art Gallery, University of California, Los Angeles. *Forty Years of California Assemblage.* 4 April–21 May. Traveled to San Jose Museum of Art, California, 9 June–13 August; Fresno Art Museum, California, 8 September–12 November; Joslyn Art Museum, Omaha, Nebraska, 15 December 1989–4 February 1990. Catalogue; essays by Anne Ayres, Peter Boswell, Philip Brookman, Verni Greenfield, and Henry Hopkins.

Hallwalls, Buffalo, New York. *Nepotism.* 6 May–2 June. Catalogue; essays by David Hershkovits and Carlo McCormick.

Hallwalls, Buffalo, New York. *Bay Area Conceptualism: Two Generations.* 15 September–10 November. Catalogue; essays by Nayland Blake and Renny Pritikin.

The Museum of Contemporary Art, Los Angeles. *Constructing a History: A Focus on MOCA's Permanent Collection.* 19 November 1989–4 March 1990.

1990 University Gallery Fine Arts Center, University of Massachusetts, Amherst. *In Site: Five Conceptual Artists from the Bay Area.* 2 February–17 March. Catalogue; essay by Regina Coppola.

Art Department Gallery, San Francisco State University. *Public Art: Models & Drawings.* 12 February–2 March. Brochure; essay by Rebecca Solnit.

The Museum of Contemporary Art, Los Angeles. *Paradox of Progress: Collages and Assemblage in the Permanent Collection.* 22 April–22 July.

Institute of Contemporary Art, University of Pennsylvania, Philadelphia. S*igns of Life: Process and Material, 1960–1990.* 15 June–12 August. Catalogue; foreword by Patrick T. Murphy, preface by Judith Tannenbaum, essay by Melissa E. Feldman.

1991 Fundación Caja de Pensiones, Madrid. *El Jardín Salvaje.* 22 January–10 March. Catalogue; essay by Dan Cameron.

The Museum of Contemporary Art, Los Angeles. *Selections from the Permanent Collection: 1975–1991.* 25 August–15 December.

Artspace, San Francisco. *Erotic Drawings.* 17 September–31 October.

1992 Wooster Gardens, New York. *Healing.* 29 February–25 April. Traveled to Rena Bransten Gallery, San Francisco, 12 May–13 June.

The Living Room, San Francisco. *Domestic Trappings.* 5 May–6 June.

Thread Waxing Space, New York. *Mssr. B's Curio Shop.* 6 June–11 July. Catalogue.

Gallery Paule Anglim, San Francisco. *David Ireland, Annette Messager, Bill Viola.* 14 October–14 November.

1993 Colby College Museum of Art, Waterville, Maine. *Skowhegan '93.* 14 July–26 September.

1994 Haines Gallery, San Francisco. *Issues of Image.* 19 July–20 August.

The Museum of Modern Art, New York. *Mapping.* 6 October–20 December. Catalogue; essay by Robert Storr.

Gallery Paule Anglim, San Francisco. *Solid Concept Three.* 12 October–12 November.

Artist's Space, New York. *Conceptual Art from the Bay Area.* 29 October 1994–7 January 1995.

Walker Art Center, Minneapolis. *Duchamp's Leg.* 6 November 1994–26 March 1995. Traveled to Miami Art Museum, 2 December 1995–3 March 1996.

1996 Swiss Institute, New York. *Time Wise.* 1 April–30 May.

Gallery Paule Anglim, San Francisco. *San Francisco Art Institute 125th Anniversary Tribute Show.* 10 April–4 May.

The Museum of Modern Art, New York. *Thinking Print: Books to Billboards 1980–1995.* 20 June–10 September.

1998 California Center for the Arts, Escondido. *Affinities and Collections.* 14 February–3 May.

Museum of Contemporary Art, San Diego, California and Auditorio de Galicia, Santiago de Compostela, Spain. *Double Trouble: The Patchett Collection.* Museum of Contemporary Art, San Diego, 27 June–5 September. Traveled to Museo de las Artes and Instituto Cultural Cabañas, Guadalajara, Mexico, 10 September–22 November; Museo de Monterrey, Mexico, February–April 1999; Museo Universitario Contemporáneo de Arte, Mexico City, April–June 1999; Auditorio de Galicia and Iglesia San Domingos de Bonaval, Santiago de Compostela, Spain, 10 July–5 September 1999; Sala Amós Salvador, Logroño, Spain, November 1999–February 2000. Catalogue; volume 1: essays by Elizabeth Armstrong, Kevin Power, and Julian Zugazagoitia; volume 2: essay by Karal Ann Marling, interview with Tom Patchett by Ralph Rugoff; both volumes: statements about works in exhibition by Tania Owcharenko Duvergue, Rita Gonzalez, Melissa Ho, Karal Ann Marling, and Holly Myers.

San Francisco Art Institute. *pFORMative Acts.* 1 September–1 November.

Asheville Art Museum, North Carolina. *Off the Wall: Eight Contemporary American Sculptors.* 19 November 1998–6 March 1999. Traveled to Visual Arts Gallery, University of Alabama at Birmingham, 12 September–8 October 1999. Brochure; essay by Michael Klein.

1999 De Cordova Museum and Sculpture Park, Lincoln, Massachusetts. *On the Ball: The Sphere in Contemporary Sculpture.* 16 January–14 March.

Bedford Gallery, Dean Lesher Regional Center for the Arts, Walnut Creek, California. *Beholding Beauty: Bay Area Curators Explore Modern and Post-Modern Beauty.* 9 February–28 March. Brochure.

Jack Shainman Gallery, New York. *The Conversation.* 6–31 July.

Irvine Fine Arts Center, California. *Ideas in Things.* 10 September–31 October. Catalogue; essay by Tim Jahns.

Hackett Freedman Gallery, San Francisco. *Homage to the San Francisco Art Institute.* 1–30 October. Catalogue; essay by Barbara Janeff.

Oakland Museum of California. *Meaning and Message: Contemporary Art from the Museum Collection.* 6 November 1999–12 March 2000.

Fine Arts Museums of San Francisco, M.H. de Young Memorial Museum. *Museum Pieces: Bay Area Artists Consider the de Young.* 20 November 1999–12 March 2000. Catalogue; essay by Glen Helfand.

2000 Bakalar and Huntington Galleries, Massachusetts College of Art, Boston. *Rapture.* 20 January–4 March. Catalogue; introduction by Jeffrey Keough, essay by Robert E. Alvis.

Microsoft Art Collection, Redmond, Washington. *Eccentric Forms and Structures.* 20 January–31 March. On-line essay by Michael Klein.

Christopher Grimes Gallery, Santa Monica. *Seascape.* 30 March–29 April.

Los Angeles County Museum of Art. *Made in California: Art, Image, and Identity, 1900–2000.* Section 1: 22 October 2000–18 March 2001; Sections 2, 3, and 4: 22 October 2000–25 February 2001; Section 5: 12 November 2000–25 February 2001. Catalogue; introduction by Stephanie Barron, essays by Stephanie Barron, Sheri Bernstein, Michael Dear, Howard N. Fox, and Richard Rodriguez.

2001 Apex Art Curatorial Program, New York. *Making the Making.* 5 January–3 February. Brochure; essay by Charles Goldman.

The Museum of Contemporary Photography, Columbia College, Chicago. *Antonia Contro and Maurizio Pellegrin, Clement Cooper, David Ireland.* 2 March–28 April. Brochure.

Museum of Contemporary Art, San Diego. *Lateral Thinking: Art of the 1990s.* 16 September 2001–13 January 2002. Travels to Colorado Springs Fine Arts Center, 27 September 2002–4 January 2003; Hood Museum, Dartmouth University, Hanover, 3 January–14 March 2004; Dayton Art Institute, 17 July–17 October 2004. Catalogue; preface by Hugh M. Davies, essay by Toby Kamps, catalogue entries by Tamara Bloomberg, Miki Garcia, Stephanie Hanor, Toby Kamps, Kelly McKinley, and Rachel Teagle.

2002 Pasadena Museum of California Art. *On-Ramps: Transitional Moments in California Art.* 1 June–1 September. Brochure; essays by Michael Duncan, Peter Frank, Nancy Moure, and Thomas Solomon.

University of California, Berkeley Art Museum. *XXLII.* 14 August 2002–3 March 2003.

2003 Des Moines Art Center, Iowa. *Magic Markers: Objects of Transformation.* 1 February–20 April.

Gallery Paule Anglim, San Francisco. *Solid Concept IV.* 11 June–3 July.

KATHY BORGOGNO AND BARBARA EATON

SELECTED BIBLIOGRAPHY

Statements and Lectures by the Artist

In *American Visionaries: Selections from the Whitney Museum of American Art.* New York: Whitney Museum of American Art, 2001: 149, ill.

In *The Annual.* Exh. cat. San Francisco: San Francisco Art Institute, 1976: 45, ill.

Audiotaped lecture at Nora Eccles Harrison Museum of Art, Utah State University, Logan, 1995. Archive of the Nora Eccles Harrison Museum of Art.

Audiotape and unpublished transcript of lecture at San Francisco Art Institute, 17 March 1987. Archive of the San Francisco Art Institute.

In *Capp Street Project 1984.* San Francisco: Capp Street Project, 1985: 14–16, ill.

In *David Ireland.* Exh. brochure. Philadelphia: The Fabric Workshop, 1989: n.p., ill.

In *David Ireland's House on View.* Exh. poster. San Francisco: self-published, 1978, ill.

In Domergue, Denise. *Artists Design Furniture.* New York: Harry N. Abrams, 1984: 90, ill.

In *18 Bay Area Artists.* Exh. cat. Berkeley: University Art Museum, University of California, 1977: 12–13, ill.

In Feinsilber, Pamela. "David Ireland" in "Portraits Power/ Power Portraits." *San Francisco* (February 2000): 26, ill.

In Garrels, Gary. *Visions of Paradise: Installations by Vito Acconci, David Ireland, and James Surls.* Exh. cat. Cambridge, Mass.: MIT Committee on the Visual Arts, 1984: n.p., ill.

In *Home Show: 10 Artists' Installations in 10 Santa Barbara Homes.* Exh. cat. Santa Barbara, Calif.: Santa Barbara Contemporary Arts Forum, 1988: 22–23, ill.

"Inseparable Text for: Chair with Short Leg or All the Swiss That's Fit to Print. 1978. Revitalized, 1986." *WPA Document.* Washington, D.C.: Washington Project for the Arts, 1986: 54, ill.

In Lischka, G. J., ed. *Alles und Noch Viel Mehr, Das Poetische ABC: Die Katalog Anthologie de 80 er Jahre.* Bern, Switzerland: Benteli, 1985: 550–51, ill.

In *Local Color: The di Rosa Collection of Contemporary California Art.* San Francisco: Chronicle Books, 1999: 117, ill.

"Memoir: Transvaal (1957)." *The Threepenny Review* 4 (spring 1983): 26–27, ill.

In *New Furnishings: A Survey of Post Modern Bay Area Furniture Design.* Exh. cat. Santa Clara, Calif.: Triton Museum of Art, 1985: 23, ill.

In *Sculpture at the Point.* Exh. cat. Pittsburgh: Carnegie Museum of Art, 1988: 36, ill.

In *The Visual Artists Awards.* Pasadena, Calif.: Flintridge Foundation, 1998: 14–15, ill.

Interviews

"David Ireland Interview." *Headlands Art Center* (Sausalito, Calif.) 2 (winter 1986): n.p., ill.

Domergue, Denise, interviewer. Unpublished interview with David Ireland at 500 Capp Street, San Francisco, 27 November 1982. Archive of the artist.

Garrels, Gary, interviewer. Unpublished interview with David Ireland at Massachusetts Institute of Technology, Cambridge, Mass., 22 March 1984. Archive of the artist.

Hoffman, Laura J., interviewer and director. *David Ireland, 500 Capp Street: A House with Much Tea,* 1996. Videotape, 35 min.

Jenkins, Steven, interviewer. "A Conversation with David Ireland." *Artweek* 25 (7 April 1994): 16–17, ill.

Krevsky, Diana, interviewer. Audiotape and unpublished transcript of interview with David Ireland at 500 Capp Street, San Francisco, 1983.

Krevsky, Diana, interviewer and editor. "David Ireland's Art/ Sound/Ideas," radio program of KUSF-FM, San Francisco. First aired 8 March 1983, on the KUSF weekly series, "Art Scene/Art Sound."

In *Meaning and Message: The Artist's Voice,* 1999. Videotaped interview conducted for exhibition *Meaning and Message: Contemporary Art from the Museum Collection,* Oakland Museum of California, 1999. 16 min. David Ireland is one of eight artists interviewed.

Nelson, Karen, and Karen Tsujimoto, interviewers. Videotaped interview with David Ireland at 500 Capp Street, San Francisco, 17 August 1999, for Oakland Museum of California. 60 min. An edited version of the interview appears in *Meaning and Message: The Artist's Voice,* 1999, produced by the museum. An unpublished transcript of the interview is also in the museum's archive.

Richards, Trudi, interviewer. "A Discussion between David Ireland and Trudi Richards, August 1976, San Francisco" in *David Ireland,* exh. brochure. Whatcom Museum of Art and History, Bellingham, Wash. (1976): n.p., ill.

———. Unpublished interview with David Ireland, August 1976. Archive of the artist.

Riess, Suzanne B., interviewer. *Inside 500 Capp Street: An Oral History of David Ireland's House,* a videotaped oral history conducted in 2001. Regional Oral History Office, The Bancroft Library, University of California, Berkeley, in collaboration with the San Francisco Museum of Modern Art.

Rifkin, Ned, interviewer. *David Ireland: Works.* Exh. brochure. Washington, D.C.: Hirshhorn Museum and Sculpture Garden, Smithsonian Institution, 1990: n.p., ill.

Rinder, Lawrence, interviewer. "'Get Off the Knowing . . .': An Interview with David Ireland." *University Art Museum Calendar* (Berkeley) (November 1988): 3, ill.

Rosato, Toni, interviewer. Interview with David Ireland at University of Colorado, Boulder, 1992. Videotape, 30 minutes.

"Talking with David Ireland/An Art of Ideas." *West* (San Francisco) 1 (winter 1994/95): 13–21, ill.

Books

For solo exhibition catalogues, see Exhibition History.

Albright, Thomas. *Art in the San Francisco Bay Area, 1945–1980: An Illustrated History.* Berkeley and Los Angeles: University of California Press, 1985.

American Visionaries: Selections from the Whitney Museum of American Art. New York: Whitney Museum of American Art, 2001.

Coates, Jim, and Paul Marion, eds. *Generator Room.* Lowell, Mass.: Loom Press, 1998.

Domergue, Denise. *Artists Design Furniture.* New York: Harry N. Abrams, 1984.

Foley, Suzanne. *Space/Time/Sound: Conceptual Art in the San Francisco Bay Area: The 70s.* San Francisco: San Francisco Museum of Modern Art, 1981; distributed by University of Washington Press, Seattle.

Headlands Journal 1986–1989, vol. 1. Sausalito, Calif.: Headlands Center for the Arts, 1991.

Hess, Alan. *Hyperwest: American Residential Architecture on the Edge.* New York: Watson-Guptill Publications, Whitney Library of Design, 1996.

Johnstone, Mark, and Leslie Aboud Holzman. *Epicenter: San Francisco Bay Area Art Now.* San Francisco: Chronicle Books, 2002.

Klausner, Betty. *Touching Time and Space: A Portrait of David Ireland.* Milan, Italy: Charta, 2003.

Levy, Leah. *Capp Street Project 1984.* San Francisco: Capp Street Project, 1985.

Lischka, G. J., ed. *Alles und Noch Viel Mehr, Das Poetische ABC: Die Katalog Anthologie de 80er Jahre.* Bern, Switzerland: Benteli, 1985.

Local Color: The di Rosa Collection of Contemporary California Art. San Francisco: Chronicle Books, 1999.

Loeffler, Carl E., ed. *Performance Anthology: Source Book for a Decade of California Performance Art.* San Francisco: Contemporary Arts Press, 1980.

Simon, Joan. *Ann Hamilton.* New York: Harry N. Abrams, 2002.

Stroud, Marion Boulton. *New Material as New Media: The Fabric Workshop and Museum.* Cambridge, Mass.: MIT Press, 2003.

Unterman, Patricia. *Food Lover's Guide to San Francisco,* 2d ed. San Francisco: Chronicle Books, 1997.

The Visual Artists Awards. Pasadena, Calif.: Flintridge Foundation, 1998.

Selected Articles and Reviews

1966

Benoit, Monique. "Furry Symbol of Virility." *San Francisco Chronicle,* 4 April 1966: 25, ill.

Ireland, David. "Uptempo of Things African." *Building Products Guide: Interior Design and Decorating* 7 (October 1966): 108–9, ill.

Kennedy, Pat. "David and Joanne Ireland Leave Thursday to Direct East African Safari." *Bellingham (Wash.) Herald,* 10 October 1966: 2, ill.

Kilich, Betty. "Safari." *Home Furnishings Daily,* 22 February 1966: 6–7, ill.

Schroeder, Mildred. "And Lions in the Living Room. . . ." in "Women Today." *San Francisco Sunday Examiner and Chronicle,* 6 March 1966: 14, ill.

1968

Hayes, Elinor. "Couple Brings Africa Home." *Oakland Tribune,* 5 May 1968: 22, ill.

1974

Albright, Thomas. "Vivid, Bright Bay Art." *San Francisco Chronicle,* 22 August 1974: 44.

1976

Ballatore, Sandy. "Bay Area Sampling." *Artweek* 7 (19 June 1976): 1, 16.

Wilson, William. "Grim Portrait of Bay Area" in "View" (Part IV). *Los Angeles Times,* 31 May 1976: 1–2.

1977

Dickson, Joanne A. "18 Bay Area Artists, Part I." *Artweek* 8 (5 March 1977): 5.

Frankenstein, Alfred. "What's Going on in the Bay Area." *San Francisco Sunday Examiner and Chronicle,* 20 February 1977: 41.

1980

Ross, Janice. "David Ireland's House a Curious Art Piece." *Oakland Tribune,* 29 July 1980: C7, ill.

Stofflet, Mary. "Thriving—If Not Exploding: Bay Area 1980." *images & issues* 1 (winter 1980–81): 12–16, ill.

1981

Bowles, Henry. "Building of the Quarter: David Ireland House." *Archetype* 2 (spring 1981): 64–69, ill.

"David Ireland" in "Exhibition in Print." *Journal: A Contemporary Art Magazine* (Los Angeles Institute of Contemporary Art) 4 (winter 1981): 48–49, ill.

Dunham, Judith L. "A Sanctuary for History." *Artweek* 12 (14 March 1981): 7, ill.

Junker, Howard. "David Ireland, Leah Levy Gallery" in "Reviews: San Francisco." *Artforum* 19 (April 1981): 74, ill.

Saeks, Diane Dorrans. "At Home with Artist David Ireland." *San Francisco* 23 (July 1981): 68–69, 71–73, ill.

1982

Atkins, Robert. "Architecture: Artists Do It Better." *San Francisco Bay Guardian,* 16 June 1982: 23.

Lambie, Alec. "Corrugated House." *Fine Homebuilding* 7 (February/March 1982): back cover, ill.

O'Connor, Tom. "Amuse to Use: Making Furniture as Art." *Focus* (October 1982): 36–39, 91, ill.

Rasch, Horst. "Mein Haus ist Meine Kunst." *Häuser* (February 1982): 28–33, ill. (English supplement: n.p., ill.)

Woodbridge, Sally. "Light Metal." *Progressive Architecture* (August 1982): 72–75, ill.

1983

Albright, Thomas. "The House as a Work of Art." *San Francisco Chronicle,* 24 November 1983: 75, ill.

"'All I Had To Do Was Put My Craft Behind It.'" *University Art Museum, Pacific Film Archive Calendar* (Berkeley), August 1983: 2, ill.

Ashbery, John. "An Artist's Daring Dream House." *House & Garden* 155 (May 1983): 98–109, 192, ill.

Atkins, Robert. "Designer Dwellings." *San Francisco Focus* 30 (April 1983): 38–43, ill.

———. "David Ireland's House." *Journal: A Contemporary Art Magazine* (Los Angeles Institute of Contemporary Art) 4 (spring 1983): 57–59, ill.

———. "David Ireland: Leah Levy Gallery/San Francisco" in "Reviews: West Coast." *Flash Art* 113 (summer 1983): 66, ill.

———. "Light Motif." *California Magazine* 8 (September 1983): 88–89, ill.

———. "David Ireland, Leah Levy Gallery" in "Reviews: San Francisco." *Artforum* 22 (November 1983): 86–87.

———. "David Ireland's 65 Capp Street." *Arts and Architecture* 2 (winter 1983): 66–69, ill.

Spiegel, Janet. "A House That's a Work of Art" in "San Francisco Living." *Los Angeles Times*, 23 January 1983, *Home*: 14–15, 20, ill.

1984

Brenson, Michael. "David Ireland" in "Sculpture: Puryear Postminimalism." *New York Times*, 10 August 1984: C24.

Junker, Howard. "David Ireland at Leah Levy" in "Review of Exhibitions: San Francisco." *Art in America* 72 (January 1984): 132, 135, 137, ill.

MacAdams, Lewis. "The Blendo Manifesto." *California Magazine* 9 (March 1984): 78–88, ill.

Taylor, Robert. "Views of Heaven at MIT." *Boston Sunday Globe*, 8 April 1984: B3.

1985

Baker, Kenneth. "5 Artists Thinking of Leonardo." *San Francisco Chronicle*, 28 November 1985: 89.

Burkhart, Dorothy. "Leonardo Would Be Pleased." *San Jose Mercury News*, 6 December 1985: 16D.

Domergue, Denise. "By Artists/For Artists." *House & Garden* 157 (August 1985): 130–35, 164, ill.

Forgey, Benjamin. "Room with Artistic View: At the WPA, Creating Eerie Beauty from Plain Space." *Washington Post*, 9 February 1985: G1, G5, ill.

Lienhard, Marie-Louise. "Eines Künstlers Haus: 500 Capp Street San Francisco." *Tages Anzeiger Magazin* (Zurich) (September 1985): 6–12, ill.

1986

Arbus, Amy. "To Each His Home." *Washington Post Magazine* (16 November 1986): 28–35, ill.

Dunning, Jennifer. "Douglas Dunn and His Dancing Door." *New York Times*, 13 June 1986: C3.

McCormick, Carlo. "David Ireland: East Carolina University" in "Reviews: Greenville, N.C." *Artforum* 25 (October 1986): 137, ill.

Raynor, Jerry. "David Ireland Installs an Environmental Art Work at ECU." *Daily Reflector* (Greenville, N.C.), 4 May 1986: C8, ill.

Shannon, John. "Old Cafeteria Gets Facelift: Artist Begins Installation" in "Style." *East Carolinian*, 29 April 1986: 7, ill.

Solnit, Rebecca. "After the Master." *Artweek* 17 (11 January 1986): 3–4.

1987

Baker, Kenneth. "Ireland's Installation Runs True to Life." *San Francisco Chronicle*, 8 May 1987: 86, ill.

Drewes, Caroline. "The Lighthouse: Artist David Ireland Resides within His Art." *San Francisco Examiner*, 7 January 1987: E1, E7, ill.

Helfand, Glen. "David Ireland: Filling Spaces with a Sense of History." *San Francisco Sentinel*, 24 April 1987: 26, ill.

Ingersoll, Richard. "Housework: Understanding the Rituals of a Home." *Crit: The Architectural Student Journal* (Washington, D.C.) 18 (spring 1987): 38–42, ill.

Leonard, Michael. "Exploration, Accumulation and Reclamation." *Artweek* 18 (2 May 1987): 8, ill.

Solnit, Rebecca. "A New Place for Art: Art as Place—Part I." *Artweek* 18 (5 September 1987): 21, ill.

———. "A New Place for Art: Art as Place—Part II." *Artweek* 18 (17 October 1987): 11, ill.

Thayer, Kyle. "Dwelling as Reciprocity: The Marin Headlands." *Places* 4 (1987): 68–77, ill.

Weisang, Myriam. "Selective Surface" in "Image." *San Francisco Examiner*, 22 March 1987: 22–25, ill.

Atkins, Robert. "Life Studies." *Elle* 4 (December 1988): 52, ill.

Baker, Kenneth. "Art Comes to Dinner in Santa Barbara." *San Francisco Chronicle,* 21 September 1988: E1.

Crowder, Joan. "There's No Place Like Home" in "Scene." *Santa Barbara News Press,* 9 September 1988: 25–27, ill.

Graziani, Ron. "The Home Show: Public Art in Private Places." *Santa Barbara Magazine* (November/December 1988): 53–57, 58, 60–61, ill.

Guenther, David. " 'Sculpture at the Point' Uneven, Badly Timed." *In Pittsburgh,* 8 June 1988: 6–7.

Ketcham, Diana. "When Houses Are More Than Homes—The Art of Matta-Clark and Ireland." *Oakland Tribune,* 18 October 1988: C3, ill.

McCormick, Carlo. "David Ireland: Damon Brandt" in "Reviews: New York." *Artforum* 27 (September 1988): 138–39, ill.

Russell, John. "Some New Acquisitions at the Modern Museum." *New York Times,* 16 December 1988: C36.

Solnit, Rebecca. "500 Capp Street: David Ireland's Interiors." *Stroll: The Magazine of Outdoor Art and Street Culture* 6/7 (June 1988): 48–54, ill.

———. "Arts." *Pacific Sun* (Mill Valley, Calif.), 11 November 1988: 19.

———. "Object Lessons on the Place for Art." *Artweek* 19 (26 November 1988): 3, ill.

Tsujimoto, Karen. "David Ireland: A Decade Documented: 1978–1988." *University Art Museum Calendar* (Berkeley), October 1988: 3, ill.

Wallach, Amei. "Making the Mundane Art and Art the Mundane." *Newsday* (30 December 1988): 17, ill.

Wilson, William. "Prize Winners That Look to a Losing Future." *Los Angeles Times,* 5 June 1988, *Calendar:* 96–97.

Atkins, Robert. "David Ireland." *7 Days* (11 January 1989): 54.

Bach, Penny Balkin. "To Light Up Philadelphia: Lighting, Public Art, and Public Space." *Art Journal* 48 (winter 1989): 324–30, ill.

Baker, Kenneth. "Six Conceptualists Who Can Stir It Up." *San Francisco Chronicle,* 14 January 1989: C6.

———. "Artists in Residences: The Newest Art Events Are Taking Place in the Privacy of Other People's Houses." *House & Garden* 161 (January 1989): 38, 40 ill.

Berkson, Bill. "David Ireland's Accommodations." *Art in America* 77 (September 1989): 178–87, 225, ill.

Cosentino, Julia. "Art from the Lost and Found: Off-Beat Artist David Ireland." *City on a Hill* (Santa Cruz, Calif.), 19 January 1989: 27, ill.

Curtis, Cathy. "Artist Likes 'Invisible' Art but David Ireland Does Show His Work in UC Irvine Exhibit." *Los Angeles Times* (Orange County Edition), 23 April 1989: 50B.

Greenberg, Blue. "Who Should Decide What Art the Public Can See?" *Durham (N.C.) Morning Herald,* 9 July 1989: n.p., ill.

Hammond, Miki G. "UC Irvine Exhibit Reflects Artist's Belief That Art Occurs in Process of Life Itself." *Irvine (Calif.) World News,* 20 April 1989: B19.

Harris, John. "Home Is Where His Art Is." *Bellingham (Wash.) Herald,* 17 January 1989: C1, ill.

Holst, Lise. "David Ireland: Germans Van Eck" in "Reviews: New York." *Art News* 88 (December 1989): 160, ill.

Lacayo, Richard and Jamie M. Saul. "David Ireland's Art Doesn't Just Hang on a Wall—It Is the Wall." *People Weekly* 31 (10 April 1989): 135–39, ill.

Levin, Kim. "David Ireland" in "Choices: Art." *Village Voice,* 10 January 1989: 40.

Levy, Mark. "Images of Power" in "World Chronicle: San Francisco." *Art International* 6 (spring 1989): 66–68, ill.

Litt, Steven. "The Public Domain." *Raleigh (N.C.) News and Observer,* 16 June 1989: 3, 5.

Martinez, Katherine. "Artist Ireland Challenges Tradition." *New University* (Irvine, Calif.), 3 April 1989: 21, ill.

Nesbitt, Lois E. "David Ireland: Germans Van Eck" in "Reviews: New York." *Artforum* 28 (December 1989): 142–43, ill.

Novakov, Anna. "David Ireland: University Art Museum, Berkeley." *Sculpture* 8 (May/June 1989): 91, ill.

Porges, Maria. "David Ireland: University Art Museum, University of California, Berkeley." *Art Coast Magazine* (March/April 1989): 102, ill.

Redd, Chris. "Public Art Dialogue = Southeast: Durham Conference Fails to Address the Big Issues in a Controversial Field." *Arts Journal* (Asheville, N.C.) (August 1989): 4–5, ill.

Solnit, Rebecca. "Reminders, Denominators, Souvenirs." *Artweek* 20 (28 January 1989): 3.

Sorenson, Dina. "David Ireland." *Arts Magazine* 64 (December 1989): 76, ill.

Stein, Karen D. "Brave New World." *Architectural Record* 177 (September 1989): 118–25, ill.

Szakacs, Dennis. "Public Art: The Big Lie?" *Independent Weekly* (N.C.), 22 June 1989: 16–17, ill.

Tamblyn, Christine. "David Ireland: University Art Museum" in "Reviews: Berkeley." *Art News* 88 (March 1989): 186–87, ill.

Tsai, Eugenie. "David Ireland: Museo de Arte Moderno." *Arena* (January/February 1989): 110–11, ill.

1990

Baker, Kenneth. "Triton Hosts the Best of Traditional Art/David Ireland Works at Paule Anglim." *San Francisco Chronicle,* 20 October 1990: C5.

Bonetti, David. "Rare Ireland Show Is on the Ball." *San Francisco Examiner,* 19 October 1990: C2, ill.

Burchard, Hank. "Window Is a Wash." *Washington Post,* 3 August 1990: N57.

Floss, Michael. "The Naked Home: David Ireland at Gallery Paule Anglim." *Artweek* 21 (25 October 1990): 14, ill.

Forgey, Benjamin. "New Views Through the Picture Window: David Ireland's Hirshhorn Installation." *Washington Post,* 27 July 1990: D2, ill.

Gibson, Eric. "At Hirshhorn, Seeing Is Only Part of Vision." *Washington Times,* 30 July 1990: E3.

Katsumata, Wayne. "David Ireland" in "Revitalizing Scene 3" (in Japanese). *AXIS* 35 (spring 1990): 2–3, ill.

Marincola, Paula. "Signs of Life." *Contemporanea* 21 (October 1990): 92, ill.

Nesbitt, Lois E. "(Self-) Representation." *Arts Magazine* 64 (summer 1990): 61–67, ill.

Perrée, Rob. "Het Onzichtbare Werk Van David Ireland." *Kunst Beeld* (Amsterdam) 14 (February 1990): 32–34, ill.

Roche, Harry. "David Ireland" in "Critic's Choice/Art." *San Francisco Bay Guardian,* 24 October 1990: 49, ill.

Slesin, Suzanne. "The Design 100: An Exhibition Celebrates Style-Setters and Mold-Breakers." *New York Times,* 8 March 1990: B6.

Unger, Miles. "Lowell's Proud Past Brought Back to Light: Work Reveals Heroic Industrial Forms." *Boston Sunday Globe,* 11 November 1990: 11, 14, ill.

1991

"Il Patrimonio Storico: Fort Barry." *Abitare* no. 294 (March 1991): 192–99, 232, ill.

Jacobson, Susan. "A Sculptor's Order: David Ireland." *CCAC News* (Oakland, Calif.) 1 (summer 1991): 1, 3, ill.

Kahn, Eve M. "An Experiment in Public Art." *Wall Street Journal,* 21 October 1991: A16.

Lienhard, Marie-Louise. "You Can't Make Art by Making Art: David Ireland in Switzerland." *Parkett* 29 (1991): 149–55, ill.

Maurer, Simon. "Helmhaus: David Ireland." *Züritip* (Zurich) (28 June–4 July 1991): 30–31, ill.

1992

Abbe, Mary. "Flour Power" in "Vasari Diary." *Art News* 91 (September 1992): 14, 16, ill.

Curtis, Cathy. "Favorite Things" in "Calendar." *Los Angeles Times* (Orange County Edition), 11 March 1992: F2, F5.

Halpern, Nora. "David Ireland: Ruth Bloom" in "Reviews: Los Angeles." *Flash Art* (International Edition) 25 (November/December 1992): 102, ill.

Kandel, Susan. "David Ireland: Calculatedly Carnivalesque Work." *Los Angeles Times,* 17 September 1992: F6–7, ill.

Pagel, David. "David Ireland." *Art Issues* 25 (November/December 1992): 47, ill.

Scarborough, James. "David Ireland at Ruth Bloom Gallery." *Artweek* 23 (8 October 1992): 20, ill.

Smith, Joan. "When Push Comes to Shovel." *San Francisco Examiner,* 12 April 1992: D1, D8.

1993

Jarrell, Joe. "David Ireland: Ruth Bloom Gallery, Santa Monica" in "Reviews: California." *Sculpture* 12 (January/February 1993): 66, ill.

Raczka, Robert. "David Ireland" in "Reviews: Pennsylvania." *New Art Examiner* 21 (September 1993): 37, ill.

Tanner, Marcia. "A Little Game Between 'I', 'Me' and Marcel: Duchamp's Ghost Haunts Ireland—in California." *Visions* (spring 1993): 40.

Van de Walle, Mark. "David Ireland: Laura Carpenter Fine Art" in "Reviews: Santa Fe." *Artforum* 31 (summer 1993): 115, ill.

1994

Baker, Kenneth. "Artist Finds Poetry in Isolation." *San Francisco Chronicle,* 17 March 1994: D1, D5, ill.

Bonetti, David. "'The Most Fantastic and Impossible Rock in the World': Photo Installation Celebrates the Isolated, Rugged Beauty of an Emerald Isle." *San Francisco Examiner,* 17 March 1994: C1, C8, ill.

Duncan, Michael. "David Ireland at the Ansel Adams Center" in "Review of Exhibitions: San Francisco." *Art in America* 82 (November 1994): 138, ill.

Webster, Mary Hull. "A Monk's Grace: David Ireland's Skellig at Ansel Adams Center." *Artweek* 25 (7 April 1994): 16, ill.

Weiffenbach, Jean-Edith. "What Bay Area?" *Art Journal* 53 (22 September 1994): 46–47.

1996

Artner, Alan G. "Ireland's 'Bedlam' Makes Sense" in "Tempo." *Chicago Tribune,* 25 April 1996: sec. 5, 2.

Baker, Kenneth. "Two New Outlooks on Conceptual Art/Idea-Centered Pieces Make a Comeback." *San Francisco Chronicle,* 31 July 1996: E1.

Bonetti, David. "Tattoos as a Serious Art Form/Exhibit at Yerba Buena Arts Center Treats Them as More Than Skin Deep." *San Francisco Examiner,* 20 June 1996: C1.

Connors, Thomas. "David Ireland: The Arts Club of Chicago" in "Reviews: Chicago." *Sculpture* 15 (October 1996): 57–58, ill.

Crawford, Leslie. "Visual Art: David Ireland" in "Class Acts: The First Annual Arts Achievement Awards." *San Francisco Focus* 43 (January 1996): 39–48, 110, ill.

Porges, Tim. "David Ireland" in "Reviews: Chicago." *New Art Examiner* 24 (September 1996): 38–39, ill.

Princenthal, Nancy. "David Ireland at Jay Gorney" in "Review of Exhibitions: New York." *Art in America* 84 (March 1996): 97–98, ill.

Sand, Olivia. "David Ireland: Trophies, Jay Gorney Modern Art, New York." *Artis* 48 (February/March 1996): 60–61, ill.

1997

Bassett, Hillary. "Institute of Contemporary Art/Portland: David Ireland" in "Regional Reviews: Maine." *Art New England* 18 (June/July 1997): 31–32.

Weinstein, Jeff. "Art in Residence." *Artforum* 35 (March 1997): 61, ill.

1998

Baker, Kenneth. "Modern Living in an Uneasy Chair." *San Francisco Chronicle,* 19 March 1998: E1, E4, ill.

Bonetti, David. "Kemp: An Artist Unmasks the Past" in "Gallery Watch." *San Francisco Examiner,* 27 March 1998: D11.

1999

Nelson, James R. "Exhibit Offers Look at End-of-Millennium Aesthetics." *Birmingham (Ala.) News,* 26 September 1999: 6F.

2000

Bonetti, David. "Charting 35 Years of California Art." *San Francisco Examiner,* 6 January 2000: B8.

Csaszar, Tom. "Reading, Pennsylvania" in "Reviews." *Art Papers* 24 (September/October 2000): 47, ill.

Heartney, Eleanor. "David Ireland at Jack Shainman" in "Review of Exhibitions: New York." *Art in America* 88 (October 2000): 172–73.

Johnson, Ken. "David Ireland" in "Art in Review." *New York Times,* 31 March 2000: E35.

Klausner, Betty. "Dumb Balls." Excerpt from forthcoming book on David Ireland. *Land Forum* (Berkeley) 4 (2000): 94–97, ill.

Silver, Joanne. "Photo Exhibit Is Pure 'Rapture'." *Boston Herald,* 28 January 2000: S6.

Temin, Christine. "Assorted Artists Capture 'Rapture'" in "Living Arts." *Boston Globe,* 2 February 2000: D1, D7, ill.

2001

Baker, Kenneth. "De Young Paintings Get New Look: Ireland Builds Show on 8 Borrowed Works." *San Francisco Chronicle,* 28 February 2001: E3, ill.

———. "David Ireland: Paule Anglim" in "Reviews." *Art News* 100 (June 2001): 134–35, ill.

Duncan, Michael. "David Ireland at Paule Anglim" in "Review of Exhibitions." *Art in America* 89 (October 2001): 172, ill.

Knight, Christopher. "Art Reviews." *Los Angeles Times,* 5 October 2001: F22.

Roth, Charlene. "David Ireland at Christopher Grimes" in "Reviews: Southern California." *Artweek* 32 (November 2001): 21–22, ill.

2002

Zellen, Jody. "Episode: David Ireland at Christopher Grimes." *dArt International* (winter 2002): 39, ill.

Video Recordings

Labat, Tony. *David Ireland's House.* 1977–78.

———. *David Ireland's House: Outside.* 1979.

———. *Lunch with Mr. Gordon.* 1979.

Marioni, Tom. *David Ireland: Repair of the Sidewalk.* 1976.

SHARON E. BLISS AND BARBARA EATON

Catalogue numbers denote both the exhibition checklist and works reproduced in this publication but not included in the exhibition. The latter works are identified as such. The checklist identifies works for presentation at the Oakland Museum of California; a modified version of the exhibition will tour nationally. Figure numbers indicate additional illustrations for the text and chronology. Full information for all images is given below. Works are listed in general chronological order. Dates separated by a slash indicate that a work was subsequently altered by the artist. In the listing of dimensions, height precedes width precedes depth. For works on paper, measurements indicate sheet size unless otherwise noted. In most cases, titles and dates have been supplied by the artist, the owners, or the custodians of the artwork. In some instances of titles and dates, the artist has modified previously published information.

Frontispiece. David Ireland, 1999
Copyright © Elisa Cicinelli

Catalogue numbers

1.
Quarter Circle Drawing, 1972–73
Ink, wax, and dirt on paper
39½ x 39¾ inches
Courtesy of the artist; Gallery Paule Anglim, San Francisco; Christopher Grimes Gallery, Santa Monica, California; and Jack Shainman Gallery, New York

2.
Figure with Harmless Torpedo, 1973
Tempera and crayon on paper
25 x 19 inches
Courtesy of the artist; Gallery Paule Anglim, San Francisco; Christopher Grimes Gallery, Santa Monica, California; and Jack Shainman Gallery, New York

3.
Folded Paper Landscape, 1973
Paper bag
29¾ x 19 inches
Courtesy of the artist; Gallery Paule Anglim, San Francisco; Christopher Grimes Gallery, Santa Monica, California; and Jack Shainman Gallery, New York

4.
Leaning Figure, 1973
Tempera and crayon on paper
25 x 19 inches
Courtesy of the artist; Gallery Paule Anglim, San Francisco; Christopher Grimes Gallery, Santa Monica, California; and Jack Shainman Gallery, New York

5.
Proscenium, 1973
Graphite, tempera, and charcoal on paper
25 x 19 inches
Courtesy of the artist; Gallery Paule Anglim, San Francisco; Christopher Grimes Gallery, Santa Monica, California; and Jack Shainman Gallery, New York

6.
Wave, 1973
Graphite on paper
25 x 19 inches
Courtesy of the artist; Gallery Paule Anglim, San Francisco; Christopher Grimes Gallery, Santa Monica, California; and Jack Shainman Gallery, New York

7.
Architecture, 1974
Monotype on paper
41 x 29¼ inches
Courtesy of the artist; Gallery Paule Anglim, San Francisco; Christopher Grimes Gallery, Santa Monica, California; and Jack Shainman Gallery, New York

8.

Dirt Work with Flakes, 1974
Dirt on paper
38 x 25¾ inches (irreg.)
Courtesy of the artist; Gallery Paule Anglim, San Francisco;
Christopher Grimes Gallery, Santa Monica, California; and
Jack Shainman Gallery, New York

9.

Landscape, 1974
Monotype on paper
40 x 30 inches
Courtesy of the artist; Gallery Paule Anglim, San Francisco;
Christopher Grimes Gallery, Santa Monica, California; and
Jack Shainman Gallery, New York

10.

Peeled Drawing, 1974
Talcum on paper
22¼ x 26¼ inches (irreg.)
Courtesy of the artist; Gallery Paule Anglim, San Francisco;
Christopher Grimes Gallery, Santa Monica, California; and
Jack Shainman Gallery, New York

11.

Untitled Landscape, 1974
Monotype on paper
29¾ x 31½ inches
Courtesy of the artist; Gallery Paule Anglim, San Francisco;
Christopher Grimes Gallery, Santa Monica, California; and
Jack Shainman Gallery, New York

12.

Black Crayon with Rectangular Hole, 1975
Wax crayon on paper
22¾ x 20¼ inches
Courtesy of the artist; Gallery Paule Anglim, San Francisco;
Christopher Grimes Gallery, Santa Monica, California; and
Jack Shainman Gallery, New York

13.

Crayon with Rectangular Hole, 1975
Wax crayon on paper
28¼ x 20 inches
Courtesy of the artist; Gallery Paule Anglim, San Francisco;
Christopher Grimes Gallery, Santa Monica, California; and
Jack Shainman Gallery, New York

14.

*A Portion of: From the Year of Doing the Same Work
Each Day,* 1975
Concrete and polymer on plastic screen mounted on canvas
70¾ x 44 inches
Courtesy of the artist; Gallery Paule Anglim, San Francisco;
Christopher Grimes Gallery, Santa Monica, California; and
Jack Shainman Gallery, New York

15.

*A Portion of: From the Year of Doing the Same Work
Each Day/Elephant's Castle,* 1975
Concrete and polymer on paper
52 x 77 inches (irreg.)
Courtesy of the artist; Gallery Paule Anglim, San Francisco;
Christopher Grimes Gallery, Santa Monica, California; and
Jack Shainman Gallery, New York

16.

Waxed Cement with Hole, 1975
Cement and wax on gessoed paper
22½ x 20 inches
Courtesy of the artist; Gallery Paule Anglim, San Francisco;
Christopher Grimes Gallery, Santa Monica, California; and
Jack Shainman Gallery, New York

17.

White Crayon Drawing, 1975
Wax crayon on paper
28 x 20 inches
Courtesy of the artist; Gallery Paule Anglim, San Francisco;
Christopher Grimes Gallery, Santa Monica, California; and
Jack Shainman Gallery, New York

18.

Wire and Concrete, 1975
Concrete and wire on canvas
23½ x 18¾ x 2¾ inches (irreg.)
Courtesy of the artist; Gallery Paule Anglim, San Francisco;
Christopher Grimes Gallery, Santa Monica, California; and
Jack Shainman Gallery, New York

19.

Finger Prints, 1975–76
Plasticine on fiberglass mesh
18⅜ x 21 inches (irreg.)
Courtesy of the artist; Gallery Paule Anglim, San Francisco;
Christopher Grimes Gallery, Santa Monica, California; and
Jack Shainman Gallery, New York

20.
Zigzag, 1975–76
Plasticine on fiberglass mesh
13⅞ x 19½ inches (irreg.)
Courtesy of the artist; Gallery Paule Anglim, San Francisco;
Christopher Grimes Gallery, Santa Monica, California; and
Jack Shainman Gallery, New York

21.
*A Painting on a Wall in a Room Being the Same Material
as the Floor*, 1976
Installation for exhibition *18 Bay Area Artists*, Los Angeles
Institute of Contemporary Art, 1976
Cement on drywall
13 x 20 feet (approx.)
Photograph courtesy of the artist
(Reproduced in catalogue only)

22.
Sidewalk repair, 500 Capp Street, San Francisco, 1976
Photograph courtesy of the artist
(Reproduced in catalogue only)

23.
Footprint of 500 Capp Street, 1976–77
Shoe polish on paper
25 x 19 inches
Courtesy of the artist; Gallery Paule Anglim, San Francisco;
Christopher Grimes Gallery, Santa Monica, California; and
Jack Shainman Gallery, New York

24.
Ground Floor Plan of 500 Capp Street, 1976–77
Graphite on paper
25 x 19 inches
Courtesy of the artist; Gallery Paule Anglim, San Francisco;
Christopher Grimes Gallery, Santa Monica, California; and
Jack Shainman Gallery, New York

25.
Collection of Relics with Mike Roddy's Ink Cans, 1976–78
Metal cabinet with found objects
60 x 24 x 12 inches
Courtesy of the artist; Gallery Paule Anglim, San Francisco;
Christopher Grimes Gallery, Santa Monica, California; and
Jack Shainman Gallery, New York
Photograph courtesy of Henry Bowles
Copyright © Henry Bowles
(Reproduced in catalogue only)

26.
Confluxus, 1977
Installation for exhibition *18 Bay Area Artists*, University of
California, Berkeley Art Museum, 1977
Play-Doh and paper on drywall
10 x 46 feet (approx.)
Photograph courtesy of the artist
(Reproduced in catalogue only)

27.
Rubber Band Collection with Sound Accompaniment, 1977
Rubber bands, glass jar, wire, wood stool, wood molding,
tape recorder, and earphones
54½ x 20½ x 13½ inches
Courtesy of the artist; Gallery Paule Anglim, San Francisco;
Christopher Grimes Gallery, Santa Monica, California; and
Jack Shainman Gallery, New York
(Reproduced in catalogue only)

28.
Spanish Corner Cabinet, 1977–97
Wood, enamel, cardboard, metal, glass ice-cream dishes,
spoons, concrete, broom, wire, sponge, branch, spooled wire,
and dirt
62 x 69 x 18 inches
Collection of Jack Shainman, New York

29.
Three-Legged Chair, 1978
Wood chair, journal, and metal chain
30½ x 18 x 17 inches
Courtesy of the artist; Gallery Paule Anglim, San Francisco;
Christopher Grimes Gallery, Santa Monica, California; and
Jack Shainman Gallery, New York
Copyright © 1985 Abe Frajndlich

30.
TV with Viewing Chair, 1978
Television set, wood table, and wood chair
43½ x 27½ x 19½ inches
Courtesy of the artist; Gallery Paule Anglim, San Francisco;
Christopher Grimes Gallery, Santa Monica, California; and
Jack Shainman Gallery, New York
Photograph courtesy of Henry Bowles
Copyright © Henry Bowles
(Reproduced in catalogue only)

31.
Broom Collection with Boom, 1978/88
Brooms, wire, copper, concrete, and C-clamp
52 x 31 x 82 inches
Courtesy of the artist; Gallery Paule Anglim, San Francisco;
Christopher Grimes Gallery, Santa Monica, California; and
Jack Shainman Gallery, New York

32.
Elephant Stool with Shade, 1978/91
Wallpaper, wood stool, wire, and velvet
47 x 13 x 13 inches
Collection of REFCO Group, Ltd., Chicago

33.
500 Capp Street (interior view with fireplace), San Francisco,
1980
Photograph courtesy of M. Lee Fatherree
Copyright © M. Lee Fatherree
(Reproduced in catalogue only)

34.
A Decade Document, Withcomet, Andcomet, Andstool, 1980–90
Wood, paper, Comet, and paint
86 x 40¾ x 20 inches (approx.)
Collection of San Francisco Museum of Modern Art;
purchased through a gift of Valerie Maslak and the Accessions
Committee Fund: gift of Evelyn and Walter Haas, Jr., Mimi
and Peter Haas, Helen and Charles Schwab, and Mr. and
Mrs. Brooks Walker, Jr.

35.
500 Capp Street (interior view with copper window),
San Francisco, 1981
Photograph courtesy of Henry Bowles
Copyright © Henry Bowles
(Reproduced in catalogue only)

36.
65 Capp Street (interior view), San Francisco, 1981
Photograph courtesy of Henry Bowles
Copyright © Henry Bowles
(Reproduced in catalogue only)

37.
65 Capp Street (exterior view), San Francisco, 1982
Photograph courtesy of Henry Bowles
Copyright © Henry Bowles
(Reproduced in catalogue only)

38.
Dumbball, 1983
Concrete
4 inches diameter
Courtesy of the artist; Gallery Paule Anglim, San Francisco;
Christopher Grimes Gallery, Santa Monica, California; and
Jack Shainman Gallery, New York

39.
Dumbball Box, 1983
Wood, plastic laminate, glass, lightbulb, and concrete
42 x 47 x 19½ inches
Courtesy of the artist; Gallery Paule Anglim, San Francisco;
Christopher Grimes Gallery, Santa Monica, California; and
Jack Shainman Gallery, New York

40.
500 Capp Street (exterior view), San Francisco, 1983
Photograph courtesy of M. Lee Fatherree
Copyright © M. Lee Fatherree
(Reproduced in catalogue only)

41.
*Mixed-Media Piece with Photograph, Dumbball, and Tether on
Green Shelf,* 1983–89
Concrete, framed photograph, wire, screw, enamel, wood,
and wax
41 x 16 x 15½ inches
Collection of Merry Norris, Los Angeles

42.
Installation view of exhibition *Currents: David Ireland,*
New Museum of Contemporary Art, New York, 1984
Photograph courtesy of New Museum of Contemporary Art,
New York
(Reproduced in catalogue only)

43.
Jade Garden (interior view with corrugated metal wall),
1984–85
A collaboration with Robert Wilhite for Washington Project
for the Arts, Washington, D.C.
Photograph courtesy of Henry Bowles
Copyright © Henry Bowles
(Reproduced in catalogue only)

44.

Jade Garden (interior view with couch), 1984–85
A collaboration with Robert Wilhite for Washington Project
for the Arts, Washington, D.C.
Photograph courtesy of Henry Bowles
Copyright © Henry Bowles
(Reproduced in catalogue only)

45.

Contadina, 1985
Installation for exhibition *Inspired by Leonardo*, San Francisco
Art Institute, 1985
Polyurethane on drywall
16 x 54½ x 26 feet
Photograph courtesy of Henry Bowles
Copyright © Henry Bowles
(Reproduced in catalogue only)

46.

500 Capp Street (interior view with *Broom Collection* and
woven chairs), San Francisco, 1985
Photograph courtesy of Abe Frajndlich
Copyright © 1985 Abe Frajndlich
(Reproduced in catalogue only)

47.

Dumbball Action, 1986
Gelatin silver print
14 x 11 inches
Courtesy of the artist; Gallery Paule Anglim, San Francisco;
Christopher Grimes Gallery, Santa Monica, California; and
Jack Shainman Gallery, New York

48.

500 Capp Street (interior hallway view), San Francisco, 1986
Photograph courtesy of Abe Frajndlich
Copyright © 1986 Abe Frajndlich
(Reproduced in catalogue only)

49.

Headlands Center for the Arts, Building 944 entryway,
Sausalito, California, 1986–87
Photograph courtesy of Henry Bowles
Copyright © Henry Bowles
(Reproduced in catalogue only)

50.

Headlands Center for the Arts, Building 944, Rodeo Room,
Sausalito, California, 1986–87
Photograph courtesy of Richard Barnes
Copyright © Richard Barnes
(Reproduced in catalogue only)

51.

Newgate (aerial view), 1986–87
Installation at Candlestick Point State Recreation Area,
San Francisco
Concrete
Photograph courtesy of the artist
(Reproduced in catalogue only)

52.

Newgate, 1986–87
Installation at Candlestick Point State Recreation Area,
San Francisco
Concrete
Photograph courtesy of the artist
(Reproduced in catalogue only)

53.

500 Capp Street (interior view with logs in doorway),
San Francisco, 1987
Photograph courtesy of Suzanne Parker
Copyright © Suzanne Parker
(Reproduced in catalogue only)

54.

New Shoes, 1987
Metal and wood table with enamel, concrete, and paper
72¾ x 24 x 20 inches
Collection of The Museum of Modern Art, New York; gift of
Emily and Jerry Spiegel, 1990
Digital image © 2002 The Museum of Modern Art, New York

55.

Smithsonian Falls, Descending a Staircase for P.K., 1987
Installation for exhibition *David Ireland: Gallery as Place*,
San Francisco Art Institute, 1987
Concrete
11½ x 19 x 11 feet (irreg.)
Photograph courtesy of San Francisco Art Institute Archives
Copyright © 2002 Simo Neri
(Reproduced in catalogue only)

56.
Three Attempts to Understand Van Gogh's Ear in Terms of the Map of Africa, 1987
Elephant ear, enameled wood table, concrete, and wire
96 x 36 x 18 inches
Collection of Eileen and Peter Norton, Santa Monica, California

57.
Bassinet, 1988
Enamel bowl, wire, fabric, and dye
40 x 27 x 22 inches
Courtesy of the artist; Gallery Paule Anglim, San Francisco; Christopher Grimes Gallery, Santa Monica, California; and Jack Shainman Gallery, New York
Photograph courtesy of the artist
(Reproduced in catalogue only)

58.
David Ireland in his garage, 500 Capp Street, San Francisco, 1988
Photograph courtesy of Suzanne Parker
Copyright © Suzanne Parker
(Reproduced in catalogue only)

59.
Installation view from exhibition *Awards in the Visual Arts 7,* Los Angeles County Museum of Art, 1988
Photograph courtesy of the artist
Copyright © 2003 Museum Associates/LACMA
(Reproduced in catalogue only)

60.
Pittcairn, 1988
Installation for *Sculpture at the Point,* organized by the Three Rivers Arts Festival, an activity of the Carnegie Museum of Art, Pittsburgh, 1988
Cast concrete
Photograph courtesy of Howard P. Nuernberger
(Reproduced in catalogue only)

61.
Pittcairn, 1988
Installation for *Sculpture at the Point,* organized by the Three Rivers Arts Festival, an activity of the Carnegie Museum of Art, Pittsburgh, 1988
Cast concrete
Photograph courtesy of Howard P. Nuernberger
(Reproduced in catalogue only)

62.
School of Chairs, 1988
Installation for exhibition *David Ireland: A Decade Documented, 1978–88* (MATRIX 120), University of California, Berkeley Art Museum, 1988
Metal chairs with fabric and wood
32 x 17 x 17 inches each; overall: 32 x 96 x 96 inches (approx.)
Photograph courtesy of the artist
(Reproduced in catalogue only)

63.
Untitled Identified Objects, 1988
Dirt and paper
8 x 4 x 3 inches each (approx.)
Courtesy of the artist; Gallery Paule Anglim, San Francisco; Christopher Grimes Gallery, Santa Monica, California; and Jack Shainman Gallery, New York
Photograph courtesy of Suzanne Parker
Copyright © Suzanne Parker
(Reproduced in catalogue only)

64.
Spout o' Tools, ca. 1988–89
Concrete, hammer, and ax
20 x 10 x 9½ inches
Collection of Ellen Ramsey Sanger and John M. Sanger, San Francisco

65.
Confessional, 1989
Metal chairs and C-clamps
48 x 20 x 20 inches (approx.)
Private collection, New York
Copyright © 2002 Jon and Anne Abbott

66.
Kimberly, 1989
Metal cabinet, enamel bowl, ceramic figurines, window casing, wire mesh, dirt, concrete, and lightbulb
78½ x 30 x 25 inches
Collection of Addison Gallery of American Art, Phillips Academy, Andover, Massachusetts; gift of Agnes Bourne
(Reproduced in catalogue only)

67.
No Mind in Things, 1989
Aluminum pitcher, wood table, and concrete
16 x 22⅜ x 10⅜ inches
Private collection, New York
Copyright © 2002 Jon and Anne Abbott

68.

Rubber Shoe, ca. 1989
Rubber
5¾ x 13 x 4¾ inches
Courtesy of the artist; Gallery Paule Anglim, San Francisco;
Christopher Grimes Gallery, Santa Monica, California; and
Jack Shainman Gallery, New York
Photograph courtesy of the artist
(Reproduced in catalogue only)

69.

Ear Painting, 1990
Acrylic and enamel on paper
16 x 12 inches
Courtesy of the artist; Gallery Paule Anglim, San Francisco;
Christopher Grimes Gallery, Santa Monica, California; and
Jack Shainman Gallery, New York

70.

Ear Painting, 1990
Acrylic and enamel on paper
16 x 12 inches
Courtesy of the artist; Gallery Paule Anglim, San Francisco;
Christopher Grimes Gallery, Santa Monica, California; and
Jack Shainman Gallery, New York

71.

Air Where You Are, ca. 1990
Fixall, wire, and glass jar with metal lid
5¾ x 15½ x 8¾ inches
Courtesy of the artist; Gallery Paule Anglim, San Francisco;
Christopher Grimes Gallery, Santa Monica, California; and
Jack Shainman Gallery, New York
Photograph courtesy of the artist
(Reproduced in catalogue only)

72.

Intentional Spill, 1990–91
Wood box, cardboard, oil paint, glue, and metal can
40 x 17 x 17 inches
Collection of Mr. and Mrs. Barry Hockfield, Penn Valley,
Pennsylvania

73.

David Ireland working on exhibition *David Ireland in
Switzerland: You Can't Make Art by Making Art,* Helmhaus,
Zurich, 1991
Photograph courtesy of Friedrich Zubler
(Reproduced in catalogue only)

74.

Good Hope, 1991
Copper, wire, broom, concrete, and wood stool
77 x 22 x 13 inches
Collection of University of California, Berkeley Art Museum;
purchase made possible by a bequest from Therese Bonney,
Class of 1916

75.

Harp, 1991
Metal basin, metal stool, wire, cheesecloth, fabric dye, and
C-clamp
69 x 20 x 12 inches
Collection of Oakland Museum of California; gift of the Art
Guild and Reichel Trust 93.5.1

76.

Installation view from exhibition *David Ireland in
Switzerland: You Can't Make Art by Making Art* (hallway),
Helmhaus, Zurich, 1991
Photograph courtesy of Friedrich Zubler
(Reproduced in catalogue only)

77.

Installation view from exhibition *David Ireland in
Switzerland: You Can't Make Art by Making Art* (window),
Helmhaus, Zurich, 1991
Photograph courtesy of the artist
(Reproduced in catalogue only)

78.

Vanity, 1991–2000
Porcelain sink, metal, felt, fabric, and mirror with wood frame
59 x 29½ x 21 inches
Courtesy of the artist; Gallery Paule Anglim, San Francisco;
Christopher Grimes Gallery, Santa Monica, California; and
Jack Shainman Gallery, New York

79.

Ego, 1992
Branded alder wood, glass, and wood cabinet
60½ x 40 x 15 inches
Collection of Nora Eccles Harrison Museum of Art,
Utah State University, Logan; Marie Eccles Caine Foundation
Gift, NEHMA 1995.4

217

80.

Initial Machine, 1992
Metal, motor, and enamel
50½ x 20 x 20 inches
Courtesy of the artist; Gallery Paule Anglim, San Francisco;
Christopher Grimes Gallery, Santa Monica, California; and
Jack Shainman Gallery, New York
(Reproduced in catalogue only)

81.

Initial Machine (rotating), 1992
Metal, motor, and enamel
50½ x 20 x 20 inches
Courtesy of the artist; Gallery Paule Anglim, San Francisco;
Christopher Grimes Gallery, Santa Monica, California; and
Jack Shainman Gallery, New York
(Reproduced in catalogue only)

82.

Other Id, 1992
Branded alder wood, glass, metal, paint, and pillow
66 x 43 x 21½ inches
Collection of Iris and B. Gerald Cantor Center for Visual
Arts, Stanford University, Stanford, California; Modern and
Contemporary Art Fund, 1998.109.a-d

83.

Penn's Pocket, 1992 (reconstructed for exhibition)
Drywall, paint, photograph, and lightbulb
10 x 30 x 5 feet (approx.)
Courtesy of the artist; Gallery Paule Anglim, San Francisco;
Christopher Grimes Gallery, Santa Monica, California; and
Jack Shainman Gallery, New York

84.

*79 Dumbballs with Carriers, Dedicated to the Memory of
John Cage,* 1992
Concrete and wood
32 x 21 x 17 inches (stacked)
Collection of Tom Patchett, Santa Monica, California

85.

Snow Pour, 1992
Minneapolis Sculpture Garden, Walker Art Center
Photograph courtesy of the artist
(Reproduced in catalogue only)

86.

Tray of Dumbballs, 1992
Cement and silver-plated tray
5 x 21 x 12 inches
Collection of Ann and Bob Myers, Orange, California

87.

Flag of Spain, 1992–94
Wood, enamel, and metal cans
41 x 38 x 9 inches
Collection of Ann Hatch and Paul Discoe, San Francisco

88.

After Skellig, Green, 1993
Enamel on paper
12 x 9 inches
Courtesy of the artist; Gallery Paule Anglim, San Francisco;
Christopher Grimes Gallery, Santa Monica, California; and
Jack Shainman Gallery, New York

89.

After Skellig, Red, 1993
Enamel on paper
12½ x 9½ inches
Courtesy of the artist; Gallery Paule Anglim, San Francisco;
Christopher Grimes Gallery, Santa Monica, California; and
Jack Shainman Gallery, New York

90.

Basement Studio with Brown Panel, 1993
Enamel on gelatin silver print
16 x 23¼ inches
Courtesy of the artist; Gallery Paule Anglim, San Francisco;
Christopher Grimes Gallery, Santa Monica, California; and
Jack Shainman Gallery, New York

91.

Boulevard, 1993
Detail from exhibition *David Ireland: Installation,* Mattress
Factory, Pittsburgh, 1993
Concrete lawn ornaments, metal cabinet, patio furniture, and
ficus trees
Photograph courtesy of the artist
(Reproduced in catalogue only)

92.

Cast Concrete Head with Dumbball, 1993 (no longer extant)
Concrete and wood
36 × 6 × 8 inches (approx.)
Photograph courtesy of the artist
(Reproduced in catalogue only)

93.

Concrete Acorns in Wire Basket, 1993
Gelatin silver print
20 × 23¾ inches
Courtesy of the artist; Gallery Paule Anglim, San Francisco;
Christopher Grimes Gallery, Santa Monica, California; and
Jack Shainman Gallery, New York

94.

Concrete Study, 1993
Gelatin silver print
20 × 23⅞ inches
Courtesy of the artist; Gallery Paule Anglim, San Francisco;
Christopher Grimes Gallery, Santa Monica, California; and
Jack Shainman Gallery, New York

95.

The Ears Have It, 1993
Enamel on gelatin silver print
23½ × 16 inches
Courtesy of the artist; Gallery Paule Anglim, San Francisco;
Christopher Grimes Gallery, Santa Monica, California; and
Jack Shainman Gallery, New York

96.

*A Variation on 79, Side to Side Passes of a Dumbball, Dedicated
to the Memory of John Cage (1912–1992),* 1993
Five intaglio prints, two pine boxes, and two metal music
stands
53 × 37 × 22 inches; 45 × 36¼ × 19 inches
Published by C. Editions, San Francisco; printed by Teaberry
Press, San Francisco
Collection of Fine Arts Museums of San Francisco; gift of
Agnes Bourne

97.

500 Capp Street (interior view), San Francisco, ca. 1993
Photograph courtesy of the artist
(Reproduced in catalogue only)

98.

Rolling Skellig, 1993–94
Enamel on gelatin silver prints and steel
52 × 76½ × 22 inches
Courtesy of the artist; Gallery Paule Anglim, San Francisco;
Christopher Grimes Gallery, Santa Monica, California; and
Jack Shainman Gallery, New York

99.

Abbot Hall Artist Apartment (view with chairs), 1993–96
Addison Gallery of American Art, Phillips Academy,
Andover, Massachusetts; gift of Ann M. Hatch (AA '67)
1996.73
Copyright © Addison Gallery of American Art, Phillips
Academy, Andover, Massachusetts. All rights reserved
(Reproduced in catalogue only)

100.

Abbot Hall Artist Apartment (view with beams), 1993–96
Addison Gallery of American Art, Phillips Academy,
Andover, Massachusetts; gift of Ann M. Hatch (AA '67)
1996.73
Copyright © Addison Gallery of American Art, Phillips
Academy, Andover, Massachusetts. All rights reserved
(Reproduced in catalogue only)

101.

Installation view from exhibition *David Ireland: Skellig,*
Ansel Adams Center for Photography, San Francisco, 1994
Photograph courtesy of the artist
(Reproduced in catalogue only)

102.

Marcel B., 1994
Kipper cans, enamel, wood, steel, and cardboard box
39½ × 42 × 60 inches (irreg.)
Courtesy of the artist; Gallery Paule Anglim, San Francisco;
Christopher Grimes Gallery, Santa Monica, California; and
Jack Shainman Gallery, New York

103.

D.I., 1995
Etching, T.P.
10½ × 23⅞ inches (image), 22 × 29⅞ inches (sheet)
Printed by Aurobora Press, San Francisco
Courtesy of the artist; Gallery Paule Anglim, San Francisco;
Christopher Grimes Gallery, Santa Monica, California; and
Jack Shainman Gallery, New York

104.
D.I., 1995
Etching, T.P.
17¾ x 15⅞ inches (image), 29¾ x 22 inches (sheet)
Printed by Aurobora Press, San Francisco
Courtesy of the artist; Gallery Paule Anglim, San Francisco;
Christopher Grimes Gallery, Santa Monica, California; and
Jack Shainman Gallery, New York

105.
500 Capp Street (basement), San Francisco, 1995
Photograph courtesy of the artist
(Reproduced in catalogue only)

106.
Angel-Go-Round, 1996
Fiberglass and cast concrete figures, motor, and nylon belting
16 x 25 feet diameter
Courtesy of the artist; Gallery Paule Anglim, San Francisco;
Christopher Grimes Gallery, Santa Monica, California; and
Jack Shainman Gallery, New York

107.
Angel-Go-Round, 1996, installation view from exhibition
Affinities and Collections, California Center for the Arts,
Escondido, 1998
Photograph courtesy of California Center for the Arts,
Escondido

108.
Box of Angels, 1996
Cast figures, glass, and wood vitrine
78 x 51½ x 51½ inches
Collection of Sheldon Memorial Art Gallery and
Sculpture Garden, University of Nebraska–Lincoln;
UNL–Olga N. Sheldon Fund Acquisition Trust

109.
Duchamp's Tree, 1996
Branded alder wood and steel bottle rack
46 x 35 inches diameter
Collection of Henry and Lisille Matheson, San Francisco

110.
Wire Wall Drawing, 1996
Wire and enamel on aluminum
46 x 28 x 18½ inches (irreg.)
Courtesy of the artist; Gallery Paule Anglim, San Francisco;
Christopher Grimes Gallery, Santa Monica, California; and
Jack Shainman Gallery, New York

111.
Big Chair, 1997 (reconstructed for exhibition)
Drywall and paint
16 x 13½ x 13½ feet (approx.)
Courtesy of the artist; Gallery Paule Anglim, San Francisco;
Christopher Grimes Gallery, Santa Monica, California; and
Jack Shainman Gallery, New York

112.
Big Chair, 1997, installation view from exhibition *David
Ireland,* Institute of Contemporary Art, Maine College of Art,
Portland, 1997
Photograph courtesy of Brian Vanden Brink
Copyright © Brian Vanden Brink

113.
Window Wall, 1997 (reconstructed for exhibition)
Drywall, paint, glass, and construction debris
12 x 39 x 10 feet (approx.)
Courtesy of the artist; Gallery Paule Anglim, San Francisco;
Christopher Grimes Gallery, Santa Monica, California; and
Jack Shainman Gallery, New York

114.
Window Wall, 1997, installation view from exhibition *David
Ireland,* Institute of Contemporary Art, Maine College of Art,
Portland, 1997
Photograph courtesy of Brian Vanden Brink
Copyright © Brian Vanden Brink

115.
Evergreen, 1998
Acrylic and wax on paper
12 x 9 inches
Courtesy of the artist; Gallery Paule Anglim, San Francisco;
Christopher Grimes Gallery, Santa Monica, California; and
Jack Shainman Gallery, New York

116.
Ex Cathedra, 1998
Plywood, drywall, and paint
110 x 101½ x 102½ inches
Collection of University of California, Berkeley Art Museum;
gift of the artist and Gallery Paule Anglim 1998.19
(Exhibition copy of original work for national tour)

117.

White Drawing, 1998
Acrylic and wax on paper
15⅛ x 11 inches (irreg.)
Courtesy of the artist; Gallery Paule Anglim, San Francisco;
Christopher Grimes Gallery, Santa Monica, California; and
Jack Shainman Gallery, New York

118.

The Big Chair, 1999
Concrete
14 x 14½ x 11 feet
Collection of Karen and Robert Duncan, Lincoln, Nebraska
(Reproduced in catalogue only)

119.

Meandering Line, 1999
Acrylic and wax on paper
16¾ x 11 inches
Courtesy of the artist; Gallery Paule Anglim, San Francisco;
Christopher Grimes Gallery, Santa Monica, California; and
Jack Shainman Gallery, New York

120.

Big Chair, 2000
Steel
12 x 8 x 12½ feet
Collection of IKEA, Emeryville, California
(Reproduced in catalogue only)

121.

Drawing with Splotches, 2000
Acrylic, ink, and wax on paper
12 x 9⅛ inches (irreg.)
Courtesy of the artist; Gallery Paule Anglim, San Francisco;
Christopher Grimes Gallery, Santa Monica, California; and
Jack Shainman Gallery, New York

122.

Study for Landscape, 2000
Acrylic and wax on paper
14 x 11 inches
Courtesy of the artist; Gallery Paule Anglim, San Francisco;
Christopher Grimes Gallery, Santa Monica, California; and
Jack Shainman Gallery, New York

123.

Untitled, 2000
Acrylic and wax on paper
19¼ x 13¾ inches
Collection of Christopher Grimes, Santa Monica

124.

Cake Dome Vitrine, 2000–01
Glass cake stand and Fixall with pigment
10½ x 11 inches diameter
Courtesy of the artist; Gallery Paule Anglim, San Francisco;
Christopher Grimes Gallery, Santa Monica, California; and
Jack Shainman Gallery, New York

125.

Architecture, 2001
Acrylic and wax on paper
18⅛ x 12 inches
Courtesy of the artist; Gallery Paule Anglim, San Francisco;
Christopher Grimes Gallery, Santa Monica, California; and
Jack Shainman Gallery, New York

126.

Army Gray, 2001
Acrylic and wax on paper
17⅛ x 12⅛ inches (irreg.)
Courtesy of the artist; Gallery Paule Anglim, San Francisco;
Christopher Grimes Gallery, Santa Monica, California; and
Jack Shainman Gallery, New York

127.

Caramel Point, 2001
Acrylic and wax on paper
15 x 11 inches
Courtesy of the artist; Gallery Paule Anglim, San Francisco;
Christopher Grimes Gallery, Santa Monica, California; and
Jack Shainman Gallery, New York

128.

Caramel with Rounded Edges, 2001
Acrylic and wax on wood
17¼ x 11⅞ inches
Courtesy of the artist; Gallery Paule Anglim, San Francisco;
Christopher Grimes Gallery, Santa Monica, California; and
Jack Shainman Gallery, New York

129.

Installation view from exhibition *David Ireland and Gallery Paule Anglim Contemplate the de Young Museum,* Gallery Paule Anglim, San Francisco, 2001
Photograph courtesy of Gallery Paule Anglim
Reproduced with permission from the Fine Arts Museums of San Francisco
(Reproduced in catalogue only)

130.

Perimeter of Holes, 2001
Acrylic and enamel on paper
15⅛ x 11⅜ inches (irreg.)
Courtesy of the artist; Gallery Paule Anglim, San Francisco; Christopher Grimes Gallery, Santa Monica, California; and Jack Shainman Gallery, New York

131.

26 Holes, 2001
Acrylic and enamel on paper
15 x 10½ inches (irreg.)
Courtesy of the artist; Gallery Paule Anglim, San Francisco; Christopher Grimes Gallery, Santa Monica, California; and Jack Shainman Gallery, New York

132.

Two Hole Drawing, 2001
Acrylic and wax on paper
14⅞ x 10½ inches (irreg.)
Courtesy of the artist; Gallery Paule Anglim, San Francisco; Christopher Grimes Gallery, Santa Monica, California; and Jack Shainman Gallery, New York

133.

Whitey, 2001
Acrylic and enamel on paper
15 x 10⅜ inches (irreg.)
Courtesy of the artist; Gallery Paule Anglim, San Francisco; Christopher Grimes Gallery, Santa Monica, California; and Jack Shainman Gallery, New York

134.

Y.K.'s Corner, 2001
Fixall with pigment
8½ x 2½ x 3 inches; overall dimensions variable
Courtesy of the artist; Gallery Paule Anglim, San Francisco; Christopher Grimes Gallery, Santa Monica, California; and Jack Shainman Gallery, New York

Figures

1.

David Ireland, *Logical Form Study,* 1950–53
Charcoal and graphite on paper
15 x 10 inches
Collection of the artist

2.

David Ireland, *Untitled,* 1972
Lithograph, edition 4/8
28 x 21¼ inches
Collection of the artist

3.

Nathan Oliveira, *Graconeille and the Devil,* from the suite of lithographs *Oliveira—Twelve Intimate Fantasies,* 1964, edition 29/60
Lithograph
20 x 15 inches
Collection of Oakland Museum of California; gift of Foster D. Goldstrom 75.15

4.

Original structure at 65 Capp Street, San Francisco, 1978
Photograph courtesy of the artist

5.

Washington Project for the Arts, Washington, D.C., interior view prior to renovation by David Ireland and Robert Wilhite, 1984
Photograph courtesy of the artist

6.

Building 944, Headlands Center for the Arts, Sausalito, California, 1987–88
Photograph courtesy of Henry Bowles
Copyright © Henry Bowles

7.

Skellig Michael, Ireland, 1993
Photograph courtesy of the artist

8.

Skellig Michael (beehive huts), Ireland, 1993
Photograph courtesy of Jane Levy Reed

9.

Masai *manyatta* (manure hut), Kenya, 1966–67
Photograph courtesy of the artist

10.

David Ireland with cement drawing, New York, 1975
Photograph courtesy of the artist

11.

David Ireland, mobile installed at his parents' Bellingham,
Washington, home, 1951
Photograph courtesy of the artist

12.

Tom Marioni, *The Restoration of a Portion of the Back Wall,
Ceiling, and Floor of the Main Gallery of the Museum of
Conceptual Art,* San Francisco (with David Ireland and chair
installation by Vito Acconci), 1976
Photograph courtesy of David Ireland

13.

Textbook illustration of ancient ruins on the Lundi River,
Mashonaland, Zimbabwe
Collection of the artist

14.

David Ireland's studio, Oakland, California, 1990–91
Photograph courtesy of the artist

15.

Lamps designed by David Ireland (right and third from right)
and Rudi Marzi, installed at Fraser's, Berkeley, 1952–53
Photograph courtesy of the artist

16.

David Ireland with Jutta and Jack Rykken (left to right),
Bellingham, Washington, 1962
Photograph courtesy of the artist

17.

Letterhead for David Ireland's Hunter Africa business,
San Francisco, 1970
Collection of the artist

18.

David Ireland in Kenya, 1969
Photograph courtesy of the artist

19.

David Ireland's Union Street studio, San Francisco, ca. 1972–74
Photograph courtesy of the artist

20.

David Ireland in the Annapurna mountain range of the
Himalayas, Nepal, 1975
Photograph courtesy of the artist

21.

Douglas Dunn and Dancers' performance of *Dances for Men,
Women, and Moving Door,* Marymount Manhattan Theatre,
New York, 1986, with stage sets designed by David Ireland
Photograph courtesy of Abe Frajndlich
Copyright © 1986 Abe Frajndlich

22.

David Ireland, New York, 1988
Photograph courtesy of Suzanne Parker
Copyright © Suzanne Parker

INDEX

Page numbers in italics denote illustrations

Permission to reproduce works in this publication has been given by the owners or custodians of the works as cited in the Exhibition and Illustration Checklist. In addition, the work of the following photographers, studios, and institutions is gratefully acknowledged.

Jon and Anne Abbott, New York: pp. 113, 136

Richard Barnes: pp. 68–69

John Berens: pp. 131, 170, 171, 176, 178

Benjamin Blackwell: pp. 108, 114–15

Henry Bowles: pp. 46, 48, 49, 60 (top), 61, 64 (bottom), 65–67, 72

Mark Brlej—surepix.com: pp. 96–97

Elisa Cicinelli: p. vi

Anthony Cunha: p. 177

Willard N. Drown, III: p. 193

M. Lee Fatherree: pp. iv–v, 4, 9, 12–21, 25–33, 39–43, 50, 51, 87–91, 93, 98, 104, 109, 119, 127, 129, 132, 133, 145–47, 149, 168, 172, 173, 179, 188, 192

Abe Frajndlich: pp. 44, 45, 150, 195

Frank E. Graham: pp. 116, 117

David Ireland: pp. x, 34, 60 (bottom), 64 (top), 74, 75, 83, 86 (top), 102, 103, 110, 121, 126, 154, 157, 160, 190

Wilfred J. Jones: p. 94

Christine Labbe: pp. ii–iii

Los Angeles County Museum of Art: p. 73

Mattress Factory, Pittsburgh: pp. 84–85

The Museum of Modern Art, New York: p. xvi

Simo Neri: p. 78

New Museum of Contemporary Art, New York: pp. 62–63

Nora Eccles Harrison Museum of Art, Utah State University, Logan: p. 169

Howard P. Nuernberger: pp. 76, 77

Suzanne Parker: pp. iv, 8, 52–53, 196

Jane Levy Reed: p. 86 (bottom)

Adam Reich: pp. 47, 105, 128

San Francisco Museum of Modern Art: p. 175

William Short: pp. 106–7

John Spence: p. 118

Michael Tropea, Chicago: pp. 95, 167

University of California, Berkeley Art Museum: pp. 162–63

Brian Vanden Brink: pp. 181, 182–83

Walker Art Center, Minneapolis: p. 184

Joshua White: pp. 130, 134, 135, 142–44, 148

Friedrich Zubler: pp. 80–81, 82

NOTE ON DETAILS: p. 125 from *Dumbball Action*, 1986 (cat. 47); p. 141 from *79 Dumbballs with Carriers, Dedicated to the Memory of John Cage*, 1992 (cat. 84); p. 197 from David Ireland working on exhibition *David Ireland in Switzerland: You Can't Make Art by Making Art*, Helmhaus, Zurich, 1991 (cat. 73)

DESIGN AND COMPOSITION: Gordon Chun Design
TEXT: Caslon Roman & Italic
DISPLAY: Helvetica Neue Thin and Bold Extended
PRINTING AND BINDING: Friesens

Sixth Edition

CRIMINOLOGICAL THEORY

Frank P. Williams III
University of Houston–Downtown;
California State University—San Bernardino

Marilyn D. McShane
University of Houston–Downtown

0133349144 **6th**
Pearson 2014

PEARSON

Boston Columbus Indianapolis New York San Francisco
Amsterdam Cape Town Dubai London Madrid Milan Munich
Delhi Mexico City São Paulo Sydney Hong Kong Seoul Sin

Vice President and Executive Publisher: Vernon Anthony
Senior Acquisitions Editor: Gary Bauer
Editorial Assistant: Tanika Henderson
Director of Marketing: David Gesell
Marketing Manager: Mary Salzman
Senior Marketing Coordinator: Alicia Wozniak
Production Manager: Romaine Denis
Creative Director: Jayne Conte
Cover Designer: Karen Noferi
Media Project Manager: Karen Bretz
Full-Service Project Management/Composition: George Jacob/Integra Software Services Pvt. Ltd.
Printer/Binder: Courier, Inc.
Cover Printer: Courier, Inc.

Credits and acknowledgments borrowed from other sources and reproduced, with permission, in this textbook appear on appropriate page within text.

If you purchased this book within the United States or Canada you should be aware that it has been imported without the approval of the Publisher or the Author.

10 9 8 7 6 5 4 3 2 1

ISBN-13: 978-0-13-334914-6
ISBN-10: 0-13-334914-4